Two Centuries of Black American Art

Two Centuries of Black American Art

Two Centuries of Black American Art

David C. Driskell

With catalog notes by
Leonard Simon

Los Angeles County Museum of Art/
Alfred A. Knopf, New York, 1976

Copyright © 1976 by
Museum Associates of the
Los Angeles County Museum of Art

All rights reserved under International
and Pan-American Copyright
Conventions. Published in the United
States by the Los Angeles County
Museum of Art and Alfred A. Knopf, Inc.,
New York, and simultaneously in Canada
by Random House of Canada Limited,
Toronto. Distributed by Random House,
Inc., New York.

Library of Congress Cataloging in
Publication Data

Driskell, David C.
Two centuries of Black American art.

Bibliography: p.
Includes index.
1. Afro-American art—Exhibitions.
I. Simon, Leonard, date-
II. Los Angeles Co., Calif. Museum of
Art, Los Angeles. III. Title.
N6538, N5D74 709'.73 76-13691
ISBN 0-394-40887-X (hardcover)
ISBN 0-394-73248-0 (paperback)

Manufactured in the United States of
America
First Edition

Exhibition dates
Los Angeles County Museum of Art:
September 30-November 21, 1976
The High Museum of Art, Atlanta:
January 8-February 20, 1977
Museum of Fine Arts, Dallas:
March 30-May 15, 1977
The Brooklyn Museum:
June 25-August 21, 1977

Contents

Lenders to the Exhibition

C. R. Babe
Dr. and Mrs. William Bascom
Hans Bhalla
John Biggers
Mr. and Mrs. Sidney F. Brody
Dr. Selma Burke
Calvin Burnett
Prof. John Burrison
Dr. Margaret T. Burroughs
Claude Clark
Mrs. Terry Dintenfass
Aaron Douglas
Prof. and Mrs. David C. Driskell
William A. Fagaly
Prof. Franklin Fenenga
Dr. Norbert Fleisig
Mr. and Mrs. H. Alan Frank
Mr. and Mrs. Melvin Frank
Dr. and Mrs. Richard Frates
Lewis Glaser
Mrs. Morton Goldsmith
Leonard Granoff
Mr. and Mrs. Earl Grant
Mrs. Palmer Hayden
Felrath Hines
Earl J. Hooks
Mrs. Grace Jones
George E. Jordan
Lawrence H. Koffler
Mr. and Mrs. Sol Koffler
Dr. and Mrs. Charles H. Mandell
Mrs. Delmus R. McGill
Archibald J. Motley, Jr.
Matthew Pemberton
Myla Levy Perkins
Mr. and Mrs. Joseph L. Pierce
Mr. and Mrs. William Pierce
Dr. Lois Jones Pierre-Noel
Dr. Dorothy B. Porter
Private Collection, Harbor City,
 California
Mr. and Mrs. John Rhoden
Gregory D. Ridley, Jr.
Louis K. Rimrodt
Donald J. Shein
Edward L. Shein

Willie Starbuck
William Taylor
Robert H. Tessier
Alma W. Thomas
Mr. and Mrs. Peter H. Tillou
Mr. and Mrs. R. K. Van Zandt
Mr. and Mrs. Sid Wallach
Mr. and Mrs. Frederick L. Weingeroff
James L. Wells
Mrs. Edwina Harleston Whitlock
Mrs. Ora G. Williams
Ed Wilson
John Wilson
Robert Wilson

The Art Institute of Chicago
Brockman Gallery, Los Angeles
Cincinnati Art Museum
The Cleveland Museum of Art
The Detroit Institute of Arts
Dintenfass, Inc., New York
Fine Arts Museums of San Francisco
Fisk University, Department of Art,
 Nashville
Golden State Mutual Life Insurance
 Company, The Afro-American
 Collection, Los Angeles
Heritage Gallery, Los Angeles
Hirshhorn Museum and Sculpture
 Garden, Smithsonian Institution,
 Washington, D.C.
Huntington Galleries
Martha Jackson Gallery, New York
Los Angeles County Museum of Art
Louisiana State Museum, New
 Orleans
The Maryland Historical Society,
 Baltimore
The Metropolitan Museum of Art,
 New York
Midtown Galleries, New York
Museum of African Art,
 Washington, D.C.
Museum of Fine Arts, Boston
Museum of Fine Arts, Houston

National Collection of Fine Arts,
 Smithsonian Institution,
 Washington, D.C.
The Newark Museum
New Orleans Museum of Art
North Carolina Museum of Art,
 Raleigh
The Oakland Museum
The Phillips Collection,
 Washington, D.C.
San Francisco Museum of Art
San Jose Public Library, San Jose,
 California
Smith College Museum of Art,
 Northampton
Spelman College, Atlanta
Tennessee Botanical Gardens and
 Fine Arts Center, Nashville
University Art Gallery,
 State University of New York,
 Binghamton
University of North Carolina,
 Chapel Hill
Whitney Museum of American Art,
 New York
Angus Whyte Gallery, Boston
Frederick S. Wight Art Gallery,
 University of California,
 Los Angeles

Acknowledgments

Warmest appreciation is extended to the many individuals who have been generous with advice, research, and other essential aid. Especially helpful were Dr. Gerald Ackerman, Karen Adams, Terry Adkins, Prof. Carl Anthony, Dr. Malcolm Arth, Rodney Barfield, William Edmund Barrett, Peter Birmingham, Jacqueline Bontemps, Dr. Margaret T. Burroughs, Michael Cohn, the curatorial staff of the Historic New Orleans Collection, Prof. Gerald L. Davis, Thelma G. Driskell, John Ellington, Prof. Franklin Fenenga, Stephen Ferrill, Mr. Figgins, Prof. Ausbra Ford, Robert S. Gamble, Carroll Greene, Jr., Marcia M. Greenlee, Robert Hall, Kenneth Hart, Mrs. James T. Igoe, Mary Isom, Christene Johnson, Jane Matthews, George McDaniel, Robert McDonald, Leatrice McKissack, Eugene Ethelbert Miller, Prof. James Miller, Carlton Moss, Ford Peatross, Prof. Gregory S. Peniston, Dr. Dorothy B. Porter, Katharine Ratzenberger, Marie Roque, Helen Shannon, Edward L. Shein, Dr. Joshua Taylor, Clark Thomas, Dr. Raymond Thompson, Gladys Truss, Forestine Venson, Prof. John Vlach, Anna Wadsworth, Jonathan W. Walton, Jr., Ben F. Williams, Dreck Wilson, Muriel Wilson, Robert Wilson, Eloise Woodward, and Tony Wrenn.

Additionally, a special staff assisting Professor Driskell and Leonard Simon should be identified: Allene Beard, Dr. Allan Gordon, Steven L. Jones, and Roderick Owens. The efforts of the trustees, directors, and staff members of the Los Angeles County Museum of Art, The High Museum of Art at Atlanta, the Dallas Museum of Fine Arts, and The Brooklyn Museum are happily recognized. On the staff of the organizing museum at Los Angeles, where a great many individuals have given special support to the guest curator, particular gratitude is extended to Jeanne D'Andrea, Head of Exhibitions and Publications; Nancy Grubb, catalog editor; Kristen McCormick of the registrar's office; Head Conservator Benjamin B. Johnson; and Museum Head Photographer Edward Cornachio. Ms. Madelyn Mayo, museum intern on a Smithsonian Fellowship, has also provided admirable assistance. Many others on the staffs of the four exhibiting museums will be intimately involved in the exhibition's actual installation. To them, warmest advance thanks as this catalog goes to press months in advance of the culmination of many efforts.

A final acknowledgment must be made in the instance of the late Claude Booker. Founder of the Black Arts Council and a former staff member of the Los Angeles County Museum of Art, Mr. Booker long insisted that an exhibition not unlike *Two Centuries of Black American Art* come to pass.

R. A. S.

Introduction

Black is neither a true color nor an entirely apt word in the title for this exhibition. The artists represented were not selected because of their African ancestry alone, however direct or mixed, but to consider how this has obscured their contributions to American art history. And so it is not mere skin color that gives this survey a unity although it is true that many of the artists represented underwent uniquely personal torments because of a majority society's prejudices. Some escaped through exile: Edmonia Lewis to Rome, Henry O. Tanner to Paris, William H. Johnson to Denmark. But a larger number did not or could not. One revelation of this present assemblage is that the human creative impulse can triumph in the face of impossible odds, and at times perhaps even because of them.

One irony that tends to bear this out was an episode endured by Edward Bannister. After he had submitted his *Under the Oaks* for exhibit at the Philadelphia Centennial Exposition, it won a bronze medal. But the artist himself was nearly denied admission to the gallery displaying his work, because of his color. We are told also that Tanner's embitterment with America derived from the recognition he received not as an artist, but as a *black* artist, a kind of racial anomaly. The *real* anomaly is that our society, with few exceptions, has taken so long to recognize these gifted Americans who have strengthened the cultural fabric that cloaks and therefore enriches us all.

For those who know black American art only through contemporary exhibitions of the past decade, it will come as a surprise that so many earlier artists did not reflect "the black experience" in their subject matter. But from their portraits of whites, biblical scenes, and landscapes that have affinities with Cole and Durand, it seems that staying close to the mainstream of American art was a way for black artists to find acceptance and commissions. Perhaps this conformity (or better, sublimation) was in itself another kind of "black experience."

This exhibition, although the largest of its type held thus far, is hardly complete. An endless regret is that many black American works have vanished, or lack documentation. Even in our own times there are few public museums with appreciable collections of black American art. Hopefully this does not reflect conscious bias as much as it does unawareness. Lamentably rare, also, are American art texts or biographical dictionaries that list even a few of the names encountered in this exhibition and catalog. One can at least be grateful that in our century pioneer institutions such as the Harmon Foundation; Atlanta, Fisk, and Howard universities; the Schomburg Collection of the New York Public Library; and the Frederick Douglass Institute, Museum of African Art, among others, began serious efforts to end the anonymity of these American artists and to encourage public awareness and appreciation of their achievements.

Although the exhibition includes a number of important works that have not, until now, been seen by a large public, there are still regrettable gaps. In some instances owners were reluctant to lend; in others, surviving

works were deemed too fragile to travel. We have already noted that some may be lost forever, including Tanner's original *Daniel in the Lions' Den*, of which a later version by his hand is in the exhibition.

This exhibition and its catalog represent extensive research, negotiation, selection, and thought by Professor David C. Driskell, chairman of the Department of Art at Fisk University. An artist himself, he is an acknowledged authority on black American art and his university is a leading repository. Assisted by Leonard Simon, Professor Driskell was presented with a mandate when invited to serve as guest curator of this exhibition: to locate a broad-ranged group of works reflecting the efforts of the more significant black American artists from slave times into the mid-twentieth century. There are some exceptions: works by living artists who, although active before 1950, asked to be represented by later examples.

When the concept of this exhibition was first generated, initial research revealed a paucity of serious literature on black American art. Part of this mandate to Professor Driskell therefore included the preparation of a catalog text capable of filling a void that has existed too long. Quite apart from its direct relationship to the exhibition and its contribution to the literature, we hope that this publication will stimulate further research and scholarship that will give us a more complete history of American art.

The Museum expresses particular appreciation to nearly one hundred lenders whose names appear on page 6. Their willingness to part with treasured possessions for more than a year, permitting scores of thousands of museum visitors to see them in Los Angeles, Atlanta, Dallas, and Brooklyn, represents both admirable generosity and welcome enthusiasm for this project. *Two Centuries of Black American Art* could not have been organized and presented without substantial assistance from the National Endowment for the Humanities and Philip Morris Incorporated. This combination of government and corporate support has provided vital succor for the exhibition, this catalog, and a variety of related educational activities.

Rexford Stead
Deputy Director
Los Angeles County Museum of Art

Black Artists and Craftsmen in the Formative Years, 1750-1920

Work by black American artists has frequently been discussed as though it were a form of expression separate from that produced by artists of the majority culture. That this approach has been readily sanctioned comes as no surprise, for most literature on black American artists reflects sociological patterns that have been fostered by the tradition of classifying people and their culture according to race. Yet the black artist has neither wanted nor accepted this critical isolation. Even during the turbulence of the conflict over slavery, he continued to seek a position in the art world where he would be respected above all for the mastery of his craft. Recognizing the nature of the racially divided world into which he had been born, he struggled to maintain his humanity and his dedication to art.

While one may argue the validity of distinct categories separating artists and craftsmen according to national origin and ancestral heritage, the most crucial issue will always be the quality of the work and its relevance to the society in which it was created. Like all forms of expression, art is seldom so ordered that any one style is acceptable to all who consider themselves artists. The black artist is no different from any other in his struggle to express his own individual sensitivity to order and form and at the same time relate to the cultural patterns of the time and place in which he lives. In this sense art, though seldom allowed to perform its function without critical analysis, knows no racial boundaries. It is ultimately a universal language of form, a visual dialogue about man's cultural history that can be read and understood without regard to the color of the artist. As a participant in this dialogue the black American artist can be seen as part of the mainstream despite the paucity of critical recognition.

Traditionally, black artists were not encouraged to participate in exhibitions in which works by their white contemporaries were shown; in numerous cases, they were specifically excluded. Certainly no single exhibition can rectify such omissions, but it is both timely and proper that the rich visual heritage and cultural contributions of the black artist be presented in a manner that will permit proper recognition of his talents as craftsman and artist. It is the aim of this exhibition to make available a more accurate compendium of American art by documenting the quality of a body of work that should never have been set apart as a separate entity.

Some of the cultural patterns of black involvement in the visual arts go all the way back to Africa where art flourished long before Africans were enslaved and shipped to this continent. When European explorers invaded Africa during the last half of the fifteenth century, the men of letters among them wrote in their diaries impressions of the excellent craftsmanship that abounded among the "primitive people" they visited. Some took specimens of this native artistry back with them to Europe as souvenirs and good-luck charms. (They could not have suspected that such curiosities would serve as a catalyst centuries later for the most revolutionary break with the traditions of academic art ever to occur.) It was from the ranks of these craftsmen, labeled primitive by the

European explorers, that the first black slaves were forced to come to colonial America (fig. 1). This inhumanity of white over black and master over slave gained a permanent place in the minds of the slaves, who kept their somber memories alive through song, dance, and vigilant image, creating a new language of form that echoed Africa in a distant land. The human stock in bondage that Africa gave unwillingly to the Western world had known centuries of uninterrupted progress in the visual arts, producing one of the oldest, most sophisticated traditions of making functional art objects known to civilized man (fig. 2).[1] Nevertheless, these traditional sensibilities were abruptly rechanneled into skilled labor at the time of the slave's removal from Africa. During this period of transition, when the native crafts of the African artisan were all but lost, one sees in the folk and decorative arts of colonial America a synthesis of the distinct characteristics of African craftsmanship and iconography with the art of the majority culture.

In many civilizations where oral, written, or visual history has recorded man's ways of making art, the forms called crafts have preceded those of the fine arts. Such a pattern of creative development held true among people of African ancestry in the United States. An apprenticeship in the crafts often served to prime talent in painting, drawing, or sculpture, and skilled black artisans traditionally moved up the scale from journeyman

[Top]
Fig. 1 Advertisement for a cargo of slaves aboard the *Bance Island*, anchored off Charleston during a smallpox plague

[Right]
Fig. 2 Kente cloth and gold jewelry made by African artisans, worn by an Ashanti chief

1. Alain Locke, *Negro Art Past and Present*, (Washington, D.C.: Associates in Negro Folk Education, 1936), p. 1.

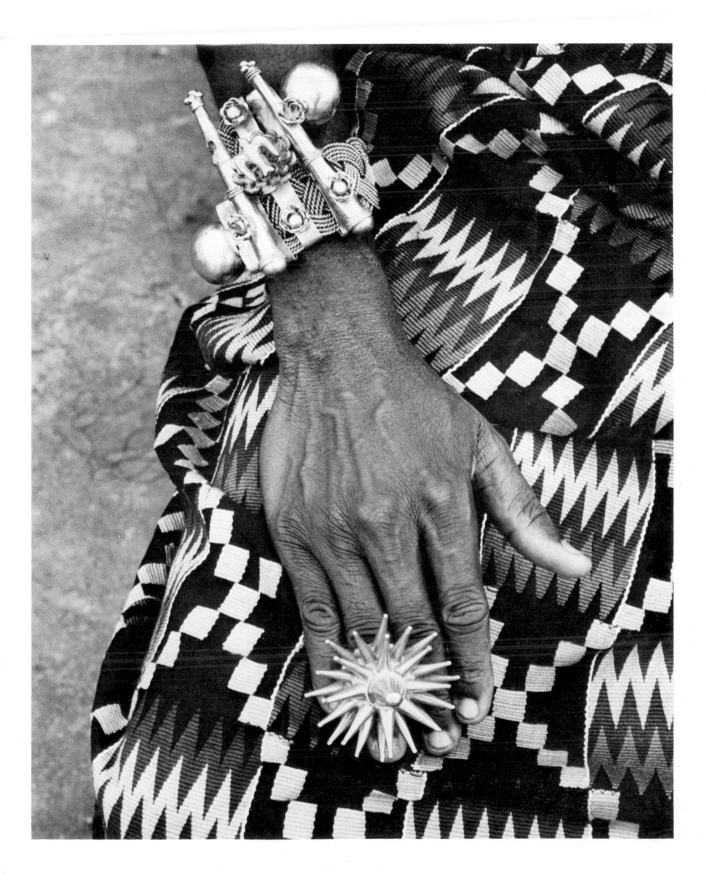

to master craftsman, then entered a particular area of the fine arts; this system endured well into the late nineteenth century.

Although history has recorded few names of black American artisans, one is increasingly aware of fine quality craftsmanship that proves they have been major contributors to every stage of this nation's cultural development since the arrival of the first slaves in Jamestown in 1619. Functional objects such as "grotesque jugs" (fig. 3, cat. no. 5), more generally classified as slave pottery; carved walking canes, often decorated with the same animal and human forms seen on similar objects found in West Africa; highly patterned raffia basketry (cat. no. 9); religious voodoo objects such as the so-called *Slave Mask* included in this exhibition (cat. no. 6); and carved wooden grave markers (figs. 4, 5) bear witness to the fact that certain African forms made their way into American society during the period of slavery and became accepted elements of the craft and fine arts tradition.[2] These functional forms provide a rich record of black achievement that is worthy of further study.

At times it was evident that a slave's knowledge about the crafts of his native land was not suitable in the colonies without his undergoing a period of retraining.[3] Since slavemasters deliberately sought to eliminate any form of African culture that might contribute to group

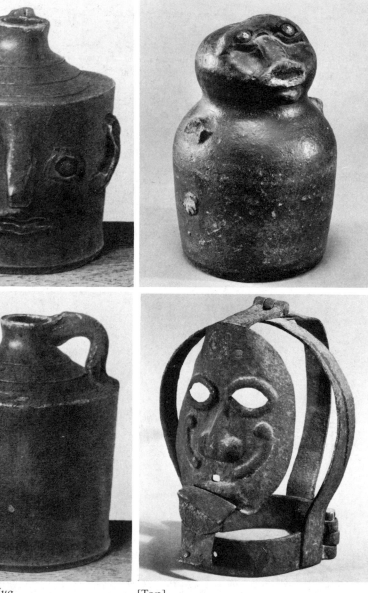

Fig. 3 *Grotesque Jug*
Index of American Design
National Gallery of Art,
Smithsonian Institution

[Top]
Cat. no. 5 *Jug in the Form of a Human Head*
[Bottom]
Cat. no. 6 *Slave Mask*, nineteenth century
[Right]
Cat. no. 9 *Basket*, late nineteenth century

2. Judith Wragg Chase, *Afro-American Art and Craft* (New York: Van Nostrand Reinhold Company, 1971), p. 53.
3. Giles B. Jackson and D. Webster Davis, *The Industrial History of the Negro Race in the United States* (Richmond: n.p., 1908), p. 13.

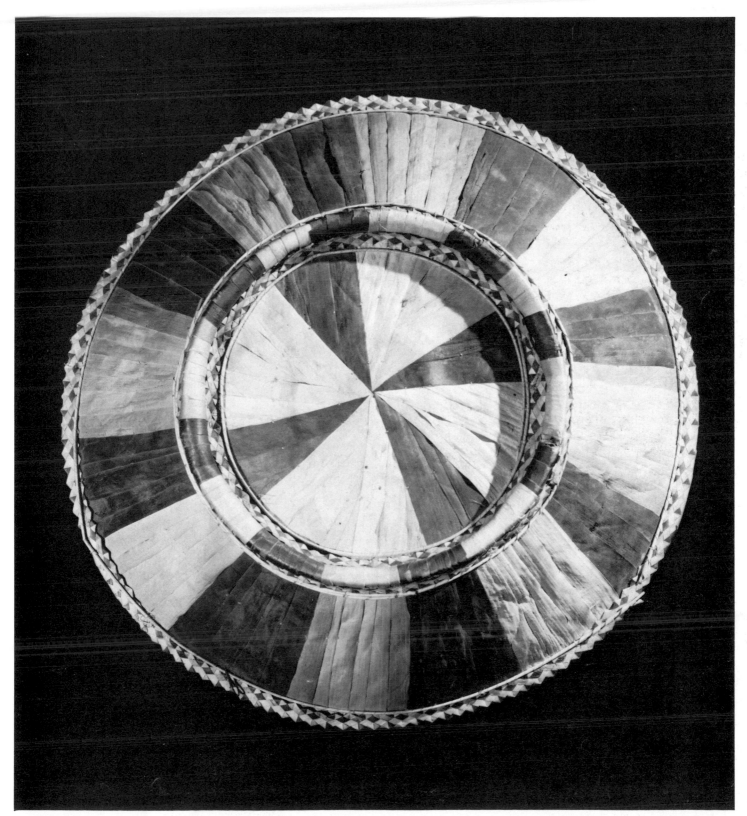

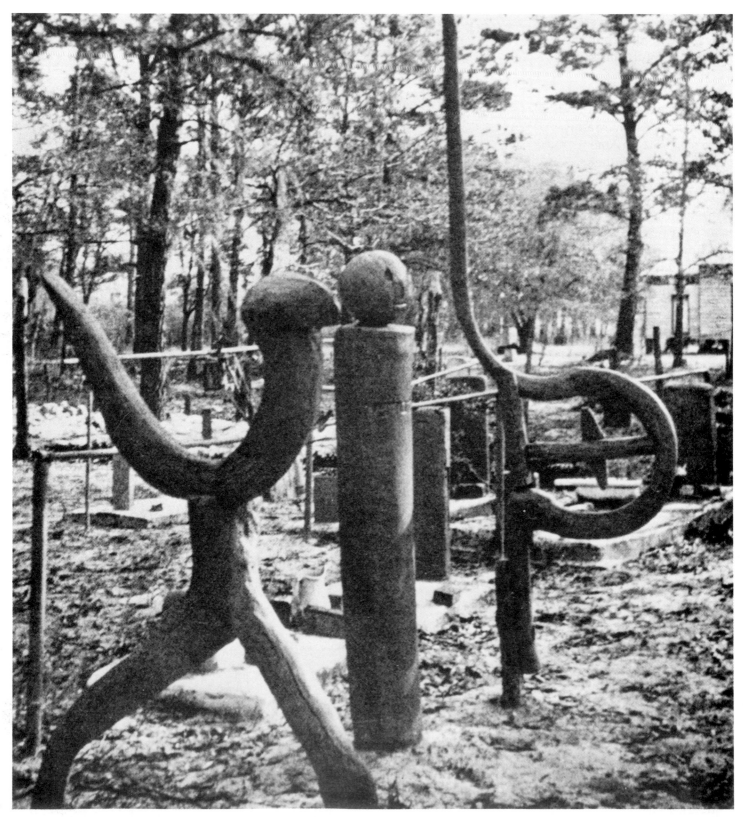

communication, much of their art was either destroyed or condemned as pagan and sinful. This severance of ties with Africa meant a loss not only of traditional forms but of the status accorded the craftsman in various African societies where art was vital to every man's life. In America there was no longer a need for the services of the skilled carver whose position in Africa had called for making the musical instruments, ceremonial masks, and other sculptural works essential to art, dance, and music (fig. 6). A well-trained carpenter might decorate architectural interiors for his owner, but this was not the same honor as creating a mask for the village chief.

As its prosperity increased, the developing white American middle class became more and more dependent on craftsmen of African ancestry to enhance the quality of post-colonial life. A German physician touring the United States in 1783 observed that:

> ...The gentlemen in the country have among their Negroes as the Russian nobility among the serfs, the most necessary handicraftsmen, cobblers, tailors, carpenters, smiths, and the like whose work they command at the smallest possible price or for nothing almost. There is hardly any trade or craft which has not been learned and is not carried on by Negroes.[4]

The services of skilled black ironsmiths, silversmiths, furniture-makers, and couturiers (fig. 7),

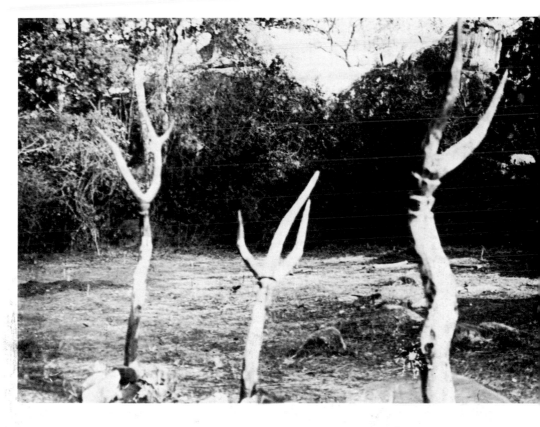

[Opposite]
Fig. 4 Carved wooden grave markers, late nineteenth-early twentieth century, Sunbury, Georgia

[Top]
Fig. 5 Ceremonial wooden grave markers carved by the Lori people, eastern Zaire

[Right]
Fig. 6 *Afro-American Drum*, ca. 1645
Collection of the British Museum

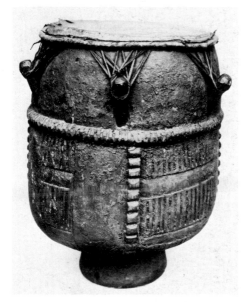

4. Johann D. Schoepf, *Travels in the Confederation, 1783-1784*, ed. A. J. Morrison (Philadelphia: n.p., 1911), vol. II, p. 221.

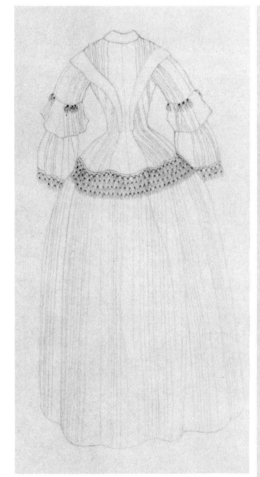

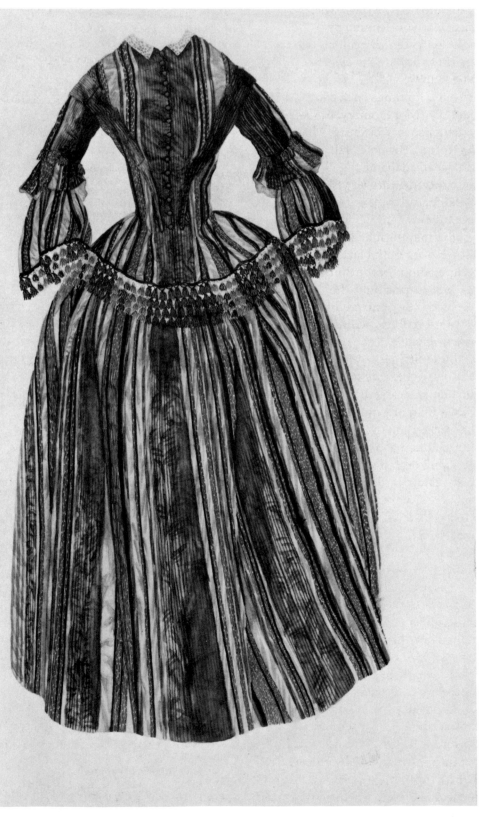

Fig. 7 *Blue and Gray Striped Dress*
Made by slaves in the nineteenth century
Index of American Design, National
Gallery of Art, Smithsonian Institution

to mention only a few,[5] were particularly welcomed by those eighteenth-century colonists who sought to imitate the elegance of the houses in which they had served in Europe. Buildings such as the State Capitol in Montgomery, Alabama; the courthouse in Vicksburg, Mississippi (fig. 8); and Swayne Hall at Talladega College in Alabama (fig. 9) were constructed entirely by slaves working under the supervision of white contractors.[6] Black carpenters built numerous mansions, as well as churches for both black and white congregations in the South (figs. 10, 11). Not surprisingly, the slaves received little or no credit; in fact, there are very few written accounts in which slavemasters permitted them to be identified by name, although the refinement of slave work was frequently stressed.

Less than one hundred years after the Declaration of Independence was signed, free people of color, both black and mulatto, dominated the craft-related trades in the Louisiana register of laborers. In 1854 there were 3,085 skilled laborers and artisans registered in the city of New Orleans; 2,668 were of African ancestry, of which 470 were classified as black and 2,198 as mulatto.[7] However, in certain fields blacks were represented only slightly: there were few printers using movable type and there were very few bakers. The threat of rebellious blacks learning to print inflammatory anti-slavery material loomed large in the minds of fearful whites who also took seriously the talk of mass poisoning by bread from black bakers.

Much information about the black artisan from colonial times to the end of the nineteenth century has come to us through newspaper announcements of slave sales and advertisements by "free men of color." Press accounts from as early as 1740 announcing the sale of slaves in Charleston, South Carolina, provide evidence of blacks working as silversmiths while America was still a British colony. So prevalent were blacks in this and other trades that whites often found themselves at a disadvantage. In 1755 the Provincial Legislature of South Carolina was petitioned to pass a law that would prevent the acceptance of black craftsmen into trades where blacks already outnumbered whites. One clause of this law was aimed at curbing the liberal practices of some slaveholders who were no doubt master craftsmen themselves:

> *No master of any slave shall permit*
> *or suffer such slaves to carry on any*

5. Henry Castellanous, a well-known Louisiana historian, wrote of these artisans: "In our factories and blacksmith shops bosses or foremen would be white, while the operatives were either blacks or mulattoes. And so with other trades, such as bricklayers or masons, carpenters, painters, tinsmiths, butchers, bakers, tailors, etc. In fact, had not the progress of the country, from the condition of unrest under which it had been laboring, developed itself into the proportions which it has since assumed, there cannot be the least doubt but that all the lower mechanical arts would have been monopolized in the course of time by the African race." He suggests that an influx of labor in the crafts wrested from blacks this potential source of power.

6. According to the memoirs of J. M. Gibson, edited in 1929 by James Alverson Gibson, Sr., and James Alverson Gibson, Jr., the courthouse in Vicksburg was designed by "a Negro mechanic slave" by the name of John Jackson who also supervised its construction, working under a white contractor.

7. Annie L. W. Stahl, "The Free Negro in Ante-Bellum Louisiana," *Louisiana Historical Quarterly* 25, no. 2 (April 1942): 301-95.

handicraft trade in a shop by himself in town, on pain of forfeiting five pounds every day. Nor to put any Negro or slave apprentice to any mechanic trade or another in town on forfeiture of one hundred pounds. PROVIDED, that nothing in this act shall be construed, to hinder any handicraft tradesman in town, from teaching their own Negroes or slaves the trades they exercise, so that they constantly employ one white apprentice or journeyman, for every two Negroes that they shall so teach and thenceforth employ.[8]

A notice in the *Southern Carolina and American General Gazette* in 1772 offered one hundred pounds as a reward to any person who knew the whereabouts of a teenage silversmith named Joe:

The said boy is near sixteen years old, ... is very arch and sensible, and wrought at the silversmith's trade many years, being at work with Mr. Oliphant, jeweller, when he absented himself, ... John Paul Grimke.[9]

The sale of another black trained as a silversmith was advertised in a Charleston newspaper in 1818:

For Sale, a prime young Negro, named Noel, well known in this city as a complete servant, and good baker—was first brought up to the Silversmith Line. He is the property of Mr. Maurel (q.v.). If this young

8. E. Milby Burton, "Contributions from the Charleston Museum," in *South Carolina Silversmiths, 1690-1800* (Charleston: Charleston Museum, 1942), pp. 207-8.
9. *South Carolina and American General Gazette,* Charleston, South Carolina, Jan. 6-13, 1772.

[Right]
Fig. 8 The courthouse, Vicksburg, Mississippi

[Opposite]
Fig. 11 Ethiopian Coptic Church, Gondar

[Right]
Fig. 9 Swayne Hall, Talladega College, Talladega, Alabama, built in the nineteenth century as a private boys' school

[Opposite]
Fig. 10 Zion Baptist Church, North Garden, Virginia

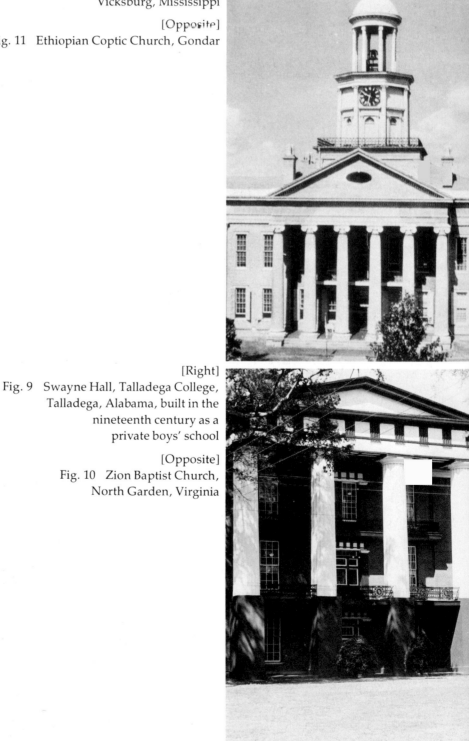

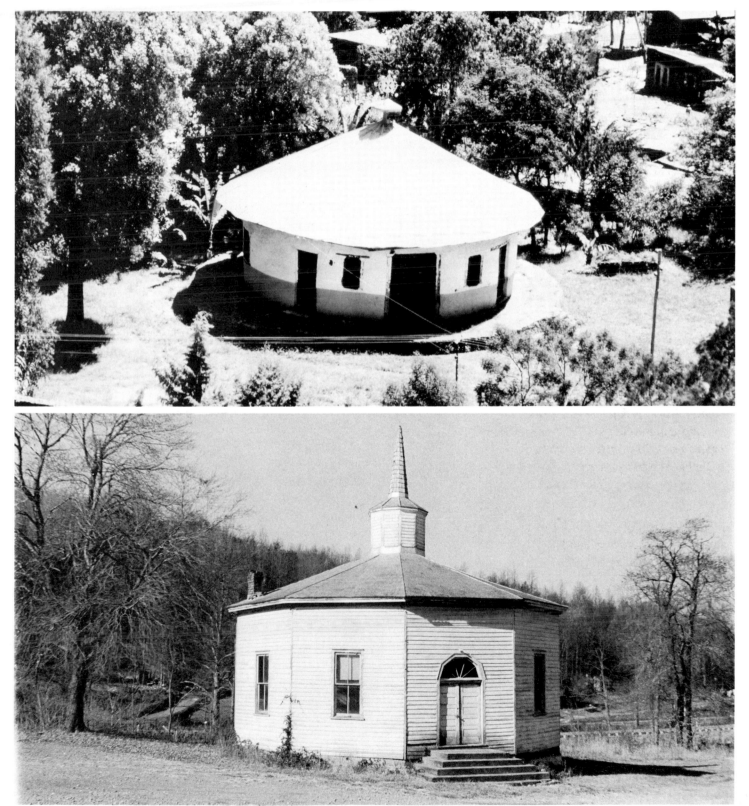

Fig. 12 Advertisement in the
Milton Gazette and Roanoke, March 1, 1827

*fellow is not disposed of at a private
sale before Thursday next, he will be
sold at Public Auction, Apply at No.
5, Verdue Range, or to Mr.
Maurel.*[10]

Professor James A. Porter cited in
Modern Negro Art the following
notice, which had appeared in the
Pennsylvania Packet, as proof of the
widespread use of black artisans as
goldsmiths in the last quarter of the
eighteenth century:

*John Letelier.—Eight dollars reward.
Ran away from the subscriber, a
negro named John Frances, by trade
a goldsmith. Said negro was carried
to New York and left in charge of
Ephraim Brasher, goldsmith, from
whom he absconded, and returned
to me—whoever takes up said negro
and delivers him to John Letelier,
goldsmith in Market Street, or to
the subscriber in New York, shall
have the above reward, and all
reasonable charges paid.*[11]

Black furniture-makers were the
master craftsmen among carpenters.
Their shops could be found in small
inland towns and in every principal
city along the East Coast. These men
counted on the patronage of wealthy
whites, including governors and
professional men of means, to
support their prosperous businesses.
Most noteworthy among the black
furniture-makers working along the
eastern seaboard in the early 1800s
was a man by the name of Thomas
Day (fig. 12). Educated in Boston and
Washington, he was recognized as an
important cabinetmaker as early as
1818, and his first dated piece reads

1820. In 1823 he moved to Milton,
North Carolina, where he purchased
a building then known as the Old
Yellow Brick Tavern (fig. 13) and set
up a very successful shop
manufacturing fine furniture of
mahogany, walnut, rosewood, and
cherry and teaching his craft to a
select number of blacks and whites in
the area. By the standards of his day
he was a very wealthy man, and
became one of the original
stockholders in the Milton branch of
the North Carolina State Bank.[12] The
finest examples of Day's furniture,
which was collected by wealthy
patrons throughout the South and
East, are still to be found in the town
of Milton and in private homes in
Raleigh (fig. 14, cat. no. 2). It is
important to note that Day, like many
of his white contemporaries, was a
slave owner. Though one cannot
explain why a black man would
participate in the enslavement of his
own kind, it is apparent that Day
simply used the cheapest form of
labor available. Like Marie Thérèse
Quan Quan, the owner of Yucca
House, he owned even more slaves
than the average white slaveholder.

The unusual patterns and motifs
that Day used to embellish numerous
stairways and architectural interiors
are a unique aspect of his work. One
handsomely carved post at a stairwell

10. *City Gazette and Commercial Daily Adviser*,
Charleston, South Carolina, February 22, 1818.
11. James A. Porter, *Modern Negro Art* (New
York: Dryden Press, 1943. Reprint. New York:
Arno Press, 1969), p. 16.
12. Stephen Jones, "Afro-American
Architecture: The Spirit of Thomas Day"
(unpub. ms., Howard University, 1973), p. 47.

22

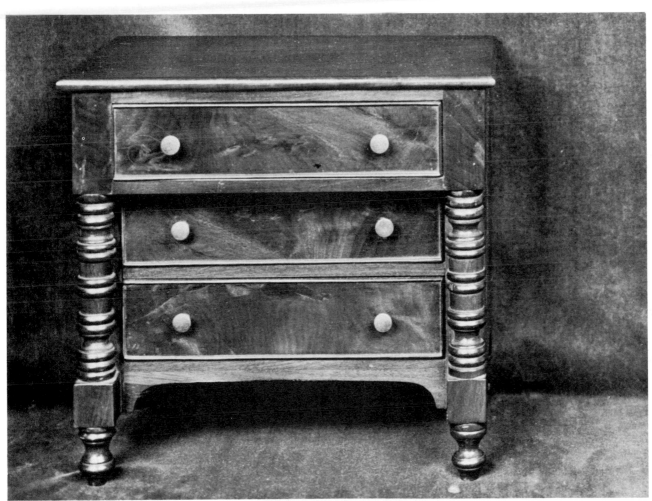

[Top]
Cat. no. 2 Thomas Day
Sampler Chest, ca. 1840

[Far right]
Fig. 13 Old Yellow Brick Tavern
Milton, North Carolina

[Right]
Fig. 14 Thomas Day
Pier Table, ca. 1850
North Carolina Museum of History

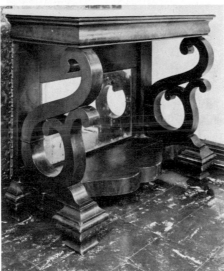

ending takes on the likeness of an African statuette (fig. 15). Another stairwell ends gracefully in a well-designed post (fig. 16) that brings to mind the Chi Wara antelope headdresses of the Bambara people of Mali. Two masks (fig. 17) that serve as guardians on the mantel posts of a fireplace in a Milton home recall the classical treatment seen in masks by Baule sculptors from the Ivory Coast (fig. 18). However, there are no records that indicate Day knew any of the African art forms his work suggests and one cannot easily explain their similarity.[13]

Dutrevil Barjon of New Orleans was not as well known as Thomas Day but it is evident that his furniture was admired and purchased by men of means throughout the Delta region. An 1822 edition of the New Orleans city directory (Paxtons) lists him as a "free man of color," having the profession of furniture-maker. During the same year, he advertised as follows:

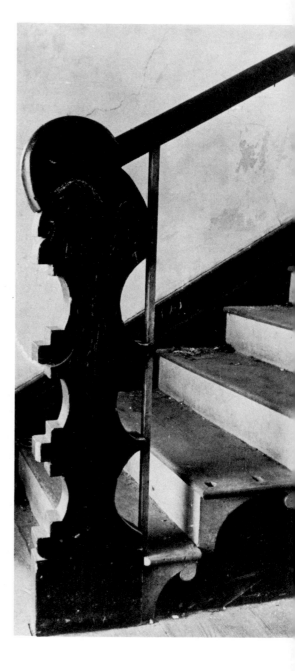

*Furniture Warehouse
Articles of Furniture made in this city*

No. 279, Royal Street, between Main and St. Philip

The subscriber having enlarged his establishment offers to the public a large assortment of furniture made in this city, and in the newest and most fashionable style. He will constantly keep on hand a complete assortment of chairs, looking glasses and other articles which he will sell cheap.

The subscriber will promptly attend

13. Ibid., p. 64.

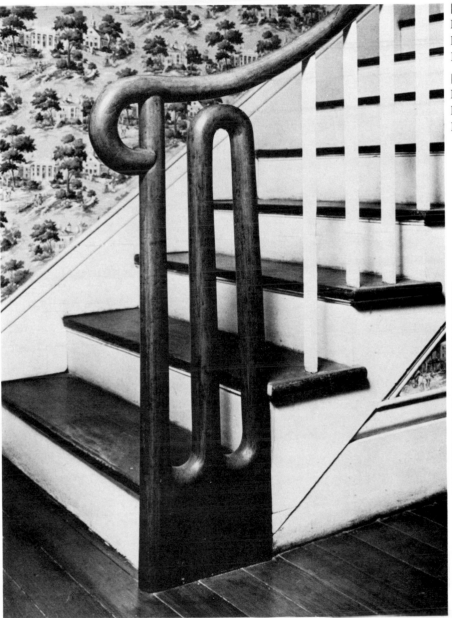

[Opposite]
Fig. 15 Stair newel post, the Paschal house, Milton, Caswell County, North Carolina

[Left]
Fig. 16 Stair newel post, the Paschal house, Milton, Caswell County, North Carolina

Fig. 16 (detail)

Fig. 17 (detail)

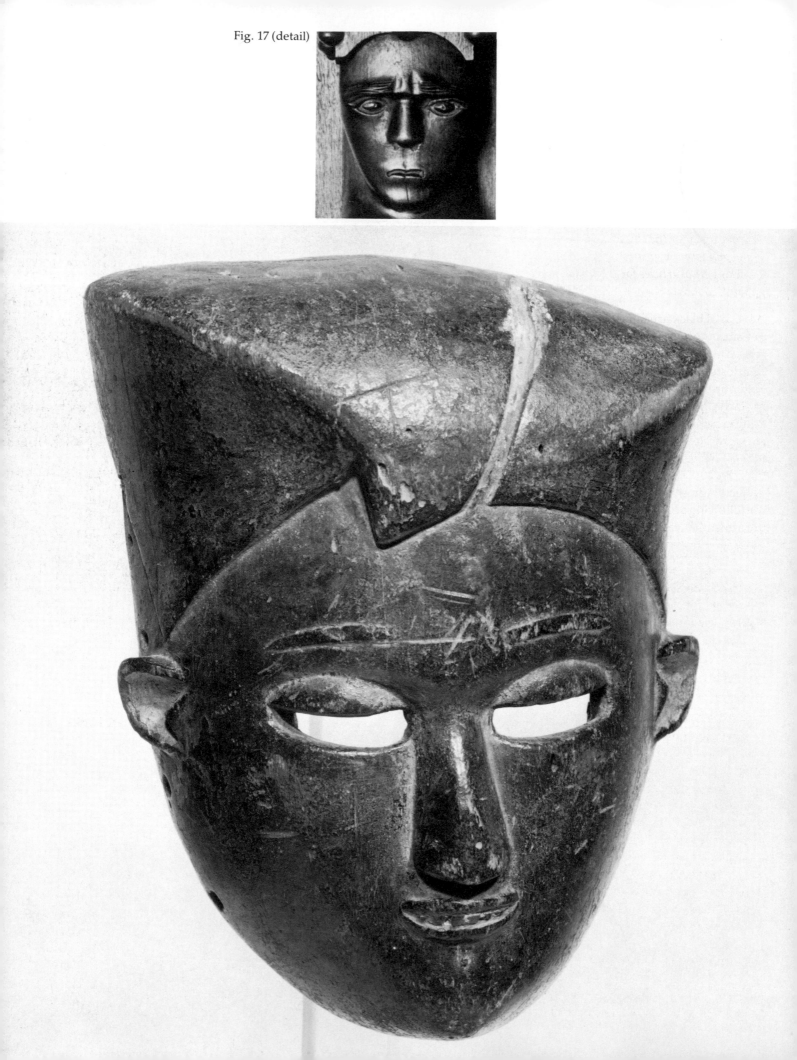

*to any order for the city or county,
and will take the greatest care in the
packing up of articles forwarded by
him.*[14]

Word of black artisans' ability as
ironsmiths brought scores of wealthy
whites to the slave markets of
Charleston, Mobile, Savannah,
Baltimore, and New Orleans in search
of black talent that could be used in
forging grillwork and making
wrought iron balconies to adorn
homes, offices, and public buildings
(figs. 19, 20). The Louisiana Work
Projects Administration Guide gives
the following account of slave labor in
the ironsmith trade in the eighteenth
century:

> *The metal work used in the
> construction of the first Ursuline
> Convent, ...was forged by slave
> labor; and through later years both
> slave and free forge workers made
> grills, guardrails, gates, and other
> wrought iron pieces that survive in
> Louisiana's time-worn buildings.*[15]

In colonial times persons of color
who worked under the tutelage of
well-known white architects were
often permitted to work independ-
ently in later life even if they had
not been granted their freedom.
Some of these artisans no doubt kept
in mind the designs of the homes they
had been forced to leave when they
were brought to America as slaves
(figs. 21-23). In some cases these
designs merged with the plantation

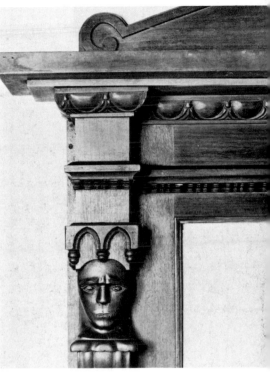

[Top]
Fig. 17 Carved mantel, private house,
Milton, North Carolina

[Opposite]
Fig. 18 *Ibibio Mask,* Nigeria
Wood
h: 7¼ in. (18.4 cm.)
Collection of Mrs. Katherine C. White

14. Barjon file, Historic New Orleans
Collection, New Orleans, Louisiana (original
source not given).
15. *Louisiana: A Guide to State W.P.A. in the State
of Louisiana* (New York: Hastings House, 1941),
p. 176.

style of architecture that was developing in various parts of the South, particularly in Louisiana. There remain to this day a few fine examples of buildings closely related in structure and appearance to certain styles of West African architecture (figs. 24, 25). Noteworthy are three houses on what is now called the Melrose Plantation, located on the Cane River near Natchitoches, Louisiana (fig. 26). Built in the late eighteenth century by Marie Thérèse Quan Quan, a former slave, two of the remaining structures, originally called the Yucca and African houses (fig. 27), can be directly linked to certain rectangular houses with rammed earth walls and Bamileke-type sloping roofs common to the regions of contemporary Zaire and Cameroon (fig. 28).

The round slave quarters on the site of the stately Keswick Plantation near Midlothian, Virginia (fig. 29), provide a very fine example of the cylindrical or beehive houses constructed throughout sub-Saharan Africa (fig. 30). Although built of brick, the Keswick slave house still retains a specifically African format and features a central fireplace that was used for both heating and cooking. Even though similar buildings do exist in France, the pigeonnier (fig. 30), a structure that was normally adjacent to stately houses in Louisiana such as Labatut, Parlange, and Melrose, also shows a definite kinship with African structures. Many of the houses built for early French settlers along the Mississippi show the influences of this transplanted African architecture on the new plantation style buildings. In the village of Kaskaskia, Illinois, there

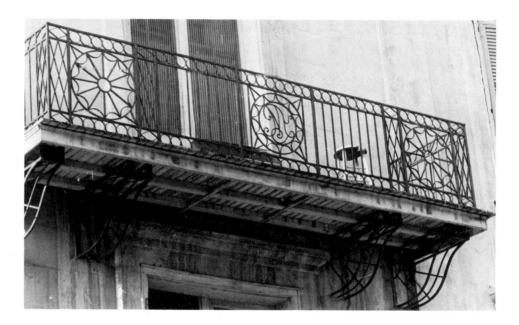

[Left]
Fig. 19 Eighteenth-century pattern for wrought iron

[Top]
Fig. 20 Wrought-iron balcony, the Roquette Mansion, 413 Royal Street, New Orleans

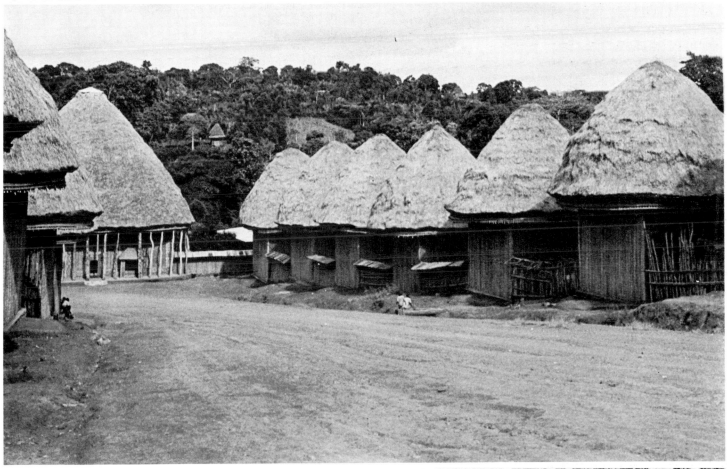

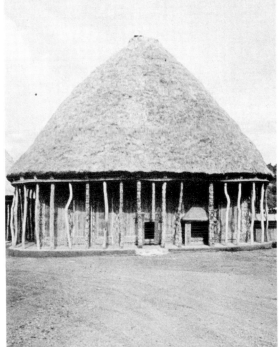

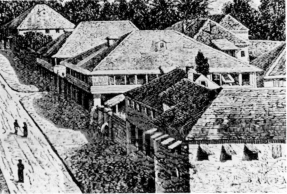

[Top]
Fig. 21 Chefferies, or meeting houses,
Batufum tribe, Bamileke group of the
Grasslands, Cameroon

[Left]
Fig. 22 Bamileke central meeting house

[Right]
Fig. 23 Early nineteenth-century housing
in Freetown, Sierra Leone.

29

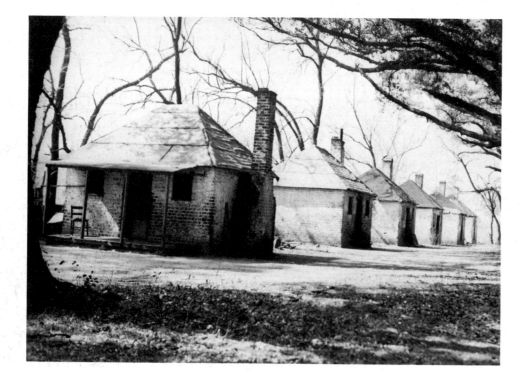

were houses built with slave labor in the style of the famous Magnolia Mound near Baton Rouge, Louisiana. These houses usually had a post and lintel structure with large upright timbers of cypress or cedar supporting boards made of the same material. Clay, spanish moss, or grass was used to daub the holes between the timbers, and the roof was frequently made of thatch, for wooden shingles were an unknown luxury. Often there was an over-hanging porch very much in the style of the African House, with posts supporting the lintels of the porch roof.

Although the black artisan contributed experience, time, and interest to the development of the crafts in America he was never fully accepted. He remained a servant even as a freedman, dependent almost entirely on the patronage of whites whose interest in people of African origin was at best based on their ability to serve as laborers.

Although the existence of black poets, musicians, and craftsmen was occasionally acknowledged in what may be called the more liberal literature of the colonial period, documentation on the lives of black artists preceding Joshua Johnston is nearly non-existent. To this day the question of Johnston's birthplace is unsettled and so is the matter of who actually owned him while he was a slave. Still less is known of how he acquired the skills he exercised in painting portraits of wealthy subjects like *The McCormick Family* (cat. no. 16) and *Young Lady on a Red Sofa* (cat. no. 19). He is believed to have been a former slave from the city of Baltimore, where he became a portrait painter, and his sensitive

[Top]
Fig. 24 Slave cabins, The Hermitage, Savannah, Georgia, Chatham County

[Left]
Fig. 25 Dairy, Archibald Blair House (formerly Van Garrett House), Virginia

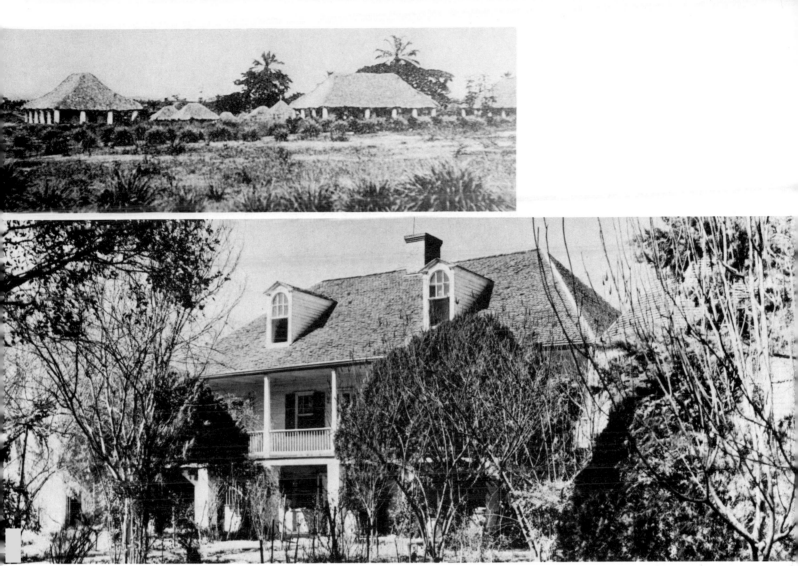

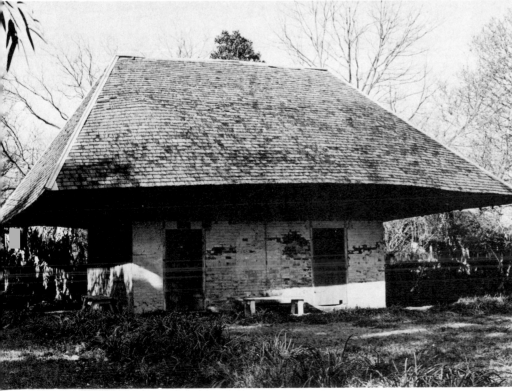

[Center]
Fig. 26 Melrose Plantation, Natchitoches, Louisiana

[Bottom]
Fig. 27 African House, Melrose Plantation, Natchitoches, Louisiana

[Top]
Fig. 28 Eighteenth-century Bamileke houses in Cameroon

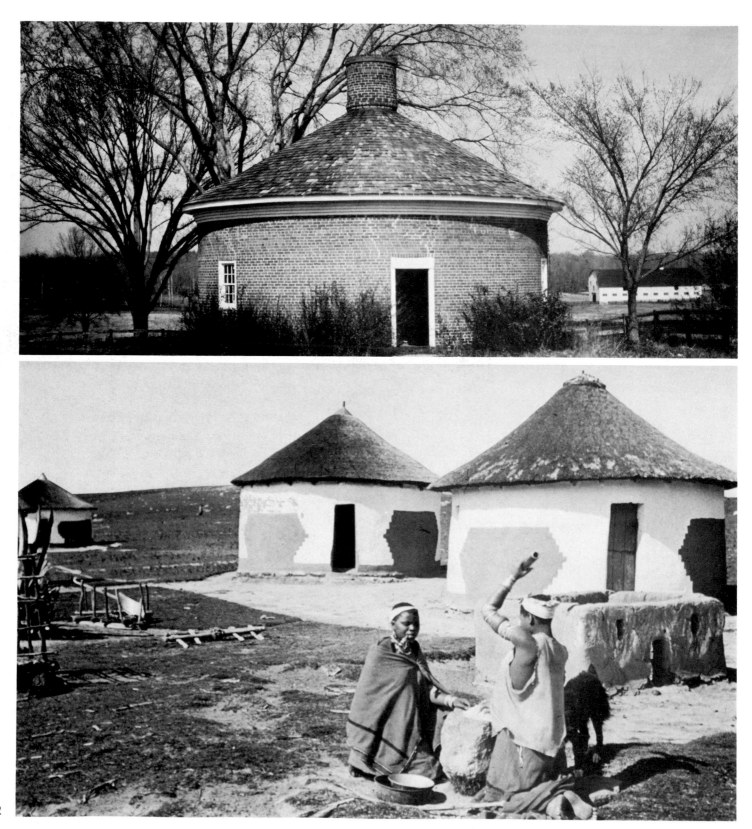

interpretation of his subjects suggests that he may have been trained by the better academicians of the day. His work bears a close stylistic resemblance to that of James and Charles Willson Peale, and at least one writer, Dr. J. Hall Pleasants, has inferred that they were his teachers. It was Dr. Pleasants' painstaking study of Johnston's work that first brought the artist to public attention in the 1930s:

A nebulous figure, a Negro painter of considerable ability with a style peculiarly his own, was a limner of portraits in Baltimore during the last decade of the eighteenth century and the first quarter of the nineteenth. As far as can be learned Joshua Johnston, or Johnson, was the first individual in the United States with Negro blood to win for himself a place as a portrait painter.

There is a persistent tradition passed down in the families of several subjects painted by Johnston that the painter was a slave owned by a forebear. But these traditions are curiously conflicting, for each of the present, or recent, possessors of paintings name as his master a different prominent early Baltimorean, contemporary but unrelated one to the other. That Johnston passed from one owner to the other in such a summary fashion seems incredible.

As a matter of fact, from the time he appears as a portrait painter in the Baltimore directory for 1796, down to his last appearance in the directory for 1824, Johnston was not a slave at all, for slaves were not

[Opposite, top]
Fig. 29 Slave quarter, Keswick Plantation, near Midlothian, Virginia

[Opposite, bottom]
Fig. 30 Traditional cylindrical Tembu houses, South Africa

[Top]
Fig. 31 Pigeonnier, Melrose Plantation, Natchitoches, Louisiana

Fig. 32 Joshua Johnston
Portrait of a Cleric
Oil on canvas
28 x 21 in. (71.1 x 53.3 cm.)
Bowdoin College Museum of Art

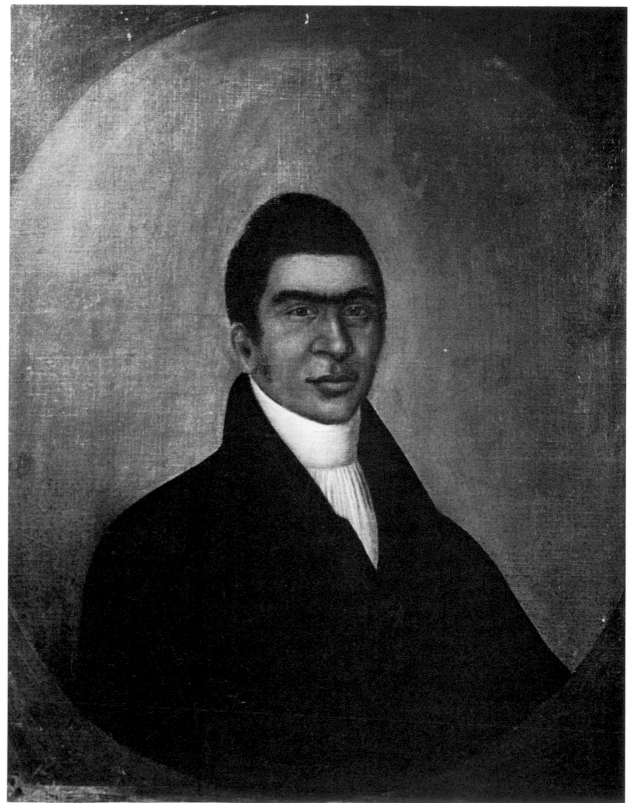

listed in directories. Moreover, in at least two listings he is specifically styled a freeman.[16]

Johnston's fame as a portraitist was widespread among the merchants of Maryland and Virginia, and all but two (fig. 32) of the subjects of his thirty-odd known works were white. It seems unlikely that he produced so few portraits during the twenty-eight years he is known to have painted, particularly when one reads the advertisement he placed in the *Baltimore Intelligence* on December 19, 1798:

> *Portrait Painting . . . as a self-taught genius deriving from nature and industry his knowledge of the Art . . . experienced many unsuperable obstacles in the pursuit of his studies, it is highly gratifying to him to make assurances of his ability to execute all commands, with an effect, and in a style, which must give satisfaction. Apply at his House, in the ally leading from Charles Street to Hanover Street, back of Sear's Tavern.*

His reference to the "many unsuperable obstacles in the pursuit of his studies" no doubt refers to the rejection he encountered because of his color; his development from a slave to a successful portraitist had little precedence in the young nation. The measure of success he did achieve went unnoticed by art historians and critics for more than one hundred years after his death.

In making the transition from slave craftsman to professional artist, the black artist was treading an even rougher path than he had followed in the crafts. That black artists had

ability in the fine arts is evidenced by the works attributed to Neptune Thurston, Scipio Moorehead, and others of comparable skill in the eighteenth century. But the majority felt that blacks lacked the intellectual capacity to engage in any form of art not closely associated with labor, and few people were willing to permit aspiring black artists the opportunity to test their skills. Margaret Just Butcher, writing on the subject of acceptance of blacks by the American art establishment, summarized the situation as follows:

> *The task of the early Negro artist was to prove to a skeptical world that the Negro could be an artist. That world did not know that the African had been a capable artist in his native culture and that, independent of European culture, he had built up his own techniques and traditions. It had the notion that for a Negro to aspire to the fine arts was ridiculous. Before 1865, any man or woman with artistic talent and ambition confronted an almost impossible barrier. Yet, in a long period of trying apprenticeship, several Negro artists surmounted the artificial obstacles with sufficient success to disprove but not dispel the prevailing prejudice.*[17]

Eventually Patrick Reason, Robert S. Duncanson, Edward M. Bannister, Edmonia Lewis, and Henry O. Tanner would come to the attention of

16. J. Hall Pleasants, *An Exhibition of Portraits by Joshua Johnston*, Peale Museum, Baltimore, January 11-February 8, 1948.

17. Margaret Just Butcher, *The Negro in American Culture* (New York: Alfred A. Knopf, 1967), p. 214.

the American public; like Joshua Johnston, they would forsake the crafts tradition and become distinguished painters, engravers, and sculptors, achieving a measure of acceptance within the mainstream of American art.

Of all the black artists of the early nineteenth century whose careers have come to our attention, none more actively applied his art to anti-slavery causes than the mulatto Patrick H. Reason, a free man whose engravings and lithographs were widely used in support of abolition. Apprenticed to an engraver while still in his teens, Reason quite early became aware of the problem of slavery in American society and the inhumane conditions that accompanied it. At a time when few blacks were interested in anything beyond survival, Reason spoke out vehemently against slavery, devoting much of his time to illustrating abolitionist literature. As early as 1835 he showed his deep concern for the denial of the rights of black women in his celebrated stipple engraving, *Am I Not a Woman and a Sister.*

Black portraits were not as uncommon in Reason's oeuvre as they had been in Johnston's. One such work, housed in the Negro Collection, Founders Library, Howard University, is a handsomely modeled portrait of Henry Bibb (fig. 33), a well-dressed young writer of thirty-three, whose book on the *American Slave* had already been well received when he sat for the artist. Reason's work shows that, like Jules Lion and Robert S. Duncanson, he was familiar with photography, which had only recently been brought to the United States from Europe. The

extent to which his artistry surpassed mere illustration and traditional portraiture may never be known since his career cannot be documented beyond the middle of the nineteenth century. The recent attribution of a portrait of the famous abolitionist John Brown to Reason suggests that he may have executed a body of work that has not yet been discovered.

Not until the last quarter of the nineteenth century did photography achieve any widespread popularity in the United States. One of the first Americans to use the camera in combination with lithography was a mulatto artist from New Orleans named Jules Lion; it is believed that he introduced the daguerreotype as an art form to the residents of New Orleans. As early as 1840, the following account of the artist's work appeared in a local newspaper:

> We are indebted to Mr. Lion of this city, for an examination of some very exquisite specimens of the Daguerreotype taken by him. They are views of objects familiar to the residents of New Orleans, such as the St. Louis Hotel, the Cathedral, the Levee, and a number of public edifices and the perfection of the process can be easily vested by comparing the solar copies with the originals. They are the first specimens of drawing by the Daguerreotype we have seen. Nothing can be more truly beautiful—the minutest object in the original is reproduced in the copy, and with the aid of a microscope, in a drawing of a few inches square, representing a building some sixty or seventy feet high, the inscription on the signs, the division between

Fig. 33 Patrick Reason
Henry Bibb
Copperplate engraving
Schomburg Center for Research in Black Culture
The New York Public Library
Astor, Lenox and Tilden Foundations

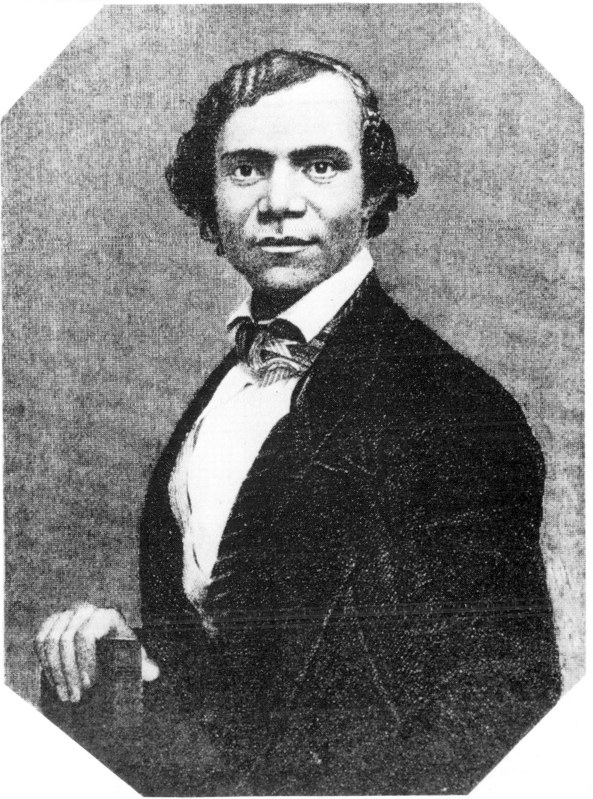

the bricks, the very insect that may have been found upon the wall at the time the inscription was taken are rendered visible. It is a wonderful discovery—one, too, that will prove as useful as it is admirable. Mr. Lion intends exhibiting his drawings in public on Sunday next.[18]

Born in Paris, where he was schooled in the academic tradition in art, Lion was one of the youngest artists to exhibit in the Salon in 1831. He was still only twenty-six when he arrived in New Orleans in 1836; two years later he was listed in the city directory of New Orleans as a "professional artist." With Pointel Duportail he conducted lectures on the daguerreotype with the notion of developing a business out of the new art form. It is assumed that he returned to Paris between 1839 and 1840 to study with Louis Jacques Mande Daguerre, the father of modern photography. In a comment on his relocation to a larger studio in 1843, Lion was again singled out for praise:

On reference to our advertising columns it will be seen that Mr. J. Lion, is prepared to take like-nesses by the Daguerreotype, or Lithographic process, at his room, #3, St. Charles Street. Mr. Lion is an artist of superior merit, of which anyone can convince himself by an examination of the specimens before his office door. As a Lithographist, he has, perhaps, not any equal in the country. His portraits are distinguished for their fidelity, correct drawing, and good taste. His Daguerreotype impressions are likewise very fine, and he possesses the art of coloring them—a process by which that faintness of outline which has been considered the chief objection to the Daguerreotype, is made to give place to a strong, bold and durable impression. Mr. Lion is well deserving of public patronage.[19]

The writer makes no mention of Lion's being listed in the city directory as a "free man of color," and from the widespread praise and patronage that Lion received during his lifetime it seems that scant attention was paid to the fact that he was a mulatto. In 1846 he was commissioned by the owner of the *New Orleans Bee* to do a series of portraits of the state legislators but was unable to complete the project after the owner died. His series of small lithographs made as studies for the portraits are presently located in the Historic New Orleans Collection. Lion's most celebrated work is said to be his *Portrait of John J. Audubon* (cat. no. 22), the famous mulatto naturalist and illustrator. At various intervals Lion returned to Paris to visit relatives and exhibit his latest work, but he always returned to New Orleans. The city directory of 1860 lists him as a portrait painter living at 439 St. Claude, and in 1866 his residence was given in Gardner's City Directory as 175 Frenchman Street. Later that year the *Bee* carried the following account of his death:

Died yesterday at 3:30 o'clock in the morning, Jules Lion at the age of 56 years, native of France. The wake is being held at…507 St. Jean Baptiste St., between Francis and Union. Friends and acquaintances of his wife, also those of his brother-in-law, Rufi Lambert and Alphonse Munoz, are invited to assist at his burial at 3:30 p.m.[20]

More than any other American artist of his time, black or white, John James Audubon was attuned to the forces of nature, cherishing the land and its creatures. He was born out of wedlock on April 26, 1785, to Pierre Audubon, husband of a wealthy society woman from Nantes, France, and Jeanne Rabine, a creole or mulatto servant who worked for the Audubons at their large plantation in Aux Cayes, Haiti.[21] Adopted by the Audubons he traveled with them to France, where he studied briefly with Jacques-Louis David before coming to America in 1803.

He explored fully the ecological and environmental subjects available to him, spending years wandering in the wilds until age made him unable to travel long distances comfortably. His genius lay in the clarity of his observations of the natural world and the fidelity of his representations.

Robert Scott Duncanson was born in 1821 in New York state; his father, a Canadian by birth, was of Scottish descent, his mother was black. At about the age of twenty-one Robert moved with his family to the town where his mother had grown up, a village now called Mount Healthy, fifteen miles from Cincinnati.

18. *New Orleans Bee*, March 14, 1840, p. 2.
19. Ibid., November 25, 1843, p. 2, col. 4.
20. Ibid., January 10, 1866.
21. A great deal of confusion obscures the details of Audubon's birth. See Francis H. Herrick, *Audubon the Naturalist: A History of His Life and Times* (New York: D. Appleton and Company, 1917), pp. 52-53, and Alice Ford, *John James Audubon* (Norman: University of Oklahoma Press, 1964), pp. 12-13, 24.

Located in a strategic position, neither north nor south, Cincinnati absorbed much of the controversy regarding the question of slavery. Prior to 1800, fugitive slaves had sought refuge in what was then called the Northwest Territory because the laws requiring a runaway slave to be sent back to his owner were seldom enforced there. But with the influx of slaves via the Underground Railroad, the whites in the territory began to see the fugitives as a threat to their own economic security and rallied for the passage of strictly binding "Black Laws." These repressive regulations prohibited black people from settling in Ohio without proof of their freedom. One law in particular required blacks to post a bond of $500 on entering the state as assurance of good behavior and proper citizenship; few people of color could secure such a large sum of money. Thus the black American intellectual population, which even at this early date counted writers, painters, and musicians in its ranks, was relatively small in Cincinnati when Duncanson arrived in nearby Mount Healthy.

The stringency of the "Black Laws" resulted in the exit of approximately 1,500 blacks to Canada after 1830. Near London, Ontario, they founded the town of Wilberforce, named for the famous British abolitionist William Wilberforce of Hull, England, whose fiery speeches had helped outlaw slavery in Great Britain in 1807. Young Duncanson's father took him to Wilberforce so he could be well-educated and have the benefit of living in a society where racial prejudice was less rampant.

When Duncanson came to Cincinnati in 1841 he was determined to become the greatest landscape artist in America. Considered by most Americans to be the "Gateway to the West," Cincinnati had a reputation for its culture, and prosperous businessmen emulated their wealthy competitors back East by becoming patrons of the arts. The numerous portrait painters trained in Cincinnati were in great demand to record the success of the merchants whose business flourished with the trade along the Ohio River. Many of these portraitists later turned to landscape painting, following the example of the most famous landscape artist of the day, Thomas Cole, who had worked in and around the city in the mid- and late 1820s. Cole later founded what came to be known as the Hudson River School, a romantic style of painting that glorified the wonders of the American landscape. Although greatly inspired by Cole's work, it seems fair to say that Duncanson's romantic views of the land centered in his own lyrical vision. At the same time, he captured the natural world with a skill that rivaled that of his greatest contemporaries.

From 1845 to 1853, Duncanson painted and worked in the cities of Cincinnati and Detroit. Earlier he had met with some success as a portrait painter, although his portraits can by no stretch of the imagination be considered his best work. Noted families such as the Longworths and Berthelets commissioned him to render their likenesses in large canvases that are still in the possession of their descendants and several Midwestern museums.

In 1848 Nicholas Longworth, a wealthy Cincinnati lawyer, commissioned Duncanson to do a series of "wall decorations" for his mansion, then called Belmont, now the Taft Museum.[22] This project put Duncanson in contact with other patrons, whose support would later prove useful in his efforts to study abroad. From 1850 until 1853, when he went abroad, Duncanson traveled to North Carolina, Pennsylvania, and New England, searching for landscapes that appealed to his sense of design. *Blue Hole, Flood Waters, Little Miami River* (fig. 34) was executed during this period and shows a maturity of style and refinement of technique that had developed from his serious study of American art and his interaction with contemporary landscape painters. The Cincinnati city directory of 1851-52 listed him as a daguerreotype artist, and evidence of his familiarity with the camera can be found in his *View of Cincinnati, Ohio, from Covington, Kentucky,* one of the few surviving paintings of a city scene in early nineteenth-century American art.[23]

Sponsored by the Anti-Slavery League, in 1853 Duncanson traveled to Europe with another Cincinnati artist, William Sonntag. During his year-long stay in Italy, the content and technique of Duncanson's work became more closely identified with the classical subjects painted by Sonntag and Cole. His several versions of the ruins of Pompeii and other popular nineteenth-century Italian scenes show his devotion to

22. James A. Porter, "Robert S. Duncanson, Midwestern Romantic-Realist," *Art in America* 39, no. 3 (October 1951): 110.

23. Cincinnati Art Museum, *Robert S. Duncanson: A Centennial Exhibition*, essay by Guy McElroy, March 16-April 30, 1972, p. 11.

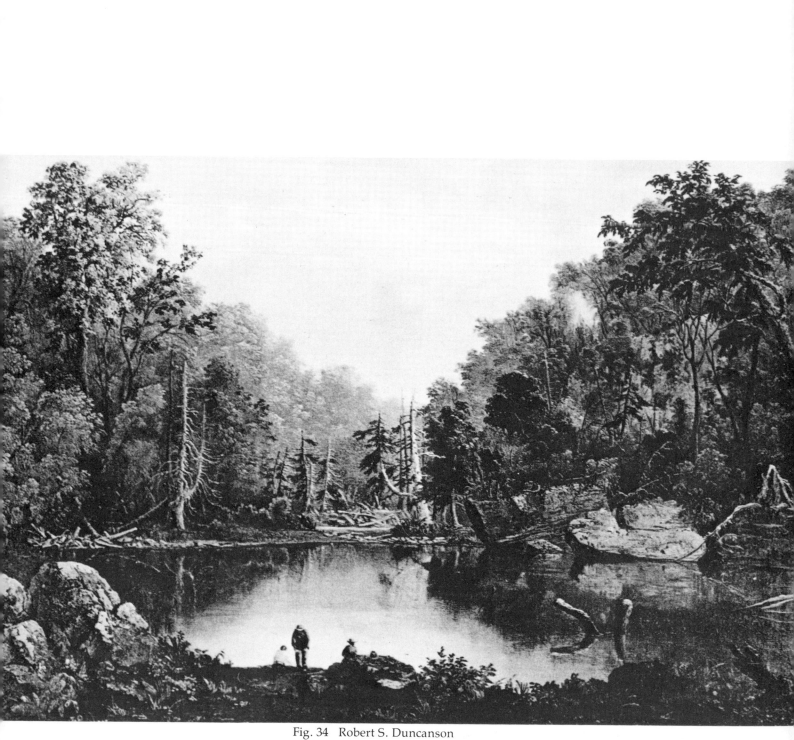

Fig. 34 Robert S. Duncanson
Blue Hole, Flood Waters, Little Miami River, 1851
Oil on canvas
29¼ x 42½ in. (74.2 x 108 cm.)
Cincinnati Art Museum
Gift of Norbert Heerman

neoclassical ideals and his continuing fascination with romantic landscapes regardless of their location.

Duncanson's interest in English literature surfaced in 1861 when he began work on a large composition inspired by Alfred, Lord Tennyson's "The Lotos Eaters."[24] Tennyson reportedly saw the painting and responded to it very favorably. That same year a leading critic of *The Cincinnati Gazette* wrote:

> *Mr. Duncanson has long enjoyed the enviable reputation of being the best landscape painter in the West, and his latest effort cannot fail to raise him still higher in the estimation of the art loving public. He has not only wooed but won his favorite muse, and now finds ample repayment for his labor of a lifetime, in the achievement of a more brilliant success than has attended most of his compeers.*[25]

Four days later a special notice about public acceptance of *The Lotos Eaters* appeared and the following observation was made:

> *Mr. Duncanson's painting...is attracting the attention of the art connoisseurs and critics of Cincinnati to a deservedly large extent. None who have yet seen it have failed to bestow upon it an amount of praise which an artist of much more extended reputation than Mr. Duncanson might justly feel proud....Let the art lovers of Gotham view and study the picture now on view at the Opera House, and they will not hesitate to enroll the name of the author in the annals of artistic fame.*[26]

In 1862 Duncanson was again forcefully confronted with the conflict over slavery, which had recently culminated in the Civil War. Only by confining his sketching and painting to isolated sites in Vermont and Minnesota (*Valley of Lake Pepin*, cat. no. 33, was completed during this period) could he avoid any encounter with the physical realities of battle.

Duncanson returned to Europe the next year, again sponsored by the Anti-Slavery League, and spent several years in Scotland studying and painting. There he exhibited *The Lotos Eaters*, met the Duchess of Sutherland, and was praised in the *London Art Journal* as the equal of any landscape artist in England.[27] Of *The Lotos Eaters* the English critic wrote:

> *The Land of the Lotos Eaters; America has long maintained supremacy in landscape art, perhaps indeed its landscape artists surpass those of England. Certainly we have no painter who can equal Church, we are not exaggerating if we affirm that the production under notice may compete with any of the modern British School. Duncanson has established high fame in the United States and in Canada.*[28]

Several writers have noted that Duncanson all but divorced himself from the social conflicts of his race. During his lifetime the American public was keenly aware of the class distinctions associated

24. Porter, *Art in America*, p. 134.
25. *The Cincinnati Gazette*, May 30, 1861.
26. Ibid., June 3, 1861.
27. *London Art Journal*, January 1, 1866.
28. Ibid.

with being born a mulatto. With a mother who was black and a father of Scottish ancestry, Duncanson's position was regarded by many whites as the plight of "the tragic mulatto," and he reacted rather sensitively to some of the questions that were asked him about the role of a black artist. However, this did not prevent him from appealing to the Anti-Slavery League and other abolitionists for support in the furtherance of his career. Nicholas Longworth gave ardent support to his efforts to travel abroad in 1853 and sent letters of introduction on his behalf to American artists then living in Italy.

Duncanson's work signaled the beginning of a mature black American art that would help destroy some of the myths about black intellectual inferiority, particularly among those who saw art as the highest manifestation of the human spirit. He devoted himself to the cause of making art rather than to a cause that used art only to convey a social message. In effect, he put competent craftsmanship and a personal style above race. His *Uncle Tom and Little Eva* (cat. no. 25), 1853, inspired by the writings of Harriet Beecher Stowe, is perhaps the most visible evidence of any sympathy he had for a black theme, and it is superimposed on a dreamlike setting where nature overshadows the human subjects. According to an article in the *Detroit Free Press*,[29] the painting provoked caustic remarks from a critic for the *Cincinnati Commercial Gazette*, who labeled it "an Uncle Tomitude." The writer called Duncanson's Uncle Tom "a very stupid looking creature" and complained that his Little Eva was "a

rosy-complexioned healthy seeming child, not a bit ethereal." Determined to receive criticism of a more objective nature, Duncanson began concentrating on romantic landscapes, both real and fanciful. Thereafter they were his predominant subjects, with the exception of a few compositions such as *Faith*, 1862, and *The Hiding of Moses*, 1866, which reveal the neoclassical influences he had absorbed in Europe.

In 1867 Duncanson returned to Cincinnati and began exhibiting the landscapes he had done in Scotland and others that he had painted from memory. It was then that he broke with the romantic realism of the Hudson River School and began emphasizing elements and scenes that bordered on fantasy. The result was a refreshing style that was altogether his own.

Duncanson made one last trip to Scotland between 1870 and 1871, when he produced some of his last paintings of Scottish scenes: *Dog's Head Scotland, Ellen's Isle* and *Lough Leane* (cat. no. 34), all of which are dated 1870. By the summer of 1871 Duncanson was again in America, exhibiting his Scottish works. His paintings were well-received, bringing up to $500 each, and he enjoyed popular acclaim as well as the respect of his peers. At this point in his life, when the future seemed most promising, Robert Duncanson fell prey to an illness that was to end his life three months later. He died in Detroit on December 21, 1872, and five days later, his obituary was published in a local paper. It read in part:

29. *The Cincinnati Commercial Gazette*, quoted in the *Detroit Free Press*, April 21, 1853, p. 2, col. 3.

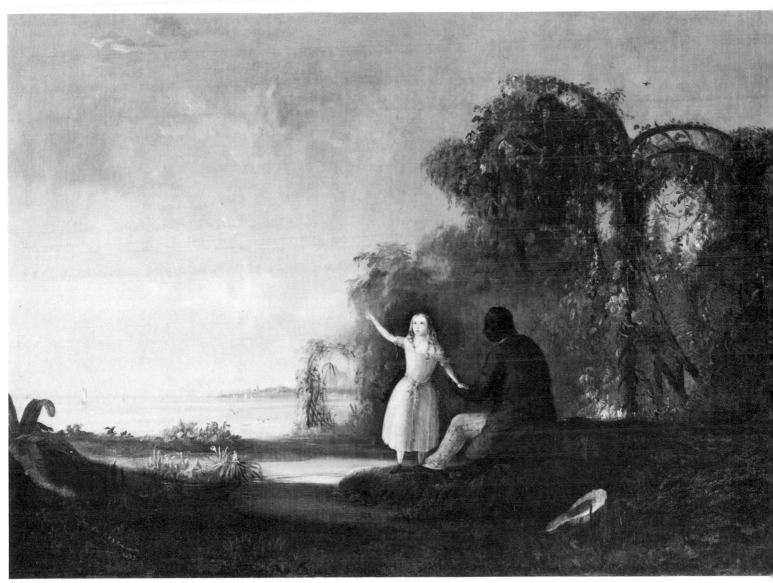

Cat. no. 25 Robert S. Duncanson
Uncle Tom and Little Eva, 1853.

DEATH OF DUNCANSON THE
ARTIST–*On Saturday last Robert S.
Duncanson, a celebrated artist of
this country, died at the Michigan
State Retreat, on Michigan Avenue,
and his remains were interred on
Monday last. He came to this city
about three months since, and
has been a patient in the above
institution most of the time since.
He had acquired the idea that in all
his artistic efforts he was aided by
the spirit of one of the great masters,
and this so worked upon his mind as
to affect him not only mentally but
physically. He was 55 years of age,
a man of modest and retiring
disposition, and a gentle man who
was greatly esteemed by all who
knew him. He was born in New York
and for the past 30 years made
Cincinnati his home. The honors
received by him both at home and
abroad were numerous. He painted
the "Land of the Lotos Eaters," after
Tennyson's poem, and when he
visited Europe the poet laureate
received him at his residence as a
recognition of his appreciation of
that great work. He also painted
his "Recollections of Italy," an
exceedingly complete production,
and another of his greatest efforts
was his painting of the "Paradise
and the Peri," which was sometime
since exhibited at the gallery of the
Western Arts Association, and
greatly admired by those of our
citizens who had an opportunity of
viewing it. Mr. Duncanson visited
Europe several times and found sale
for his works there through the
efforts of Miss Charlotte Cushman,
some of the pictures being purchased
by the Duchess of Sutherland. He
was an artist of rare accom-
plishments, and his death will
be regretted by all lovers of
his profession, and by every
American who know him either
by reputation or personally.*[30]

Duncanson combined a form of
romantic realism with poetic, almost
mysteriously expressive subjects
that convey a reverence for nature
surpassing even that of the Hudson
River School painters. He mastered
the academic style of painting then
predominant in western culture with
a competence that has been matched
by few artists who have followed him.
His skill and versatility are recorded
in his portraits, his decorative murals
in the Taft Museum, and his many
romantic views of nature. Without
question his work represents the
highest level of achievement in the art
of his country and time.

Duncanson's career is being singled
out by this writer to underscore the
achievement of an artist of African
ancestry even during a period when
the constitutional rights of all black
Americans were being blatantly
denied. That Duncanson was so
successful in exercising his superior
talent demonstrates not only his
ability to capture the lyric forms he
sought in nature, but it also attests to
the universality of the artistic
impulse. His artistry marks the
coming of age of the black artist in
America.

Duncanson was seven years old
when Edward Mitchell Bannister was
born in St. Andrews, Nova Scotia, in
1828. A young man with a yearning to
sail, Bannister traveled to Boston,
then to New York, where his first

30. *Detroit Tribune*, December 26, 1872.

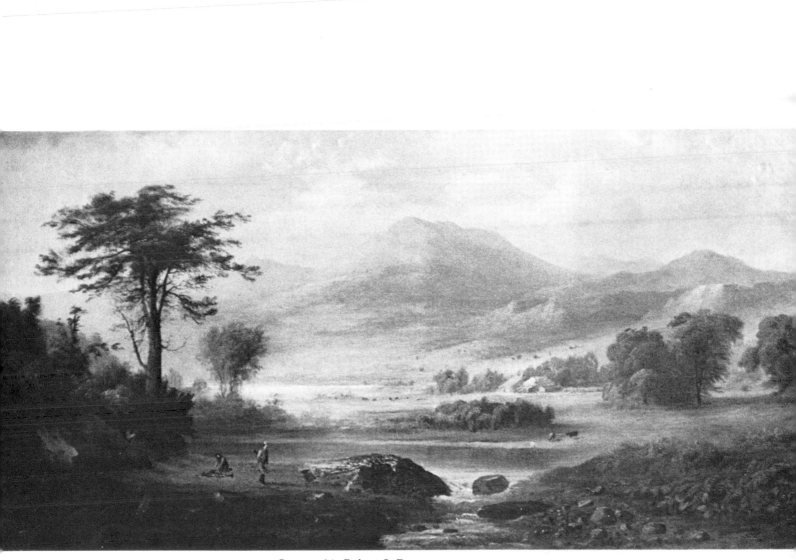

Cat. no. 34 Robert S. Duncanson
Lough Leane, 1870

occupation was that of making solar prints. His print sales afforded him the leisure to paint scenes in various parts of Rhode Island, during which time he professed a great fondness for sailing and yachting on Narragansett Bay. He settled in Boston, where in 1854 a local patron of the arts offered him his first commission, a work called *The Ship Outward Bound*. Aware of the stiff competition at hand and of his need for further training, the next year Bannister attended Lowell Institute where he studied anatomy with the noted American sculptor William Rimmer. Thereafter he was a regular participant in the exhibitions held at the Boston Art Club, even after moving to Providence, Rhode Island, in 1871.

Bannister's *Under the Oaks* was exhibited with the group of paintings representing Massachusetts artists in the Centennial Exposition in Philadelphia in 1876. This painting, now lost, was awarded the bronze medal, one of the highest honors bestowed on an artist at the exhibition. Yet when Bannister arrived and requested admission to the gallery where his painting was on view, he was not allowed to enter through the front door. The only reason given was that he was a black man and it was not customary to receive people of color at such functions; not until he identified himself as the painter of *Under the Oaks* was he admitted.

In a biographical sketch of Bannister,[31] William J. Simmons states that the artist wanted to disprove a comment published in 1867 in the *New York Herald* which noted that "the Negro seems to have an appreciation of art, while being manifestly unable to produce it."[32] While his work certainly refutes such a theory, it failed to receive the promotion or acclaim it deserved. Although he was singled out as one of the country's major artists working in the Barbizon style, only recently has his work been judged worthy of inclusion in major exhibitions of nineteenth-century American art.

Like Duncanson, Bannister rarely dealt with the position of black people in American society. He chose instead to paint romantic interpretations of nature, capturing the shimmering glow of clouds over Narragansett Bay rather than the social injustices suffered by his peers. The recently rediscovered *Newspaper Boy* (cat. no. 37), *The Hay Gatherers* (cat. no. 49), and his *Portrait of Christiana Carteaux* (his wife of forty-five years—part-Indian, part-black, she fought for the equalization of black soldiers' pay in the Union Army during the Civil War) are among his few known works with black subjects.

Daniel Robbins describes Bannister as an artist who exhibited an approach to painting more personal than sophisticated. He also explains:

He represents the level of Providence painting at the moment when the community determined actively to engage itself in the promotion of art; and, as an American Negro, he represents one of the earliest artists to achieve recognition in a field where none had practiced before.[33]

At the time of Bannister's death he had achieved fame in his own community, and his name was not soon to be forgotten, even as far away as Philadelphia where he had been honored during the centennial celebration. There is a current reawakening of interest in his work which will no doubt stimulate a more scholarly approach to the interpretation of his artistic achievement. Shortly after his death Bannister was praised by his lifelong friend and fellow artist George W. Whitaker, who wrote:

In a book entitled "Artists of the Nineteenth Century," [Osgood & Company] the name of Edward M. Bannister is given among others who best represent the art triumphs of America and Europe. Mr. Bannister was a man whose gentle, childlike spirit was an inspiration to all who knew him; whose modesty was only equalled by truthfulness as manifested in his life and works. His thoughtful contemplation embraced the beautiful, the fanciful, and the weird. He ultimated most beautiful examples of color in the tertiary pallet [sic], which hold their own with the best artists' work of our

31. William J. Simmons, *Men of Mark, Eminent, Progressive and Rising* (Cleveland: Revel, 1887), p. 1129.
32. One would assume that one hundred years later such misconceptions and generalizations, if voiced at all, would be limited to the rhetoric of a few uneducated champions of racist causes. Unfortunately, this is not the case. In 1965, a similar statement was made by two popular critics in a book called *The Vanguard Artist* (H. Rosenberg and N. Fleigel, Chicago: Quadrangle Press, 1965, p. 279). The chapter entitled "The Negro Artist" begins with the comment: "It is significant that on close interrogation—and with all good will—our artists were unable to identify a single top-flight Negro painter or sculptor now at work in the United States."
33. Daniel Robbins, *Edward Mitchell Bannister, 1828-1901, Providence Artists*, Rhode Island School of Design for the Museum of African Art, Washington, D.C., March 23-April 3, 1966.

Cat. no. 37 Edward M. Bannister
Newspaper Boy, 1869

time. He draws us from the hard realities of life, and by his deep interpretation touches the soul, clearly representing the invisible in the visible. His artistic success was reached through a poetic turn of mind which enabled him to twist and turn objects in his compositions to suit his fancy. He was one of the few artists who knew the value of deep shadows as a foundation of his paintings. His color was not of a voluptuous nature, but rather of a quiet kind that juggled with grays. It was his custom to charge his memory and ruminate well over the subject....all through life Mr. Bannister was a student, an omnivorous reader, well versed in poetry and mythology, and a lover of high class music. He was a person of gentlemanly bearing who could enter and leave a room with ease and grace. He conversed with more than ordinary intelligence on the principal topics of the day, and all deemed it a privilege to be in his company. His opinions were of a decided nature.[34]

When the American Centennial Exposition opened its doors to an eagerly waiting public on May 10, 1876, Bannister was not the only black artist included among the painters and sculptors exhibiting well over a thousand works in Memorial Hall. Much to the general surprise a black sculptress was one of the small number of women artists whose work was on view. Edmonia Lewis was represented by a work in the neoclassic tradition, a handsomely carved marble called *The Dying Cleopatra*, which was also singled out to receive an award at the Exposition.

This popular work was probably the most forthright statement that had yet been made by a black American artist about the beauty of an African people. *The Dying Cleopatra* was described by Larado Taft in *Artists of the Nineteenth Century* as being very beautiful, "very original and striking," and he felt that it deserved special mention as it demonstrated Miss Lewis' natural skill in rendering a most difficult subject. A sensitive awareness of her own racial origins and an unending desire to expose the inequities of American society were basic elements in the work of this independent, rather caustic young woman. She was among the first black women to attend Oberlin College, the first American institution of higher learning to admit women on a nonsegregated basis. But it was in Boston that Miss Lewis first began to develop her artistic talent, accepting advice from friends such as the well-known abolitionist William Lloyd Garrison. Her studies in sculpture were imaginative, and she exhibited a discipline that convinced her friends of her serious dedication to art, thus securing their support in her efforts to continue her studies in Rome.

William Gerdts, writing on the career of Edmonia Lewis in relation to those of nine other black artists of the nineteenth century, said:

Of all the artists of the movement in Italy, European or American, Edmonia Lewis was the most exotic. She was part Negro, part American Indian, and while her work falls into the general categories essayed by all of her contemporaries—portrait busts, ideal figures and playful

conceits such as her "Poor Cupid"—it should be emphasized that, more than any of the others, the inspiration for her most significant productions stemmed from her racial heritage.[35]

The zeal with which Miss Lewis portrayed racial themes indicates her strong desire to show the race hatred endured by members of her father's race, who were black, and the plight of her mother's people, the Chippewa Indians, who had also been robbed of their cultural heritage by the European quest to "civilize" the new world. Perhaps it was her work that first expressed the themes of racial injustice that would become the core of black American art in the 1920s and '30s.

Hagar (cat. no. 53), executed in 1865, uses an Old Testament character to represent the will and strength of an oppressed people, symbolizing the stride toward freedom by the black race. The heroic *Forever Free* embodies the gratitude experienced by a man and his wife while they listen to the Emancipation Proclamation. Yet even though the chain is clearly broken from the man's uplifted hand, there is a potent symbolism in the links still attached to his wrist. Lewis also championed the cause of improving life among native Americans in works such as *The Old Indian Arrow Maker*

34. J. K. Otto, *Edward Mitchell Bannister, 1828-1901, the Barbizon School in Providence,* exhibition sponsored by the Olney Street Baptist Church, Providence, Rhode Island, August 1965.
35. James A. Porter, *Ten Afro-American Artists of the Nineteenth Century,* February 3-March 30, 1967 (Washington, D.C.: Howard University, 1967), p. 18.

and His Daughter and *The Marriage of Hiawatha*, which reflect her naturalistic approach to American Indian life and culture. Even her portraits link her with abolitionist causes, for many of them were of people prominent in the anti-slavery movement. One such portrait is the celebrated bust of Abraham Lincoln, now in the San Jose Public Library. The ideals and strength with which Miss Lewis endowed her major works have in no way lost their impact over the past one hundred years.

While she enjoyed seeing the capital of western antiquity during her sojourn in the Eternal City Miss Lewis thought endlessly about the conditions endured by her people back home. Her numerous letters to friends in America attest to her inquiring mind as well as her interest in America's progress toward a truly representative democracy for the newly freed black Americans.

When the art historian Henry Tuckerman visited Miss Lewis' studio in Rome, he expressed amazement at the ease with which she produced sensitive surfaces in marble, achieving an almost ideal mastery of that medium. No doubt she had been very impressed by the work of Hiram Powers, whose studies had taken him to Rome, Florence, and other Italian cities where he was able to see the best examples of Renaissance art. But, despite the influence of Powers' neoclassicism, she was more interested in history and the ethnological presentation of black themes. In many ways Edmonia Lewis broke with the neoclassicism then popular with American sculptors and in her work one sees a new approach that reflects the human conditions of her own time. Themes that magnified or clarified the meaning of slavery and other contemporary inhumanities were her subjects. Though she chose to work in the neoclassical tradition, Miss Lewis sidestepped the canons and conventions that tied Hiram Powers and Horatio Greenough to a strictly European style within the classical revival. For her the classical axiom *homo mensura omnium* became a living motto, since in the black experience "man is the measure of all things." However, this ideal of a human-centered art would not be generally realized in black America until the 1920s when there would be an onrush by black artists to interpret humanistic themes.

In addition to the academic work of Robert S. Duncanson, Edward M. Bannister, and Edmonia Lewis, work in commercial arts such as lithography and engraving was being produced by a few black artists during the 1870s and 1880s. Notable among the latter was Grafton T. Brown, who made his living as a lithographer, painter, and draftsman.

While one finds no evidence that Brown was at all concerned with the abolitionist causes in which Patrick Reason had been engaged, one thing that they did have in common was the commercial application of their art. Like numerous other itinerant artists of his day, Brown worked in a semi-naturalistic style that records geographic locations so realistically that often they can still be identified from nature (cat. no. 50).

Brown moved from Harrisburg, Pennsylvania, the place of his birth, to San Francisco, where he divided his time equally between lithography and painting and is believed to have opened his own lithographic business in 1867. While one finds little similarity between the work of Grafton T. Brown and the majestic panoramic landscapes of Robert S. Duncanson, it is of interest to note that both artists sought to portray the beauty of the American countryside. Brown is believed not to have painted during the last twenty or so years of his life; after leaving San Francisco in 1869, he became increasingly involved in engineering and geological science, apparently finding them a more profitable source of income. He died on March 3, 1918, in St. Paul, Minnesota, where he had lived since his departure from Victoria, British Columbia, in the mid-1880s. The following notice of his death was given in the local press:

> G. T. Brown, 77 years old, 646 Hague Avenue, for years a draftsman in the City Civil Engineering Department, died late yesterday. He had been ill for five years. Born in Harrisburg, Pennsylvania, February 22, 1841, Mr. Brown came to St. Paul 25 years ago. He is survived by his widow.[36]

When Henry Ossawa Tanner was born in Pittsburgh on June 21, 1859, America was torn by strife over the questions of slavery and the sovereign rights of states, and Lincoln had not yet declared black Americans to be full citizens. At the same time African religionists throughout America were finding a source of

36. *St. Paul Pioneer Press,* March 3, 1918. 49

confidence and pride in the black church. Though young in years and poor in worldly goods, it made its exodus from the segregated sanctuary of white Christendom and gave birth to a new spirit of freedom within the race, promising both spiritual and physical well being to all true believers. Since Christian worship was the only form of expression available to blacks that whites felt no need to supervise, it was in the black church that certain African ideals survived. Foremost among them was the belief that man is central to the universe, with the power, and responsibility, to exercise God's will. As the son of Benjamin Tucker Tanner, a minister and later a bishop in the African Methodist Church, Tanner was fortunate to be born into a family of believers whose vision of its earthly mission was broad enough to embrace the creativity of the artist as a way in which "God's will could be done." A stern belief in God was instilled in the young Tanner, and his impressions of the Bible stories read to him as a child would eventually find expression in his painting.

After convincing his parents of his love for art, Tanner entered the Pennsylvania Academy of the Fine Arts in Philadelphia, the second black student to attend America's oldest art school.[37] Under the tutelage of Thomas Eakins he acquired discipline and a dedication to the pursuit of artistic excellence. Following the program of anatomical study that Eakins prescribed for most of his students, Tanner learned the fundamentals of art well, watching closely the hand of the man he came to regard as a trusted master. In Eakins he saw an idealism and a

rejection of any artistic compromise that impressed upon his mind the need to stand firm in his own convictions.

The life of Henry Tanner offers an important insight into the dichotomy in American society between race and the role of the artist in a democracy. With his autocratic spirit and immeasurable self-pride, Tanner asserted his right as an artist to be independent, a free agent. Unlike any earlier black American artist he informed the world that he could not be productive in a country where his skin color was equated with inferiority. Because he demanded acceptance based only on his indisputable talent he was determined to travel and study in those European centers where he could receive the encouragement he knew his work deserved.

Before his trip to Europe his most productive period of painting took place while he taught and traveled in the South. He began teaching at Clark College in Atlanta, Georgia, in 1889, one year after he set up shop as a photographer in that city. Like Lion, Duncanson, and Bannister before him, and doubtless influenced by the example of Eakins, Tanner found the mechanics of the camera to be significant in his own development as an artist. But since he never achieved the success he had hoped for as a photographer, he came to consider the medium only as a tool he could use to earn enough money to travel abroad.

In 1891, the thirty-two-year-old Tanner finally left Atlanta and set sail for Europe. He spent a short time in London, then headed for Rome, allowing time for a brief

stop-over in Paris.

It was his intention to remain in Paris only long enough to see the sights and visit the great picture galleries in the Louvre, then proceed to Rome for his studies. Tanner may have thought it cheaper to live in Rome than in Paris, or he may have been drawn to the seat of Christianity by a religious bias. Whatever his reasons for wanting to go to Rome, they were not strong enough to withstand the magic of the City of Light.[38]

Obviously Tanner felt a sense of freedom in Paris that he had not experienced in his native America, and more and more he accepted the idea of staying with the friends he had met there (fig. 35). He enrolled for classes at the Academie Julien with the highly respected artist-teacher Benjamin Constant, with whom he developed a warm and lasting friendship. At this time, Tanner's art began to change and to reflect qualities of European art, becoming decidedly different from the somber works painted at home. His visit to the Salon in 1892 opened new vistas to him, for he could identify personally with many of the works he saw there. Landscapes remained his most important subject and kept the artist busy until his return to the United States in the fall of 1892.

The Banjo Lesson (fig. 36), painted in America the following year, is a monumental work, not so much in size as in its affirmation of his mastery

37. The first was Robert Douglas, Jr.
38. Marcia Mathews, *Henry Ossawa Tanner: American Artist* (Chicago: University of Chicago Press, 1969), p. 54.

of genre painting, and it expresses the individuality that was beginning to surface in Tanner's work. In the painting an old man, possibly the boy's grandfather, braces his left leg to support the weight of his studious young pupil who strums away in an effort to acquire the old man's skills. The setting is ideal for this experience, and the light glowing around the heads and shoulders of the two figures is reminiscent of the art of the Dutch masters. A more recently discovered work by the artist which celebrates the theme of Thanksgiving was no doubt painted at about the same time, for similar tables appear in both backgrounds and the same people may have been used as models.

Once in Philadelphia, Tanner apparently remained there long enough to open a studio. But his rapid success at exhibiting and selling works in America soon enabled him to return to Paris where he set himself the task of preparing a painting for the Salon of 1894. He submitted a composition called *The Music Lesson* which was accepted and well received at what was then the most famous of all annual exhibitions. The following year brought even more success to the talented young artist who was already well respected at the American Art Club and other art circles throughout the city. He painted another genre composition, called *The Young Sabot Maker*; like *The Banjo Lesson*, its subject is a young man struggling to achieve mastery of a craft that an old man has attained and is willing to pass on.

After completing *The Young Sabot Maker*, Tanner began work on his painting of *Daniel in the Lions' Den*, a subject that had haunted him for a long time. He finished the painting on schedule and entered it in the Salon of 1895 where it received an honorable mention, an honor accorded no other American artist that year. Although Tanner had earlier produced other religious subjects, it is this painting that is said to have been a primer for his later biblical works. Without a doubt it represents one of his most important accomplishments in the field of religious art.

He produced another work by the same title twenty-five years later (cat. no. 57), in which Daniel's face is obscured by the darkness of the cavernous dungeon, while his pensive figure is bathed in a glowing light that falls below his shoulders. Lions mill about the area, glancing curiously at Daniel but causing him no harm. The confidence of the artist in his own individuality is evident in this expression of what was doubtless a very personal interpretation of the religious experience. Tanner had always retained his impressions of *The Crucifixion* painted by Thomas Eakins in 1881 and would later paint several aspects of that sacred event as well as other works celebrating the life of Christ—*The Raising of Lazarus, The Annunciation, Christ and Nicodemus.* All were well received in Europe and America.

Tanner's marriage in 1899 to Jessie M. Olsen, a white American, brought a new stability to the artist's life. He found in her a companion whose sympathy and support would sustain him throughout the twenty-five years of their marriage. Moreover, Jessie served as a model for several of his paintings, and he even economized from time to time by using her in more than one pose and costume in the same work. Her image was repeated

three times in a painting called *The Three Marys* (cat. no. 55), which was exhibited at the Salon of 1910. By that time Tanner's fame in the United States was an accepted fact. In 1906 his *Two Disciples at the Tomb* (cat. no. 54) had won the Harris Prize at the Art Institute of Chicago, and that same year the Carnegie Institute of Art in Pittsburgh purchased his *Christ at the Home of Mary and Martha* for its permanent collection. He won the gold medal at the 1915 Panama Pacific Exposition in San Francisco. His service to the American Red Cross in France during World War I was singled out for great praise. He became a Chevalier of the Legion of Honor in 1923. His election as an associate member of the National Academy of Design in 1909 was followed by full membership in 1927. In fact, no expatriate artist since Benjamin West had participated in so many reputable exhibitions and received so many honors for his work, and Tanner was given more decorations and awards both at home and abroad than any other American artist of African ancestry. Yet even with all this acclaim he could not return home without experiencing the pain of the racial segregation being endured by all black Americans. It was this issue that forced him to remain in Europe during most of his creative career.

Tanner adamantly rejected the notion that he should paint only subjects that reflected upon his race and its societal problems. Although he had once shown interest in black subjects with *The Banjo Lesson* and other genre paintings, it was his preoccupation with biblical themes that brought his name to the attention of the art world. Speaking of Tanner's devotion to religious themes, Professor James A. Porter wrote:

A painter of religious subjects today is more or less an anachronism, but the spiritual and artistic conviction of Tanner's work, especially that after 1900, cannot be ignored. And even before that date he might have been regarded as the first modern exponent of religious painting; for many paintings, i.e., paintings based on religious themes, had been produced in Europe and America, but none commands the respect of Tanner's. [39]

Some black leaders assumed that the recognition Tanner had been given in America would eventually convince him to return home and take a central role in founding what was then being called the "School of Negro Art." Indeed it was this very dream, the founding of a school that would encourage racial pride among black people, upon which Dr. Alain Locke hoped to base a new objective criticism of "Negro art." Disappointed by Tanner's lack of interest in black themes, Dr. Locke then re-directed his thinking toward identifying those forms in America that could link black Americans to their legacy of African art.

Tanner resented the notion of being seen as a model for black artists. Though proud of his African ancestry he could never forget the racial prejudice that he and his family had suffered while he was growing up in America. Nevertheless, his studio

39. Porter, *Modern Negro Art*, p. 73.

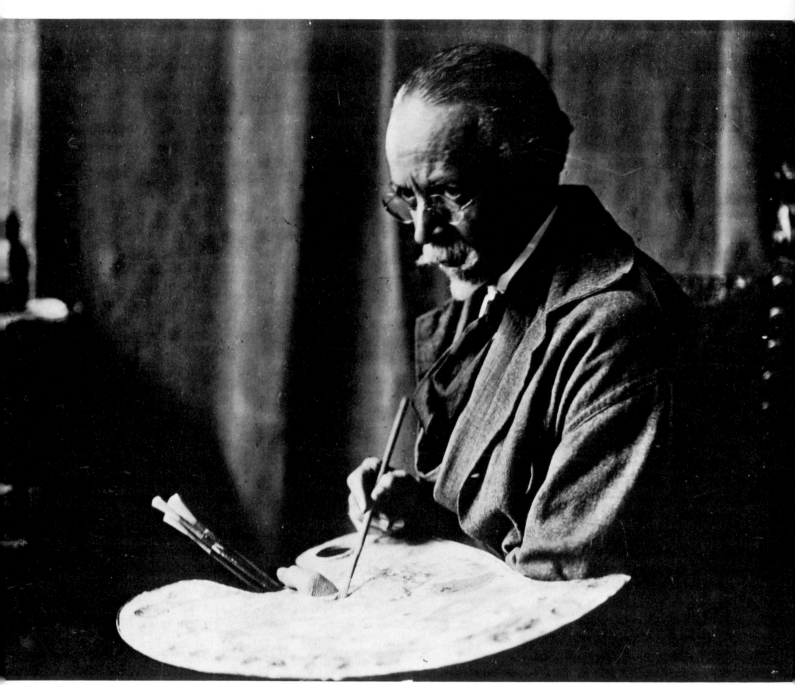

Fig. 37 Henry O. Tanner in his Paris
studio, 1929

(fig. 37) became a meeting place for the young aspiring black artists who went abroad in the 1920s and '30s. William Edward Scott and Albert H. Smith spent a considerable amount of their time in Paris studying with him. Aaron Douglas, who visited Tanner in his Paris studio in 1935, spoke of him as a "warm and cordial gentleman who seemed always to be interested in the development of the young artists back home."[40]

When the grand old master of American art died in Paris on May 25, 1937, he left a brilliant legacy. Although he had refused to participate in the many exhibitions that stimulated the founding of the New Negro Movement in American art, his achievements alone had been enough to hasten the birth of a new hope among black artists, a hope unprecedented in American cultural history. Tanner lived to see the flowering of this movement in the Negro Renaissance, even though he witnessed it not in Harlem but in the streets of his adopted Paris.

One of his students, William A. Harper, would later take an active role in bringing the Negro Renaissance into existence by contributing to the Harmon Exhibitions that were staged in the 1920s. Harper and William Edward Scott studied painting at the Art Institute of Chicago, one of the few art academies accepting black students before the turn of the century. Greatly influenced by Tanner's style during the time he studied with him in Paris, Harper seems to have been the more promising of the two young artists. His early death in 1910 prevented the full development of his talent, but he had already proven himself to be a mature landscapist who had learned as much from his brief contact with artists of the Barbizon tradition as he had from Tanner. His work, though rarely exhibited since his death, is a vivid reminder of the fever for French art that pulled Americans abroad to study at the turn of the century.

While William Scott favored illustration more than academic painting, he was nevertheless also greatly influenced by Tanner. Although he was a highly capable storyteller, he failed to direct himself to anything beyond literal interpretation. The personalization of a style distinctly his own was to come about only late in his career, and he is best remembered for his quick portrait studies of black Haitians and sensitive portrayals of rural life. Prior to his death, he worked primarily as a portraitist and mural painter; his historical portraits of the Jubilee Singers at Fisk University show his portraiture at its best.

Another young painter who worked during the same period was Edwin A. Harleston of Charleston, South Carolina. Characterized by some writers as a romantic realist, Harleston became interested in black themes at an early age. His sensitive portrayals of black subjects that capture the soul of the sitter without any academic slickness indicate the confidence he had in his own ability (cat. no. 62). After studying science at Atlanta University he went on to study medicine at Harvard. Rather than becoming a doctor, however, he chose to study art at the School of the Museum of Fine Arts, Boston, and later assisted Aaron Douglas in painting the murals for the Erastus Milo Cravath Memorial Library at Fisk University in 1931.

While some black artists of the first decade of this century explored various popular genre subjects, others turned with increasing interest to the portrayal of specifically black themes. Harleston and Scott were among those who chose to take a serious look at black life in rural and urban America.

The 1920s were a time of hope for those Americans of African ancestry who had long sought a respectable place in American society. For the first time since the days of Frederick Douglass and the founding of black colleges throughout the South, black Americans, particularly those singled out as leaders in the academic community, were being called upon to give direction and to help define the cultural life-styles of black people. This new sense of authority among black leaders brought on the optimistic belief that the nation was ready for meaningful social change to the good of the black race. Yet black participation in American culture was virtually nonexistent beyond the realm of music and dance. Thus, if they were ever to reap the benefits of full citizenship, it was necessary for black Americans to insist on functioning in all areas of American culture while at the same time preserving and promoting those traditions that defined the black experience. In this regard Marcus Garvey, though highly respected by thousands of black Americans as a

40. "Conversations with Aaron Douglas," interview with David Driskell, taped for the Division of Cultural Research, Fisk University, 1967.

symbol of the nationalist movement, stood apart from the broadening concept of "Americanism" championed by W. E. B. DuBois, Alain Locke, and by Americans of European ancestry such as Carl Van Vechten, Albert C. Barnes, and Robert J. Coady.

DuBois viewed the problems facing the black artist as purely sociological, relating specifically to the practice of racial segregation in American society. When he wrote, "In all sort of ways we are hemmed in and our new artists have got to fight their way to freedom,"[41] he was referring to the narrow interpretations of works by black artists given by white critics and to the omission of their art from major American exhibitions. He was also referring to the isolation of black artists when it came to selling and exhibiting their works, with no hope of being allowed to move from this position of inferiority for fear of being a threat to the dominant culture. By contending that the black artist could celebrate his own life-style without looking outside of his own culture for inspiration and without apologies for slavery or any other past experience, DuBois infused young black artists with a sense of self-identity and racial pride.

Philosophy professor Alain Locke saw the black artist as the visionary of the "New Negro Movement" whose images would transcend the concept of the "happy slave" that had previously been recorded by artists of the majority culture. He felt that the black artist could rediscover the ancestral arts of Africa and through such atavism inspire all Americans of African ancestry with a pride in the glories of their ancient past. Though

optimistic about the power of art as a tool for encouraging social awareness among his people, he insisted that art was the highest manifestation of man's cultural endeavor and should never be reduced to mere propaganda. Regarding the relationship of art and society, he wrote:

We should not expect art to answer or solve our sociological or anthropological questions. We must judge, create and consume it largely in terms of its universal values. But no art idiom, however universal, grows in a cultural vacuum; each, however great, always has some rootage and flavor of a particular soil and personality.[42]

White music critic and novelist Carl Van Vechten saw Harlem as the hub of "Negro culture" and many consider him to be the discoverer of the Harlem folkways. Whites streamed into this black metropolis from all parts of the world expecting to see the exotic scenes he had described in *Nigger Heaven*, published in 1926. As a photographer Van Vechten was invited to many Harlem parties where artists were present and he frequently hosted social gatherings to which blacks were invited.[43] James Allen and James Van Derzee were among the black photographers who also recorded many of these affairs.

Albert Barnes did not participate in the social life of the Harlem scene but he quietly permitted a select number of black artists to study his collection of African art at his estate in Merion, Pennsylvania. Alain Locke is said to have developed his appreciation for African art from his studies at the Barnes Foundation and later Aaron

Douglas and Claude Clark also studied African art under Mr. Barnes' tutelage.

While few histories of American art mention the contributions that Robert L. Coady made to the promotion of art by black Americans during the Harlem Renaissance, he should by no means be considered a minor figure. When citing spokesmen for the black culture one should bear in mind that Coady expressed an early interest in African art and attempted to show its relationship to black American art in numerous publications that he financed.

The voices of these men, from DuBois to Coady, helped mold the emerging ethos that would give meaning and shape to the New Negro Movement, which would later be christened the Negro Renaissance.

41. W. E. B. DuBois, "Criteria of Negro Art," *Crisis* (May 1926).
42. Alain Locke, "The Negro Takes His Place in American Art," in *Exhibition of Productions by Negro Artists* (New York: Harmon Foundation, 1933), p. 12.
43. "Douglas, Aaron," interview with David C. Driskell, taped for the Division of Cultural Research, Fisk University, 1973.

The Evolution of a Black Aesthetic, 1920-1950

In the early 1920s the awakening spirit of Negritude which encouraged racial pride, a continuing interest in the civilizations of Black Africa, and a redefining of the meaning of the black experience in America stimulated black artists, musicians, writers, and academicians and laid the groundwork for that flourishing era in the arts now called the Negro Renaissance.

In Africa art had been central to man's existence, and one could not be born, come of age, marry, or die without a work of art being made to celebrate that event. Alain Locke urged black American artists to re-establish the position of art at the core of black life and to make art a liberating force for their people. It was also Locke, possibly more than any other black figure, who saw Negritude as a viable force in making the world aware of the cultural contributions that African artists had made to modern art. Of this idea he wrote:

Africa's art creed is beauty in use, vitally rooted in the crafts, and uncontaminated with the blight of the machine. Surely the liberating example of such art will be as marked an influence in the contemporary work of Negro artists as it has been in that of the leading modernists; Picasso, Modigliani, Matisse, Epstein, Lipschitz, Brancusi, and others too numerous to mention.

Indeed we may expect even more of an influence because of the deeper and closer appeal of African art to the artist who feels an historical and racial bond between himself and it. For him, it should not function as a novel pattern of eccentricity or an exotic idiom for clever yet imitative adaptation. It should act with all the force of a sound folk art, as a challenging lesson of independent originality or as clues to the reexpression of a half-submerged race soul. African art, therefore, presents to the Negro artist in the New World a challenge to recapture this heritage of creative originality, and to carry it to distinctive new achievement in a vital, new and racially expressive art.[1]

Locke felt the need for other artists to help him visualize the ideas he so firmly believed. However, before realizing these dreams, black artists would need to understand more clearly their own position in American culture, particularly their role as entertainers of the majority culture, and to comprehend the forces affecting their society.

The Great Migration of hundreds of black people to the northern urban centers after the first World War, the emergence of a black intelligentsia, and the general postwar restlessness and disillusionment of the twenties created a new militancy and radicalism among black Americans. This attitude had political and social implications that not only gave black people more self-confidence, but also fostered nationalism and stimulated efforts at self-discovery. It was the very core of the Harlem Renaissance.

Concurrent with the renaissance was a general revolution in American culture which some believe began as early as 1912 with Mabel Dodge of Greenwich Village and other white intellectuals and artists such as Carl Van Vechten, Eugene O'Neill, Midgeley Torrance, Paul Green, Sinclair Lewis, Dorothy and DuBose Heyward, to name only a few of the more prominent. It was Mabel Dodge, a cultivated patroness of the arts, and her Greenwich Village salon group, especially Van Vechten, who established the first links with the parallel black movement in Harlem.

One critic saw this as "cultural collaboration" among black and white artists;[2] it was, however, simply a repetition of the established black-white dynamics, this time on a cultural plane. Collaboration would have meant granting black artists and intellectuals a social and cultural equality. Such cultural democracy would have implied, as Butcher points out, "an inescapable corollary of political and social democracy, and it [would have meant] an open door for the acceptance...and the full recognition of the minority contribution."[3] This was not the intention of the white avant-garde. Instead, they made blacks a symbol of white America's search for personal freedom, an escape from conventional standards of behavior.

Nathan Huggins is convinced that the black people of Harlem had little chance to define their own identities since they had become so crucial to the identities of whites who were mesmerized by black life. Harlem appeared as a place that had

1. Alain Locke, "The African Legacy and the Negro Artist," in *Exhibition of Productions by Negro Artists* (New York: Harmon Foundation, 1931), p. 12.
2. Robert Bone, *The Negro Novel in America* (New Haven: Yale University Press, 1958), p. 58.
3. Margaret Just Butcher, *The Negro in American Culture* (New York: Alfred A. Knopf, 1967), p. 21.

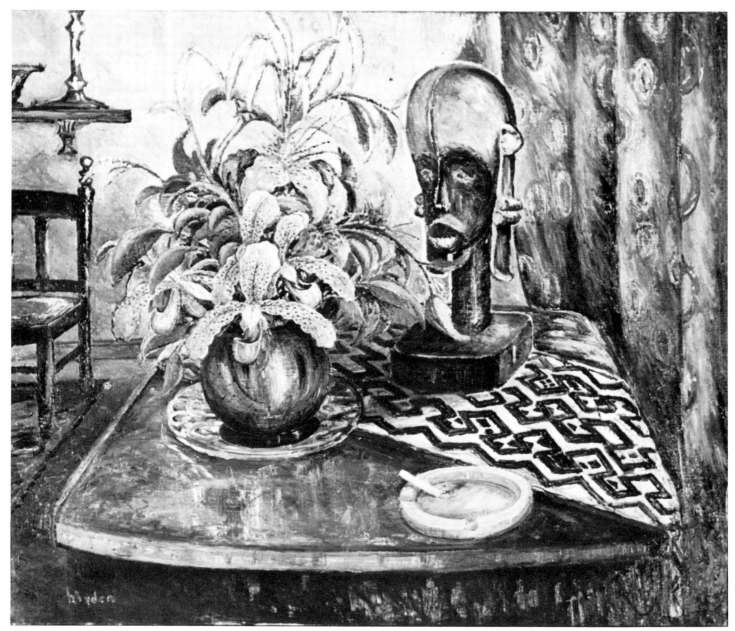

Fig. 38 Palmer Hayden
Fetiche et Fleurs, 1926
Oil on canvas
23 x 28 in. (58.4 x 73.7 cm.)
Collection of Mrs. Miriam Hayden

"magically survived the psychic fetters of Puritanism."[4] The white avant-garde found in black culture "primitive" elements that seemed vital, unspoiled, and the correct antidote to a sterile existence based on values that had become illusory. Those who portrayed black America as uncivilized, indulgent, passionate, mysterious, sexy, and savage were particularly captivated by black music and black speech. Black music was not only exotic but "instinctive and abandoned, yet, laughingly light and immediate." Black speech was "secretive, 'in', casual...fluid, impudent."[5]

Themes of black "primitivism" became popular with white artists: O'Neill's *Emperor Jones* (1920), Anderson's *Dark Laughter* (1925), Heywood's *Porgy* (1925), and Van Vechten's *Nigger Heaven* (1926), to name a few. Thus the Exotic Primitive was conceived and born from the fantasies of white America, with black America in the tacit role of midwife. There were, of course, many black entertainers and writers who exploited the situation for the benefit of white patrons. Yet some, as Langston Hughes said, were sincerely trying to express their "individual dark-skinned selves without fear or shame. If white people were pleased they were glad; if they were not, it did not matter. They knew they were beautiful."[6]

This new image of the dark-skinned self was not "primitivism," but an exploration of black and ethnic identity in America, influenced by the following conditions: (1) the rising expectations of black America encouraged by the American Dream that flourished after World War I; (2)

the Garvey-inspired nationalism that gave an unprecedented dignity to the black masses; (3) the influence and power of African sculpture and black music; and (4) limited patronage from the white avant-garde.

As artists searched for an alternate value structure they discovered that the most distinctive aspects of black culture evolved from the lower classes. Consequently, for many artists the emphasis was on interpreting the folk—the rhythmic inflections of their speech, their immediate concerns, and an affirmation of the quality of black life—without necessarily pleading the cause of racial justice. Langston Hughes explains the reason for the emphasis on the black under class rather than the middle class:

> There are the low-down folk, the so-called common-element... they furnish a wealth of colorful distinctive material for any artist because they still hold their own individuality in the face of American standardizations....[7]

The extent to which Hughes and others were successful in translating this concept into art has been mistakenly interpreted as a glori-fication of the lowest black. Even DuBois inveighed against what he perceived as undue emphasis on the black under class as subject matter at the expense of the middle class, saying vehemently, "I do not care a damn for any art that is not used for propaganda. But I do care when propaganda is confined to one side while the other side is stripped and silent."[8] At the same time Locke implored the Harlem Renaissance artists to turn to the "ancestral arts of

Africa" if they would develop a race art. He reasoned that "if African art [were] capable of producing the ferment in modern art that it has, surely this [was] not too much to expect of its influence upon the culturally awakened [black] artist of the present generation."[9]

Three artists in particular—Palmer Hayden, Archibald Motley, Jr., and Aaron Douglas—in their search for forms and content informed by Africa developed naive and non-academic styles that reflected the new aesthetics of the twenties.

Hayden, who had once favored romantic marine subjects like *Quai at Concarneau*, demonstrated his concern for the new movement with a bit of irony that must have startled the uninitiated: an unconventional still life called *Fetiche et Fleurs* (fig. 38), composed of a table covered with an African print on which were placed a vase of striking orchids, an ash tray, and a piece of African sculpture (a Fang or Pangwe reliquary head). Locke described Hayden's new style as "more modernistic...more decorative, high-keyed and in broken color."[10] Hayden would later develop

4. Nathan Huggins, *The Harlem Renaissance* (New York: The Oxford University Press, 1971), p. 89.
5. Ibid.
6. Langston Hughes, "The Negro Artist and the Racial Mountain," *The Nation*, June 23, 1926, p. 694.
7. Ibid., p. 693.
8. W. E. B. DuBois, "Criteria of Negro Art," *Crisis* (May 1926), p. 296.
9. Alain Locke, *The New Negro* (New York: Albert & Charles Boni, Inc., 1925. Reprinted Atheneum Press, 1968), p. 267.
10. Idem, *Negro Art: Past and Present* (Washington, D.C.: Associates in Negro Folk Education, 1936), p. 66.

a preference for subject matter that emphasized the mores, myths, and customs of black America from the view of a folklorist. Most of these works were painted in a semi-naive fashion that stressed narrative, anecdotal detail in a rather self-conscious way.

Motley received approval and recognition from the majority culture in the form of a solo exhibition in New York in 1928. This event undoubtedly helped to further legitimize the primitive style among black artists since he was the first other than Tanner to have a one-man show in a commercial New York gallery. In that show, along with works in his severe, realistic style, Motley showed paintings of "fantastic compositions of African tribal and voodoo ceremonials...and broad higher-keyed and somewhat lurid color schemes with an emphasis on the grotesque and genre side of modern [black] life."[11] Although he later painted WPA murals Motley was better known for his meticulously rendered caricatures of black night life. Locke felt that in the canvases he painted from 1933 to 1936 with such lively titles as *The Barbecue, The Liar, Saturday Night,* and *The Chicken Shack* there was a "swashbuckling humor" about black life that was a "promising departure." By paying sharp attention to minutiae, Motley attempted to convey the spontaneous excitement of the "sweet-backs," prostitutes, and others who inhabited his Rabelaisian world.

Aaron Douglas, a "pioneer Africanist," accepted the legacy of the ancestral arts and developed an original style, unrelated to any school, that can best be described as geometric symbolism. He combined modernism and Africanism in an astonishing synthesis, creating compositions that were spatially flat, formally abstracted, and virtually free from imitation and convention (cat. nos. 96-100). By eliminating details and reducing forms to silhouettes, he lifted everything above mere observation of the visual world. His lithe figures were stylized, yet ethnically symbolic, balanced, and harmonious; his style was an angular Art Nouveau that possessed a vitality as disconcerting as the new jazz. Unfortunately, pressure from his peers forced Douglas to use this style for murals and book illustrations only, while devoting more time to a realistic style for easel paintings. In the absence of critical interpretation to reinforce and help clarify the aesthetic and stylistic significance of Douglas' work, it is not unlikely that he, too, came to have doubts about its relevance.

These three artists who would replace *Quai at Concarneau* with *Midsummer Night in Harlem* (cat. no. 87), *My Grandmother* (cat. no. 80), and *The Barbecue,* are representative of others who came under African or Afro-American influences. The black motifs varied from the stylized copper masks of Sargent Johnson (cat. no. 69) to the expressive *The Breakaway* by Richmond Barthé. As the black artist began to make sociological rather than aesthetic decisions about his work, his imagery led him closer to aspects of atavism and an intentionally naive style labeled primitivism. It has been suggested that primitivistic imagery appeared to be the most viable alternative to the academic, assimilationist approach strongly favored by the middle class and exemplified by the work of Henry O. Tanner.

Since the career of Tanner, the one black American artist to gain a measure of support in the white world, overlapped the period under discussion it is important to understand his relationship to the Negro Renaissance. He was considered by most black Americans to be one of the most important painters in the world. Locke said that his career "may be truthfully said to have vindicated the [black] artist beyond question of shadow of doubt or a double standard of artistic judgment."[12] He was referring to Tanner's success as a salon painter in France, albeit after the influence and popularity of the academic tradition had waned. Mention has been made of the purchase of Tanner's work by the French government and by prominent American museums. He won awards at the Paris, Buffalo, St. Louis, and San Francisco Expositions as well as a French Legion of Honor medal. He was, indeed, the magic symbol of the African-American's artistic aspiration and achievement. Unfortunately, those aspirations still depended on the approval of the majority culture in one form or another. Tanner's credentials were impeccable in the eyes of most black intellectuals and artists, for he had been lauded in the art capital of the world. Although he was considered by some to be a reactionary who had "divorced himself from the task of developing a statement which

11. Ibid., p. 69.
12. Ibid., p. 22.

62

reflected the crucial social problems of his time,"[13] he was generally viewed as a hero who had overcome the system.

Thus, the legacy of the Harlem Renaissance included nationalism, primitivism, atavism, and, perhaps, "Tannerism." One could say that black art and culture were shaped during the 1930s not only by this legacy but also by the Great Depression and the aesthetics of the Regionalists and the American Scene painters. Yet if one over-looks the phenomenon of "double consciousness," then much of the tension relating to the black America of the thirties is minimized or mis-understood. Double consciousness, according to W. E. B. DuBois, is that peculiar sensation of always looking at one's self through the eyes of others.[14] He refers to the relationship of black Americans to a socio-cultural system that they are a part of and yet apart from. As a result, they have had to contend with the changes of the society in general while also confronting the vagaries of discrimination. Since they are thus inextricably linked to the American majority, the concerns of black America must be seen in the context of the whole of American culture.

When the grim realities of the Depression replaced the Jazz Age, many Americans became disil-lusioned with the political/ economic system. And, when the nation was found wanting because so many institutions and traditions had failed, there was a demand for change. The intelligentsia responded to the crisis with a new emphasis on social consciousness and a leftist leaning in politics. Yet as the discussion of the

nation's inadequacies continued, it became painfully clear there was no consensus about what was indeed American about America. It was discovered that "Americanism" could be defined just as readily along conservative or anti-conservative lines. One result of the turmoil was a conflict regarding the direction American art should take as the country began piecing together a new identity.

Some felt the solution was to support new alliances and new priorities. The small group of artists that clustered around Alfred Steiglitz (fig. 39) believed it was time to bring American art into the twentieth century by coming to grips with European modernism. This group railed against artistic provincialism and searched for individual styles that were abstract rather than represen-tational. However, until the 1940s these artists and their works remained a distinct minority. During the Depression Americans became artistically more conservative and were generally suspicious of abstract art, partly because it seemed more ornamental than useful. It was thought to be some foreign import unsuited to the pragmatic American character. Even otherwise liberal politicians disdained abstract art for its lack of any moral or didactic content. Nevertheless, the artists' attempts to synthesize a new art from various European theories were eventually vindicated as their efforts coincided with the rapid world-wide economic and political shifts of the forties and fifties. However, conserv-ative elements, both in and out of the art field, continued to resist those changes wherever they occurred.

The strongest reaction came from the Regionalists and the American Scene painters who endeavored to retain in their works an atavistic image of "a God-fearing, white-picket-fence America."[15] The leading spokesman for the conservative viewpoint was Thomas H. Benton, who recanted his own "play with colored cubes and...aesthetic drivelings"[16] and revolted "against the general cultural inconsequences of modern art."[17] With Curry, Wood, Hopper, Marsh, and others he tried to counteract the European-inspired modernist leanings in American art by creating works that "glorified the traditional American values— self-reliance tempered with good neighborliness, independence modified by a sense of community, hard work rewarded by a sense of order and purpose."[18]

This "aesthetic of the ethic" no doubt accurately reflected the majority opinion since it was supported not only by Middletown and Middlebrow, but by the Art Students League, the Whitney Museum, *Art Digest*, the A.C.A. Gallery, and the New York *Post*, to name just a few. In this revival of realistic modes and anecdotal subject matter, the vices of society could be

13. Romare Bearden, quoted in Marcia Matthew, *Henry Ossawa Tanner: American Artist* (Chicago: University of Chicago Press, 1969), p. 251.
14. W. E. B. DuBois, *The Souls of Black Folk* (New York: Fawcett Publication, 1961), p. 187.
15. Barbara Rose, *American Art since 1900: A Critical History* (New York: Frederick A. Praeger, 1967), p. 115.
16. Ibid., p. 120.
17. Ibid., p. 121.
18. Ibid., p. 115.

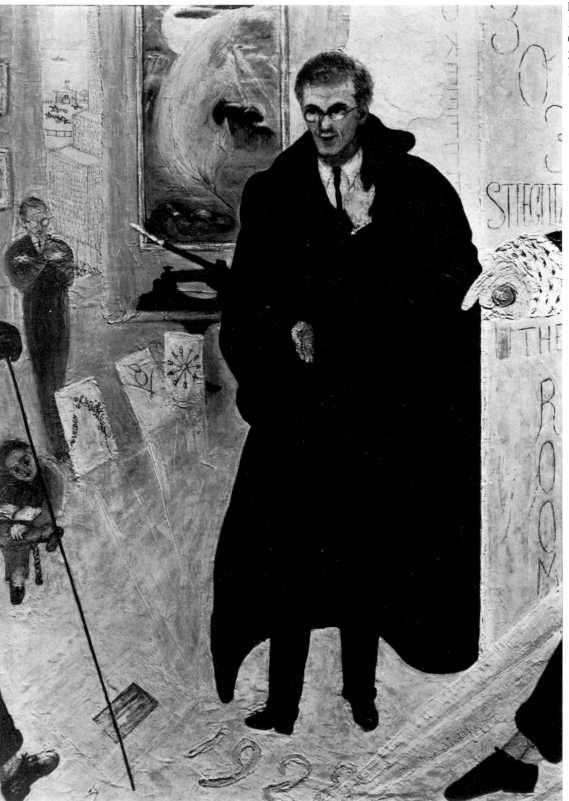

Fig. 39 Florine Stettheimer
Portrait of Alfred Stieglitz, 1928
Oil on canvas
38 x 26¼ in. (96.5 x 66.7 cm.)
Department of Art, Fisk University

held up for ridicule and change, as its virtues could be presented for emulation; political as well as other groups seeking a utilitarian function for the arts found such works useful for their needs.

According to some astute observers of American art and life,[19] the art of this crucial, self-conscious period was characterized by the advancement of American Scenes and Symbols, the formulation of the American Self-Portrait, and the expression of Reaction and Rebellion. These phrases recall those years when "Made in America" became a rallying cry for both white and black America.

Recent art historians have generally repudiated the Regionalists and most of the American Scene painters as being hopelessly reactionary and anachronistic. By the same token, black artists of the period who delved into mainstream social realism and commentary art have received similar treatment. These painters have had their works dismissed as "cheerless, harsh, haunted by a romantic nostalgia and addicted to the grotesque."[20] The same artists, sanctioned and validated during the 1930s, have also been accused of disclosing in their "graceless, unaesthetic" works the "spiritual vacancy behind the American success story." Sam Hunter, who has thus described them, is very specific about their faults:

Pictorially, they were as limited, average and undistinguished as the humiliated landscape, broken down architecture and drab scenes they made their stock-in trade of their subject matter...the least attractive aspects of American life were presented with apology.[21]

Nevertheless, what seemed deserving of opprobrium to white critics was not necessarily perceived in that light by black critics and artists. Margaret Just Butcher contends that the black minority achieved nearly universal recognition as a cultural force during the 1930s. She suggests that this occurred because black writers and artists tended to relate themselves to the common social protest rather than to racial protest only.[22]

Alain Locke, who was also a proponent of American Scene art, found the 1930s especially worthwhile for the black artist since it was a time when "American art was rediscovering the Negro."

The revolution in the attitude of the white American artist toward the [black] theme and subject is in certain respects highly significant. First, because it rests upon some subtly and slowly changing social attitudes which it reflects. Then, because it re-inforces that liberalization of public opinion in a subtle and powerful way. Finally, because as long as the [black] theme is taboo among white artists or cultivated in a derogatory way, a pardonable reaction tends to drive the [black] artist away from an otherwise natural interest in depicting the life of his own group.[23]

19. Barbara Rose, Oliver Larkins, and Sam Hunter.
20. Sam Hunter, *American Art of the Twentieth Century* (New York: Harry N. Abrams, Inc., 1972), p. 124.
21. Ibid.
22. Margaret Just Butcher, *The Negro in American Culture* (New York: Alfred A. Knopf, 1967), pp. 224-25.
23. Alain Locke, *Negro Art: Past and Present* (Washington, D.C.: Associates in Negro Folk Education, 1936), p. 47.

He was referring specifically to the sympathetic treatment of black subjects by earlier artists of the Ashcan School such as Henri, Bellows, Luks, as well as Benton, Curry, Bloch, Marsh, and others. This was revolutionary to Locke because he knew very well that if white artists and their institutions made images of the black American legitimate then, ironically, it would not be long before the black artist would also accept himself as a proper subject. Indeed, Locke felt that the black artist had even more to gain than other American artists from the desire to create a native art independent from European influences and rooted in themes of the American scene.[24]

Thus, one reason given by white critics for their condemnation of the general aesthetic climate of the 1930s is the same reason it has been lauded by black critics: the popularization of imagery derived from native American sources. It was especially important to black critics that these sources include black people and their activities. For, as Locke suggested, this would indicate that black people were being considered significant to the country. White critics tended to stress the importance of the art object over the role of the artist while black critics tended to do the reverse.

Although Locke used the word revolution to describe some of the changes in attitude of certain white artists of the 1930s, this change had begun gradually some years earlier. Interaction among black and white intellectuals and artists had been especially prevalent during the 1920s, and it was that period of the Jazz Age and the Harlem Renaissance that indirectly informed the aesthetics of the black American in the 1930s.

The hard times brought on by the social and economic displacement of the Depression forced art and culture into a secondary status at best. Had it not been for the continued support of the Harmon Foundation and the introduction of the New Deal programs, aesthetics would have had little meaning, especially for black artists, because the "last-hired and first-fired" syndrome applied to art as well as to labor.

Nevertheless, the era that saw Joe Louis win the heavyweight boxing title and Bessie Smith die because of malign neglect also saw a government policy that left an indelible mark on the art of black America. The Public Works of Art Project and the Federal Art Project of the WPA were organized in 1933 with a grant of $1,408,381.[25] It is not clear whether this support came from the suggestion of Edward Bruce—a banker, lawyer, and sometime painter who was a delegate at an international economic conference in London—or whether the impetus came from the protests of unemployed artists. The purpose of the project was to employ artists at craftsmen's wages to embellish public property, a socialistic approach to art that was unprecedented in the United States.

This program was not, of course, designed with the black artist in mind, but he benefited because it was implemented with a minimum of discrimination; participants were supposedly selected on the basis of their qualifications as artists and their need for employment. The subject matter assigned to artists was the American scene in all its phases. By 1934, 3,521 artists had created more than 15,000 murals, sculptures, paintings, prints, drawings, and crafts that were all the property of the United States government. Much of this art was executed or placed in public buildings and parks.

Some black artists, buoyed by this temporary aid, deceived themselves by accepting it uncritically. Many welcomed the project simply as a way to survive for a while. Others mistakenly assumed that the bread lines, strikes, and demonstrations would at least modify the old system if not completely overturn it. The development of other New Deal programs seemed a promising indication that America was finally seeking social justice for all of its citizens. It also seemed encouraging that black artists were given the same opportunity as white artists and that they were asked to paint the American way of life. The tenor of the times also suggested that the artistic themes of the 1920s just might be extended to include a class *and* a race consciousness. This notion was further supported by the revolutionary success achieved by the Mexican muralists, by the Communist Party which encouraged nationalism by suggesting that black Americans were an oppressed nation within a nation, and by the popular acceptance of the Regionalists and American Scene painters.

Thus the climate that created the "socially inclined" artist also met the needs of black citizens, artists and non-artists alike, who not only

24. Ibid., p. 57.
25. The factual material regarding this program comes from Edward Bruce, quoted in *The Art Digest,* May 1, 1934, p. 32.

wanted to express their "Americanness" but were impatient to help effect social change. When Benton said that "no American art can come to those who do not live an American life, who do not have an American psychology and who cannot find in America justification of their lives,"[26] the black artist could feel, ironically, that he was perhaps the most American of all since he had not chosen other alternatives and almost always existentially viewed himself within the American context.

Such rhetoric necessarily resulted in a social realism that dominated American art of the 1930s. Most of the white artists of this period have been critically superseded by others who were committed to modernism and abstraction. For the black artists and critics who never came to grips with modernism (neither the European nor the American variety), the use of the work of art as primarily a vehicle for communicating a social message became almost universally accepted. Art that emphasized formal concerns was generally ridiculed by black leaders who knew little about aesthetic issues.

In assessing the artists of the 1930s in his essay "The Negro in Modern Art," James Porter commented that he wished their "efforts at social criticism were more direct and accusatory— less concerned with day-dreaming or with symbolistic wishfulness. More gallic deftness and honesty of statement and less pretense of indifference or frustration. Overdramatizing the feeling of separateness from the mainstream of American life because of over-sensitiveness to race discrimination is submission...."[27]

If the role of the artist was to be a critic of society, as Porter suggested, this could hardly have been accomplished by the nonrepresentational systems favored by the formalists. On the other hand, a white critic, Barbara Rose, in evaluating the same period from a different viewpoint, maintains that "the American artist faced the problem of extricating his art from a debilitating provincialism as well as from the demands of leftist politics, which required that art serve a social purpose."[28]

Another white critic, Sam Hunter, chose as his hero from this period not the Regionalists nor the American Scene painters but Stuart Davis, who worked in an abstract and semi-abstract style. Hunter says, "Stuart Davis' art...provided more refreshing answers in the quest for a native art than the various styles of romantic realism offered.... Throughout the period of reaction, in the twenties and thirties, Davis painted according to aesthetic principles far more strict and exacting than those of his contemporaries."[29]

If double consciousness permits the black American to see himself only through the eyes of others, perhaps the sociologist can explain why he tends to reflect the more conservative and traditional elements. Those who would have the least to gain by maintaining the status quo are, more often than not, the staunchest supporters of values long since abandoned by the leading thinkers of the majority culture. A classic example is Henry O. Tanner, who disdained the radicalism of the Impressionists, the Post-Impressionists, and other innovative artists in France, preferring the

academic haven of the salon. Since the Regionalists and American Scene painters seemed to have the official approval not only of the government through the WPA but also of museums, newspapers, art schools, and the public, it is understandable that they would exert the most profound influence on black artists. Artists like Marcel Duchamp and Man Ray were either unknown or dismissed as being irrelevant to the needs of the black community.

In 1934 Romare Bearden wrote a scathing diatribe against the "timidity," the "mere rehashings," and the "hackneyed and uninspired" work of the black artists. Disgusted that they had "evolved nothing original or native like the spiritual or jazz music" he suggested that their development had been slowed by three factors: (1) the lack of a valid standard of criticism; (2) hindrance from foundations and societies that were supposed to encourage them; and (3) a lack of a definite ideology or social philosophy to guide them.[30] However, according to Bearden one of the chief problems of the black artist was the lack of an appreciative critical audience.

Art should be understood and loved by the people. It should arouse and

26. Oliver Larkin, *Art and Life in America* (New York: Holt, Rinehart and Winston, 1960), p. 416.
27. James A. Porter, "The Negro in Modern Art," in *The New Negro Thirty Years Afterward* (Washington, D.C.: Howard University Press, 1955), p. 55.
28. Rose, *American Art since 1900*, p. 155.
29. Hunter, *American Art*, p. 162.
30. Romare Bearden, "The Negro Artist and Modern Art," *Journal of Negro Life*, December 1934, pp. 371-72.

stimulate their creative impulses.... The best art has been produced in those countries where the public most loved and cherished it.... We need some standard of criticism then, not only to stimulate the artist, but also to raise the cultural level of the people.... I am not sure just what form this system of criticism will take but I am sure that the [black] artist will have to revise his conception of art.[31]

The lack of patronage was an obstacle to the development of an indigenous black art style not easily overcome. As Henry McBride of the New York *Sun* commented:

There is no question but that the race is artistic, but the difficulty comes when we attempt to decide if that race is to speak for itself or for us. At once weighty problems confuse the issue. Art patronage, until just recently, at least, has come from the aristocracy. Is there a sufficient Negro aristocracy to support Negro geniuses or shall the Negro adopt himself to white necessities and so to speak, paint white.[32]

Eleanor Roosevelt expressed a similar concern while dedicating the South Side Art Center in Chicago: "I think we now realize here in this country that what we need to do is develop an audience for our artists of every kind...that the power to appreciate is often just as important as the power to actually create something...."[33]

James Porter commented in 1943 that:

The opportunities afforded Black painters and sculptors so far through the WPA Federal Arts Projects raise the hope that equal opportunities will soon appear through private and commercial patronage and that the prejudice and mistrust that have restricted the [black] artist and warped his milieu will be abolished.[34]

At this point it was obvious that patronage was essential if black artists were to realize their full potential. But no one had any immediate solutions, although Porter later chided the black press for their lack of support. He said that the black artist:

...requires a discriminating, consistent and generous patronage. It is unfortunate that the Negro Press has done so little to advance the hopes and aspirations of the [black] artists or to influence the growth of educational opportunity...in the field of art....Deprived of constructive art criticism and lacking other necessary incentive, the [black] artist can scarcely live much less create.[35]

Despite these seemingly insurmountable obstacles, the black painter "found his voice in the thirties." Artists like Douglas, Motley, Hayden, and Barthé who had established their reputations during the twenties continued to create their interpretations of the black American scene under the auspices of the Art Projects. In the thirties Douglas continued to extract harmonic formal designs from scenes of lower-class black life in his *Aspects of Negro Life* murals painted for the New York Public Library. He elaborated on his clean, precise, decorative style with subtle color gradations, while the ambiguous spatial relations of forms that appear to be both flat and illusionistic remained. The formal structure of Douglas' mural style, distinct from that of his easel paintings, appears to have been obtained from having emptied, softened, and smoothed the forms of Analytical Cubism. The result is an intriguing blend of abstract construction with objective perception. His first notable works appeared as illustrations in *Crisis* magazine submitted at the invitation of W. E. B. DuBois. This association with DuBois led to the execution of many more illustrations and mural panels and Douglas successfully turned his palette to modernizing a style that reflected themes from African history. He designed jackets and plates for a variety of books by Countee Cullen, Alain Locke, Langston Hughes, and James Weldon Johnson. His best-known illus-

31. Ibid., p. 372.
32. "The Negro Annual," *Art Digest*, May 15, 1934, p. 18.
33. *Magazine of Art*, May 7, 1941.
34. James A. Porter, *Modern Negro Art* (New York: Dryden Press, 1943. Reprint. New York: Arno Press, 1969), p. 133.
35. Porter, "The Negro in Modern Art," p. 55.

trations are those in the series he executed for Johnson's *God's Trombones*.

Richmond Barthé, unquestionably the leading black sculptor of the era, had his first New York solo exhibition in 1931. He worked in a romantic realist style that stressed a kind of surface illusionism rather than mass. His subjects ranged from simple, dignified genre and figure studies of black people, with an emphasis on portraiture, to public works on a heroic scale. Stylized, studied movements like those seen in dance were recurrent. Barthé's sculpture was less a statement of sculptural form than an affirmation of his people's physical and spiritual vitality.

The most interesting and promising style remained that of the neo-primitives, whose reputation was immeasurably enhanced by William H. Johnson, Horace Pippin, and Jacob Lawrence. Pippin and Lawrence were in the forefront of a group of "primitive" and "neo-primitive" artists that included Archibald Motley, Jr., Alan Crite, William Edmondson, Palmer Hayden, and Leslie Bolling.

The idea that non-professional painting had merit grew out of a contemporary art that contained certain features of primitiveness and spontaneous creation. This was acknowledged in the thirties by group exhibitions of American primitives and self-taught artists at The Newark Museum in 1930 and 1931 and at the Museum of Modern Art in 1939. Solo exhibitions at the Museum of Modern Art of self-taught artists included John Kane in 1933 and William Edmondson in 1937.

Such validations of the primitive style could very well have influenced William H. Johnson to abandon his expressionistic style for the neo-primitive one. Johnson's introduction to art had come through cartoons in a local newspaper: "I began copying the humorous drawings in our newspapers, and the joy I derived from these may without a doubt be ascribed to the way we primitive people always adore caricatures."[36] From copying cartoons, his only means of training at the time, he developed the ability to tell a story in a picture and one can see the effect of the cartoon on his work throughout his career.

After studying under George Luks at the National Academy of Design, Johnson journeyed to France in 1926 where he produced a series of still lifes and portraits. While in Europe he continued to work in a rather flat, impressionistic style, exploring color and form in a manner that proved him a painter of remarkable perception. What was to be of utmost importance to his European study was his contact with the works of Cézanne, Rouault, Soutine, and Munch. In the work of the latter two he found the exaggerated emotional forms that would play an important role in the style that distinguished his work and caused him to be singled out as one of the most versatile painters of the period.

When Johnson returned to New York in 1943 his style of painting immediately became more direct and expressively primitive (fig. 40). He began painting religious themes, speaking through them to black people. At the Johnson exhibition in Copenhagen in 1947 a Danish critic saw *Come Unto Me Little Children*, an oil from the New York primitive period, and called it "a far cry from ecclesiastical art, which in Europe has become flat and preoccupied."[37]

One must realize when viewing Johnson's paintings that the artist was not discarding all that he knew about principles and theories of art. Rather he was attempting to unite them with the direct approach to a subject that he had discovered in African and European primitive art. The neo-primitive approach is closely related to the conceptualization basic to most African art. Instead of trying to imitate nature, African artists (and the true primitive) seek to define their *idea* of the thing, molding its image in conformity with their definition of it. They must rely on their creative instincts rather than formula and conventions, and when they are successful their work achieves a direct expression of their personal vision of the world.

Horace Pippin was a true primitive and as such his work is self-contained and scarcely affected by the culture of his time. In the most successful of his works such as *Holy Mountain, No. 3* (cat. no. 77); *Christmas Morning*

36. David C. Driskell, "Some Observations on the Life and Work of William H. Johnson" (Paper delivered at the 58th Annual Meeting of the College Art Association, Washington, D.C., January 1970).
37. Ibid.

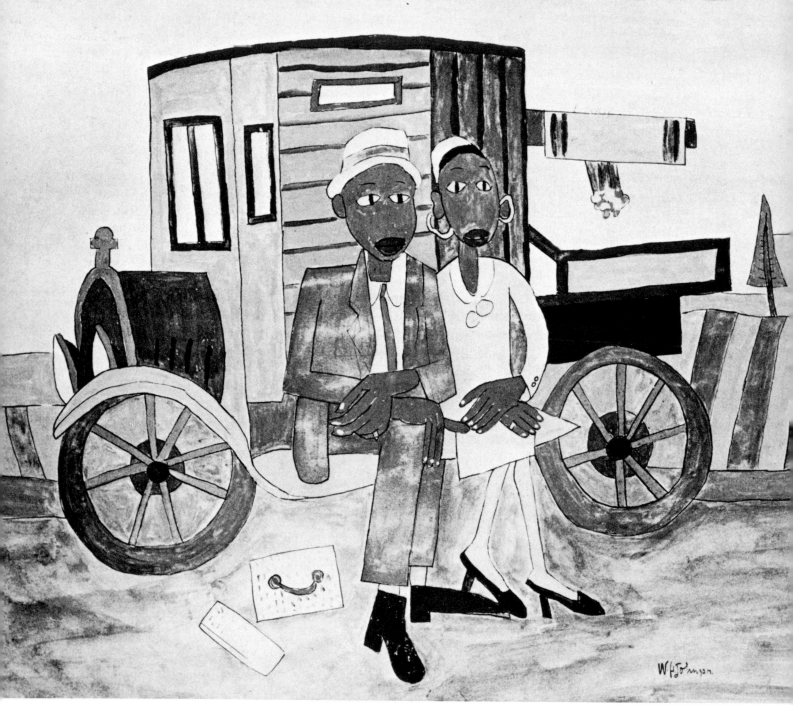

Fig. 40 William H. Johnson
The Honeymooners
Watercolor
14⅛ x 17 in. (35.9 x 43.2 cm.)
Department of Art, Fisk University

Breakfast (cat. no. 76); and *Domino Players* (cat. no. 75), he brings the image to a heightened, surrealistic pitch.

Jacob Lawrence, a master of design in the neo-primitive style, studied first with Charles Alston and Henry Bannarn, later with Refregier, Sol Wilson, and Eugene Morley at the American Artists School. He worked with the Federal Art Project and early in his career received a Rosenwald fellowship. Lawrence also admits to having been influenced by Orozco, Daumier, Goya and Brueghel. "They are forceful. Simple. Human....Then I like Arthur Dove. I like to study the design to see how the artist solves his problems, how he brings his subjects to the public."[38]

Although Lawrence was a thoroughly trained artist the characteristics of his style—simplification, narration, schematization, condensation—are frequently seen in the works of non-professionals. Despite the similarities Lawrence differs from a purely primitive painter in that his distortions are not arrived at accidentally but are deliberately cultivated as a means of creating another view of reality. He seems interested not in perfect form but in perfect distortion which penetrates through mere outward appearance to the essence. His most immediate artistic ancestors quite evidently came from the graphic world of magazine and newspaper illustration: the cartoon, the poster, the comic strip, the caricature. By exaggerating the essential features of a subject, caricatures produce a likeness that is truer than mere imitation.[39] As Lawrence's work proves, it is not proximity to reality that gives value to a work of art, but its nearness to the artist's psychic life. His work is tough, urbane, unsentimental. His stock-in-trade is strong, hard-edged shapes of unpredictable, unmodulated, intense color. Everything rests firmly on the surface of the picture in a non-illusionistic space that is impeccably designed (cat. no. 164). "It seems that his achievement rests not in his iconography, his style, or in the content of his works, but in his idiosyncratic blending of the three into a symbolic mode of expression synthesized in caricature."[40]

Locke was delighted in 1940 to observe that the "intimate, and original documentation of [black] life" in the 1930s had not led into a "back water inlet of racialist art, but on the contrary, led out to the mainstream of contemporary American art."[41] The thirties had provided what he observed as a new conception of the place of black people in American

38. Elizabeth McCausland, "Jacob Lawrence," *Magazine of Art*, November 1945, p. 254.
39. Ernst Kris and Ernst Gombrich, "The Principles of Caricature," *British Journal of Medical Psychology* 18 (1938): 319-41.
40. The ideas concerning the relation of Lawrence to caricature are from Allan M. Gordon, "Cultural Dualism in the Themes of Certain Afro-American Artists" (Doctoral dissertation, Ohio University, Athens, 1969), pp. 127-33.
41. Locke, *The Negro in Art*, p. 9.

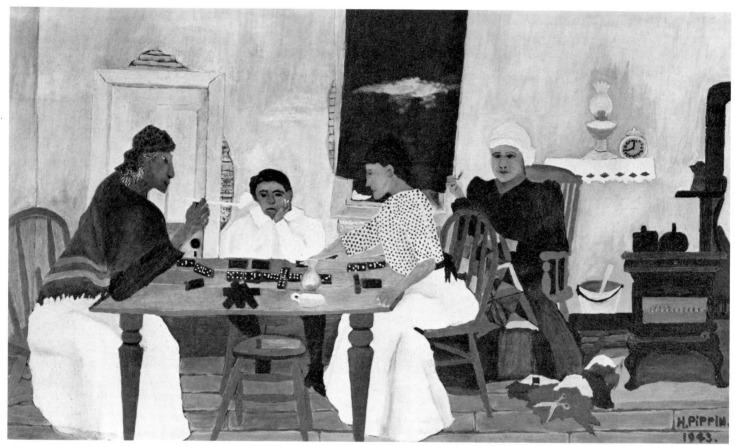

Cat. no. 75 Horace Pippin
Domino Players, 1943

culture. He was convinced that for the artist this could be the realization of a spiritual freedom. He said, however, "that freedom can never be actually realized without the adequate public support and recognition. With respect to both of these, the [black] artist's position is still precarious."[42] The artist's position was to remain precarious for the next three decades and was undermined, ironically, by those forces put into operation to improve the plight of all black people.

The forties saw the demise of the Federal Art Projects, the publication of Locke's *The Negro in Art* (1940) and of Porter's *Modern Negro Art* (1943), the rise of Abstract Expressionism, and significant gains in civil rights for black Americans. The world had been made safe for democracy and now black people wanted democracy to be made safe for them. The elimination of racial restrictions that had begun in the closing years of World War II was greatly accelerated in the postwar years. The climate created by the leadership of President Harry Truman, the efforts of the civil rights organizations, and court decisions caused substantial gains to be made for black people in the areas of social and civil justice. Encouraged by these hopeful signs, civil rights leaders began to intensify their drive to obtain complete equality for all Americans.

How did black artists fit into this atmosphere? Their "precariousness" was intensified when the public support from the WPA programs dried up. But several large group shows for black artists were organized, including *American Negro Art: Nineteenth and Twentieth Centuries*, at the Downtown Gallery in New York in 1942; *The Art of the American Negro, 1851-1940*, in Chicago in 1940, an exhibition sponsored by the McMillen Corporation in New York; and *The Negro Artist Comes of Age*, in Albany in 1945. These shows undoubtedly resulted from exposure given black artists during the WPA days, but they could hardly be considered an adequate substitute for the government's support, nor were they intended to be. They simply assuaged the consciences of those who felt "something should be done." At best they provided an introduction for new and younger artists and a place to exhibit other than a settlement house, a library, or a YMCA. Much more important and lasting, in terms of patronage, was the Annual Atlanta University Exhibition organized by Hale Woodruff in 1942. Not only was it a national exhibition sponsored by and for black artists but the policy of purchasing the award-winning paintings provided the core of a significant collection of black art.

But the real crisis in black art had been pinpointed as early as 1934 by Romare Bearden when he observed among black artists the lack of a "definite ideology or social philosophy." The vogue for blackness during the twenties that was

42. Ibid., p. 10.

encouraged by the white avant-garde had allowed the artist to express himself in a limited, "dark-skinned" way. The 1930s realism of the American Scene painters, with its government sanction and its overtones of social consciousness, had been greeted enthusiastically by black artists who had promptly proceeded to create their version of the black American scene.

In retrospect, it becomes much clearer why discussions about whether it was better to be a "Negro artist" and develop a racial art or to be an American artist who was a Negro were not resolved either in the twenties or thirties and why this irresolution contributed to the crisis of the forties. The answer is simple. Black Americans for the most part have been unable to view themselves outside an American context. The majority of black Americans have consistently attempted to become as much as possible like other (white) Americans and have resented and strongly resisted being thought of as different. The white critic George Schuyler, in refuting Langston Hughes, once went so far as to say that the black American is "merely a lampblacked Anglo-Saxon."[43] It is no wonder that any theory or philosophy that suggested separation, whether in art or elsewhere, was promptly attacked. Such ideas appeared to be a threat or delay to integration. Therefore it was not only virtually impossible to develop an aesthetic

based on a usable African past, but it was almost impossible even to discuss such concepts seriously. To say, as Hughes did, that the black artists were going to write and paint about black people whether white people liked it or not was in effect hollow, especially since no sustaining patronage had emerged from the black community.

The other leading spokesmen, Locke and Porter, did not anticipate any artistic crisis since both were optimistic, with reservations, that democracy could be made to include black people. Porter disdained any suggestions that a "black art" might be developed simply by studying or copying African sources. While he did not dismiss the power of African art as an influence, he insisted that the solution to the black artist's problem could not be found in slavish imitation of African art surfaces. In 1943 he criticized certain black intellectuals (Negro apologists he called them) for extolling "African Negro art as the 'art of the noble savage', justifying an alliance of art with primitive mentality, and a naive perspective with true achievement,"[44] and felt vindicated by the fact that their admonitions to imitate the ancestral arts had not produced a coherent aesthetic program. Instead, it had fostered "academicism and

43. George Schuyler, "The Negro Art Hokum," *The Nation* (June 16, 1926), p. 662.
44. Porter, *Modern Negro Art*, p. 99.

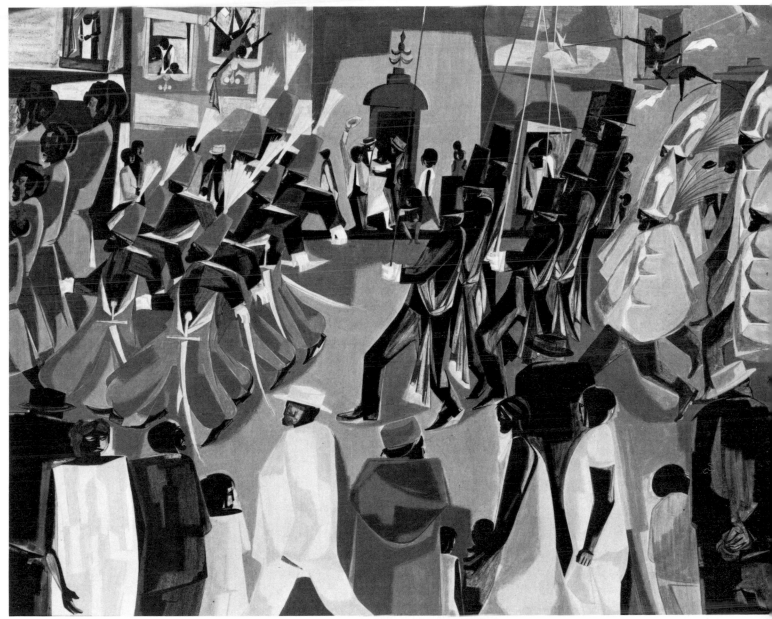

Cat. no. 164 Jacob Lawrence, *Parade*, 1960

tended moreover to confuse the special geometric forms of African sculpture with specific racial feeling."[45]

In 1940 Locke had written this appraisal:

More and more a sober realism is to be noted which goes beneath the mere superficial picturesqueness of the Negro color, form and feature and a penetrating social vision which goes deeper than the surface show and jazzy tone and rhythm of Negro folk-life. Much of our contemporary art is rightly an art of social analysis and criticism, touching the vital problems of religion, labor, housing, lynching, unemployment, social reconstruction and the like. For today's beauty cannot afford to be merely pretty with sentiment and local color; it must be solid and instructive with an enlightening truth.[46]

Thus Locke and Porter continually equated "black art" with "social analysis and criticism," not abstraction. But the loss of public and critical support for "mainstream" art left the black artist with a dilemma: should he continue to document black life and an unjust system or should he direct himself to purely formal concerns?

Two artists, Eldzier Cortor and Hughie Lee-Smith, appeared to offer the most provocative alternative to the "neo-primitive" hegemony without reverting to academicism.

Cortor used figures as metaphors for his own sense of alienation and estrangement. He favored an introspective female figure who contemplated her own predicament and related to no one (cat. no. 158). Often, when there was more than one, his figures became isolated, distorted caricatures, unreal demons in a fantasy land.

One writer has said about Hughie Lee-Smith that his "penetrating but quietly painted, statements on urban desolation and transition are so true of city life anywhere in the West that he must be regarded as an artist of world significance."[47] An inspection of Lee-Smith's works reveals that he is concerned with the relationship of urban man to his environment and to other members of society. His paintings (cat. nos. 150, 151) possess an enigmatic surrealistic quality that connects him with Edward Hopper and Giorgio de Chirico. Like the work of these two artists, Lee-Smith's illusionistic scenes often impart a melancholy emptiness. His most frequent motifs are a vast sky; an industrial structure in the distance; an empty landscape; a brilliant light; menacing shadows. They create a dreamlike wasteland, a space that seems to threaten the figures who

45. Ibid., p. 106.
46. Locke, *The Negro in Art*, p. 10.
47. Cedric Dover, *American Negro Art* (Greenwich, Conn.: New York Graphic Society, 1960), p. 48.

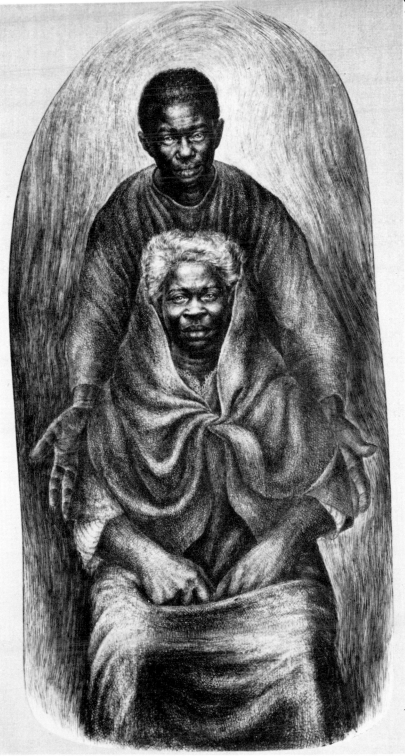

Cat. no. 174 Charles White
Take My Mother Home

appear romantic and melancholy as they hopelessly attempt to communicate. Whether he employs one or more, his figures always express hopelessness, alienation, estrangement from other human beings, and they are forced to act out puzzling, futile roles within a malevolent environment.

Once again it was a lack of critical attention and interpretation that diminished the importance of what Cortor and Lee-Smith were doing in relation to what black artists were trying to accomplish. No viable aesthetic was developed among black artists between 1930 and 1950 because black leaders and intellectuals did not take the artists nor their art seriously. Unfortunately, neither did many black artists. It was assumed that art was trivial, peripheral, while politics, economics, and religion were of central importance.

Black art, unlike black music, was never valued purely for its power to captivate the spectator. Instead the art object always served as a sign of some other cognitive interest, and could be neither pleasurable nor exciting unless it was "socially significant." It had to be treated not as art but as a lesson in social history or an instrument of social change.

By assigning a function to art that it might not be able to perform, this attitude caused artists to try to synthesize their work within the framework of known, familiar experiences. Any approach that was removed from ordinary experience (abstraction is a prime example) was rejected. Art could not be autonomous, independent, self-sufficient.

Value was seen not in formal organization, but rather in the literal depiction of objects, persons, and events of "real life." This attitude was reinforced in the late 1960s when urban artists formed cohesive groups such as Afri-Cobra (African Commune of Bad Relevant Artists) to create work in a style reflecting the mural arts. The subject matter of black art became all important: the closer art resembled "real life," the more one could "learn" from it. As a result the imaginative, sensuous totality of a work was neglected, if perceived at all. Subsequently, the value of the art depended on how moral, praiseworthy, or politically valid the subject was.

This explains the ire of DuBois and others who thought there was real danger in the twenties penchant for portraying the "Negro character in the underworld." It also explains why Porter criticized those artists who attempted to capture in their work the "exotica," as defined by white critics. Since art is evaluated in terms of its subject matter, something outside the work—the model—becomes central to its meaning. This attitude has fostered among too many black artists the notion that a "good" work of art is differentiated from a "bad" work of art essentially by its subject matter and its imitation of a "real life" model. Thus the black artist and his audience have inadvertently accepted and acted upon premises that are more pertinent to ethics than aesthetics.

However even within the academic, realist tradition the genius of an artist can elevate him above the literal. To this end, the art of Charles

White has captured the beauty of blackness as seen in the expressions and daily activities of his people (cat. no. 174). More than any other academic artist he has searched the souls of black folks, registering in his supremely successful realism the unique qualities he has found. He overcomes the problem of using his art literally to mirror social injustices by portraying people whose joys are experienced even in periods of suffering. No one needs the revelation of a secret code to understand Charles White's art even though he uses black content in his work. He reveals those fundamentals of truth known by all who believe man to be "the measure of all things."

Not only White but many other black artists have mastered academic techniques while expressing their ideas in contemporary forms. John Rhoden, Walter Williams, Edward Wilson, Elizabeth Catlett, and Earl Hooks, to mention a few, are among the many seasoned artists whose works explore the dimensions of form that reveal the dynamics of a black aesthetic.

Romare Bearden has articulated on several occasions those theories of art that he believes to be basic to the establishment of a black aesthetic. While he has accepted African art as an element in his own work, he has not allowed his art to become overladen with the saccharine "right-on" Africanized forms created by many of the young artists of the 1960s. The young black artists who resorted to imitative forms that relied heavily on the surface qualities and iconography of African art were chastised by the

critics. In 1946, long before it was fashionable to discuss the concept of black identity in relation to African heritage, Bearden wrote:

> It would be highly artificial for the Negro artist to attempt a resurrection of African culture in America. The period between the generations is much too great, and whatever creations the Negro has fashioned in this country have been in relation to his American environment. Culture is not a biologically inherited phenomenon.... Modigliani, Picasso, Epstein and other modern artists studied African sculpture to reinforce their own design concepts. This would be perfectly appropriate for any Negro artist who cared to do the same. The critic asks that the Negro stay away from the white man's art, but the true artist feels that there is only one art—and it belongs to all mankind.[48]

Since the 1950s it has become increasingly evident that some of the issues central to the art of the 1920s, 1930s, and 1940s have not received the kind of critical analysis needed to separate aesthetic from non-aesthetic concerns. Such a distinction has not yet been established; if anything, there has been a return to placing the artist at the service of a movement. And if artist and political activist are considered one, the black artist must link his work to the struggle for his liberation. Regrettably, the artist has been intimidated by the implication that his art is trivial unless it is politically oriented.

The black community must come to realize that art can have intrinsic value, and act accordingly. Otherwise, it will limit its artists to reproducing when they could define and reveal; to dealing in the anecdotal when they could discover and express truths that go beyond temporal values. Only when we recognize the historical patterns of isolation and accept the responsibility of supporting those artists who express themselves in a universal language of form will black American artists be seen as major contributors to the art of this country.

48. Romare Bearden, "The Negro Artist's Dilemma," in *Critique: A Review of Contemporary Art*, ed. David Lashak, I, no. 2 (November 1946): 20.

Color Plates

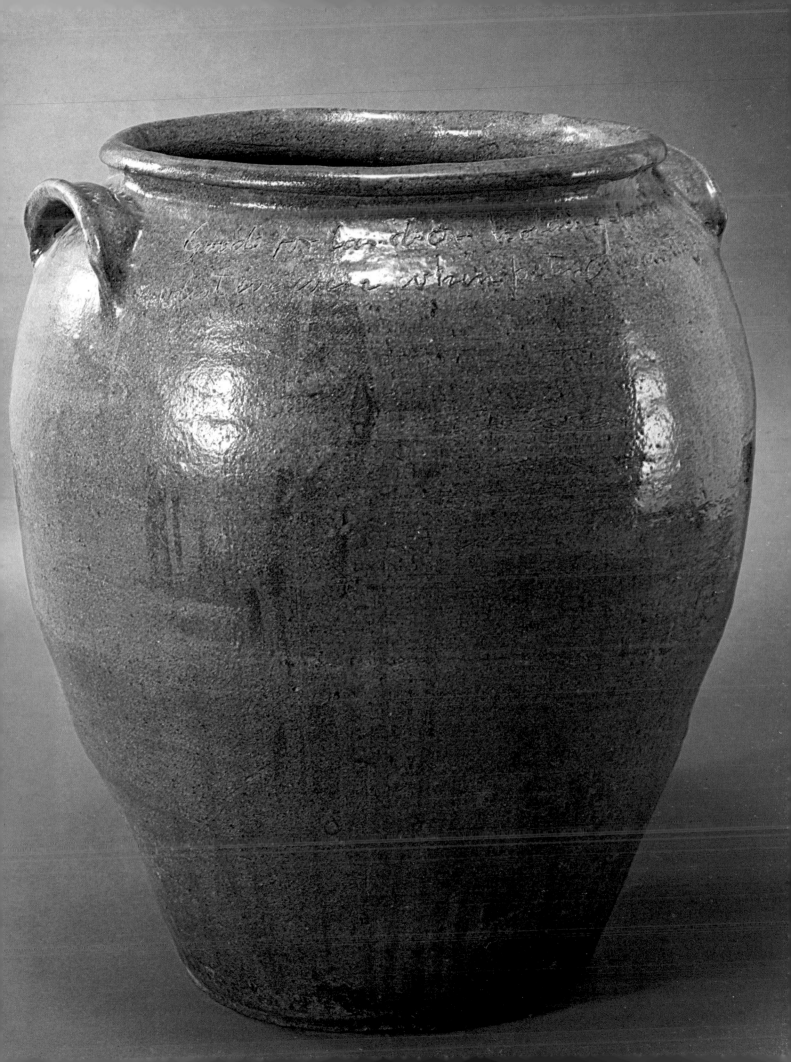

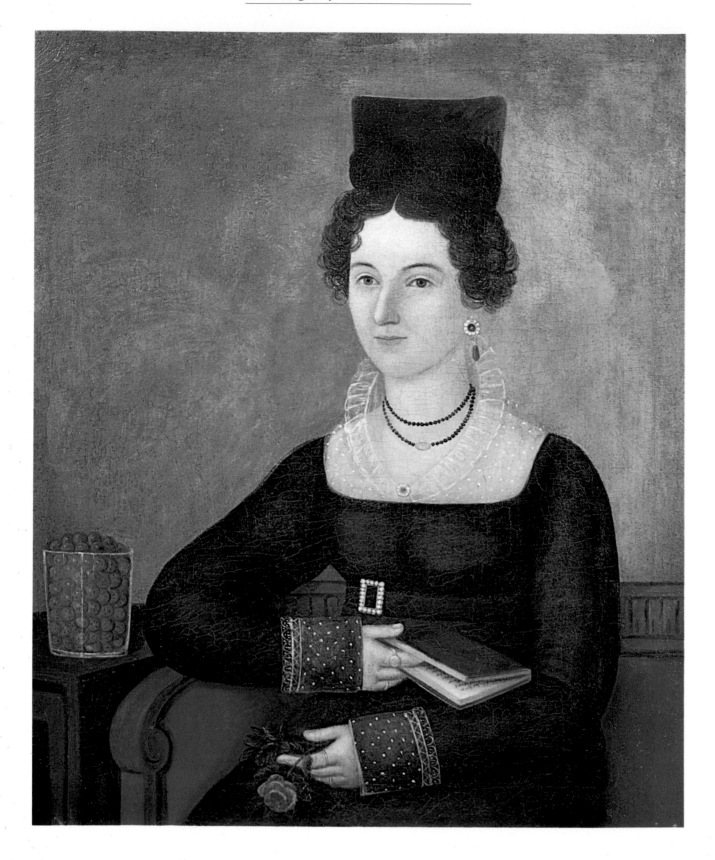

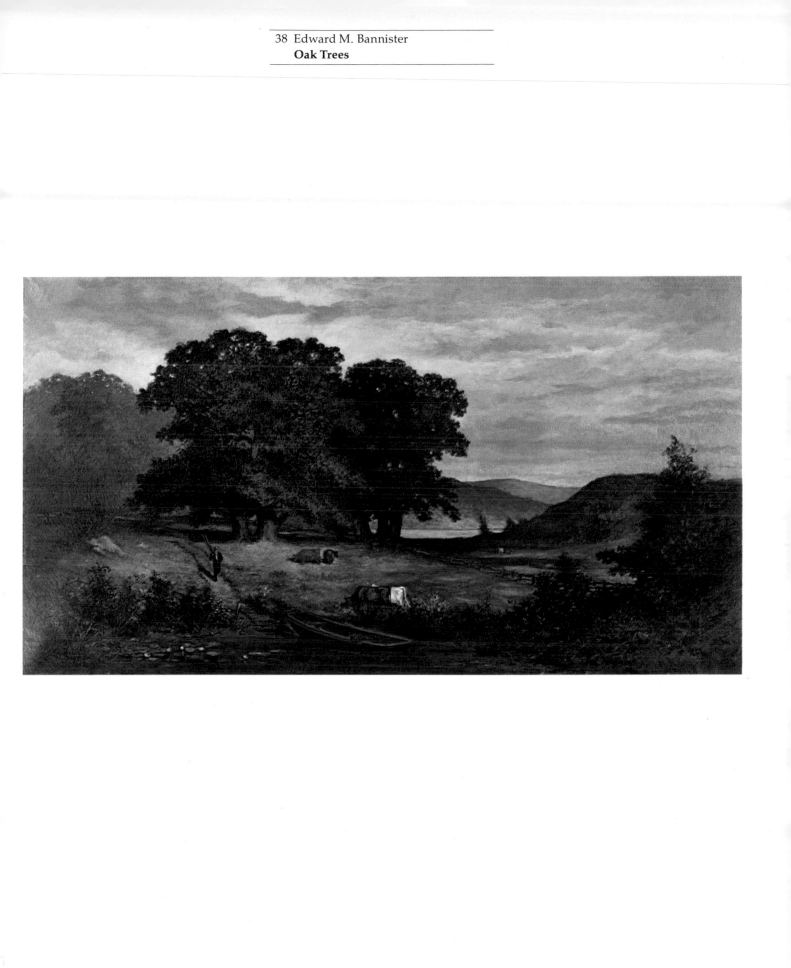

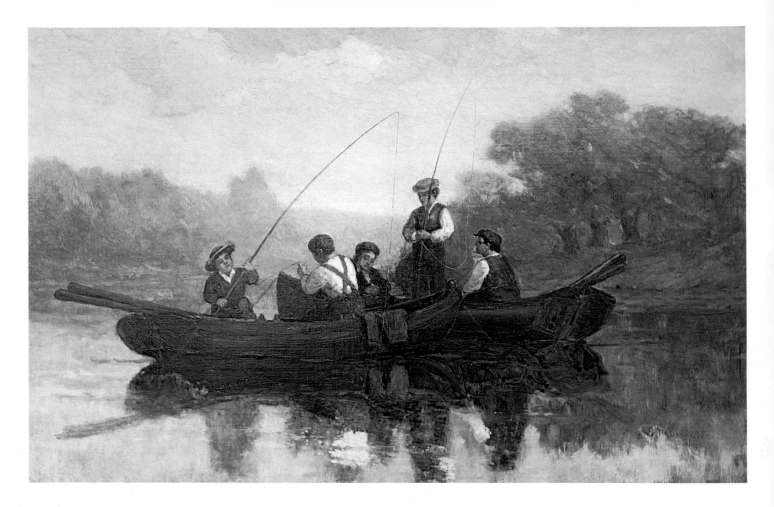

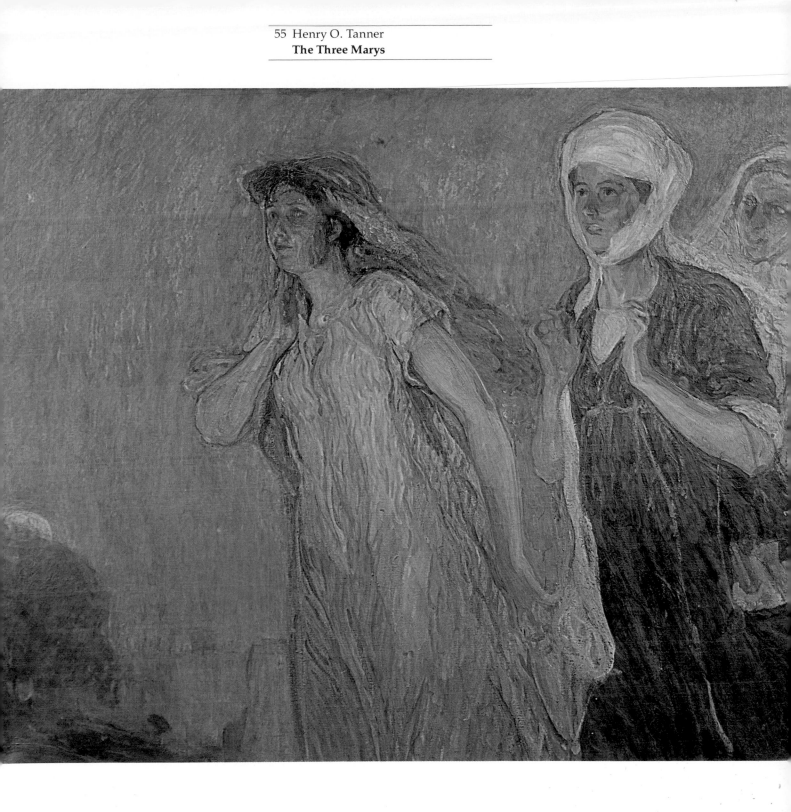

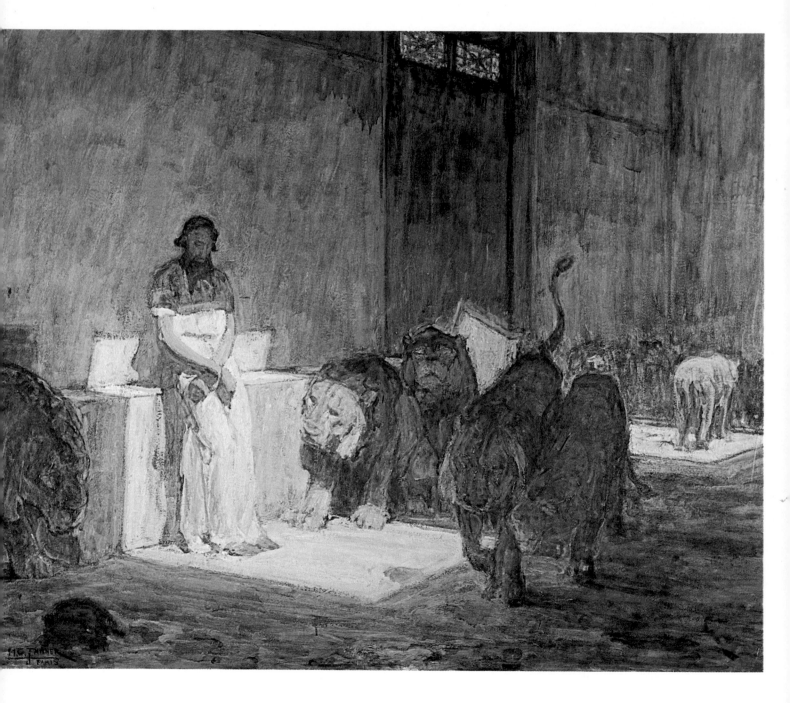

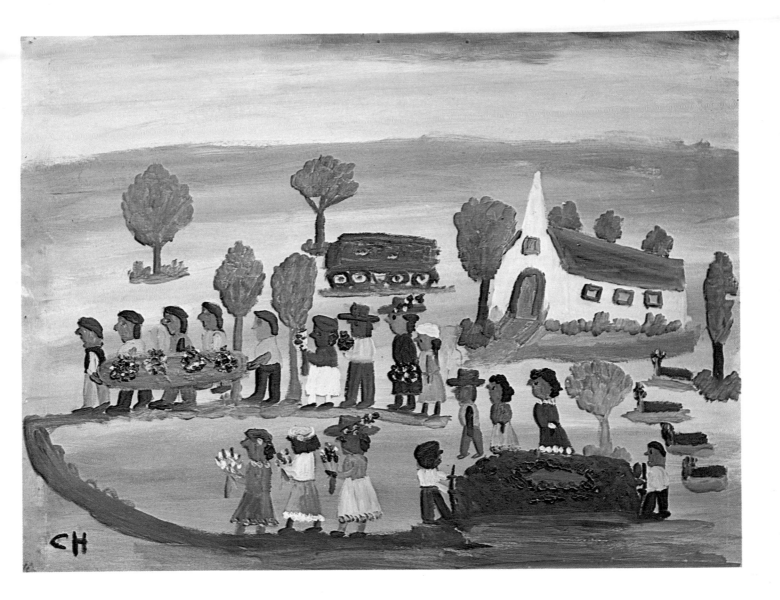

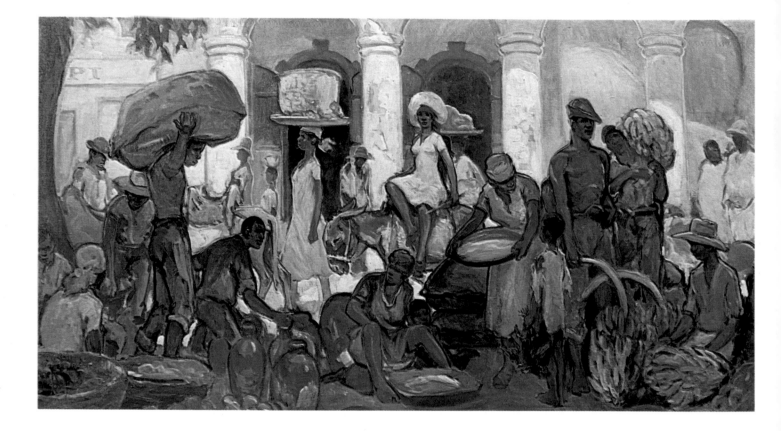

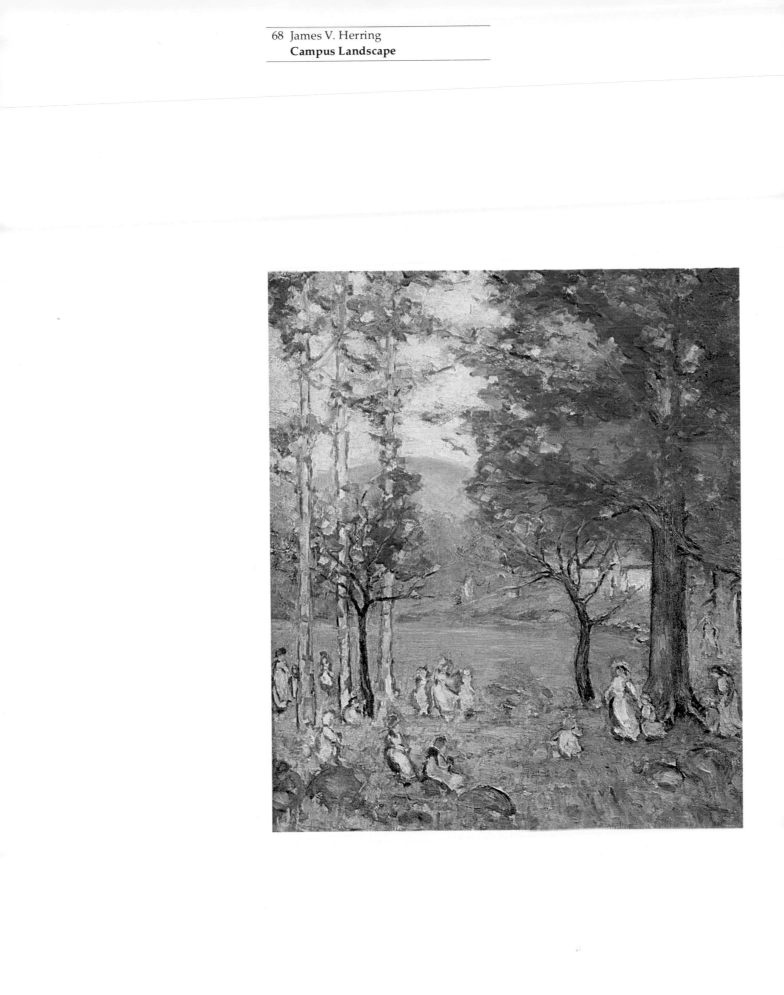

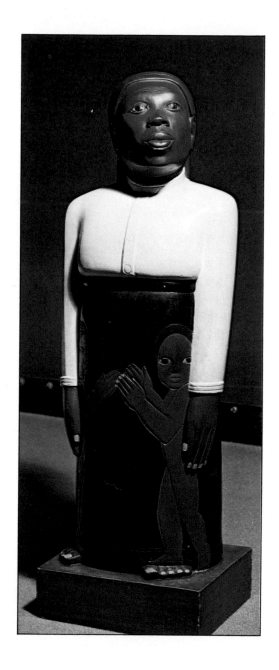

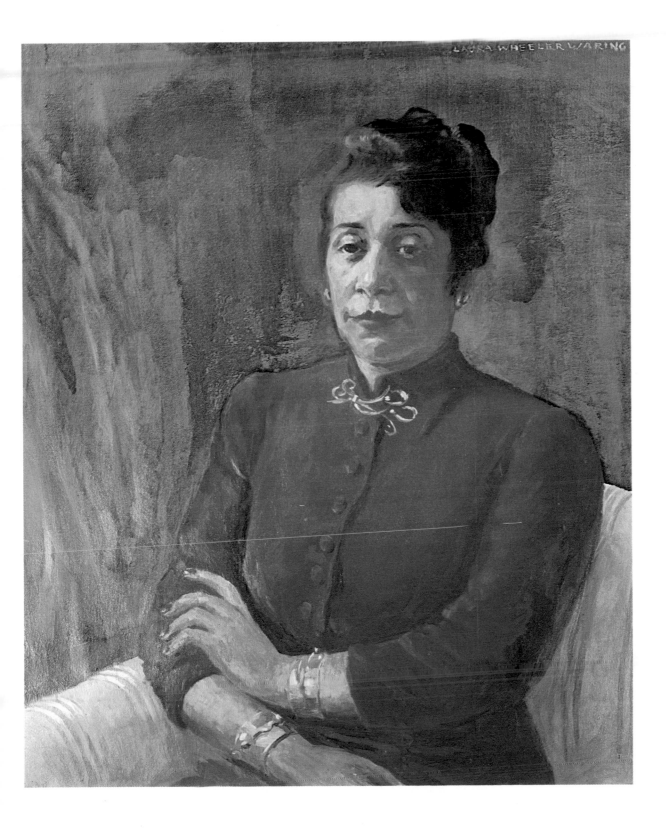

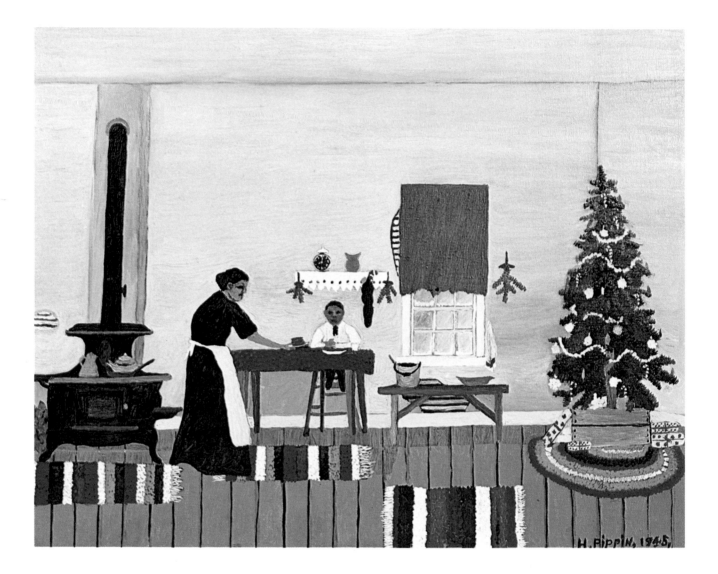

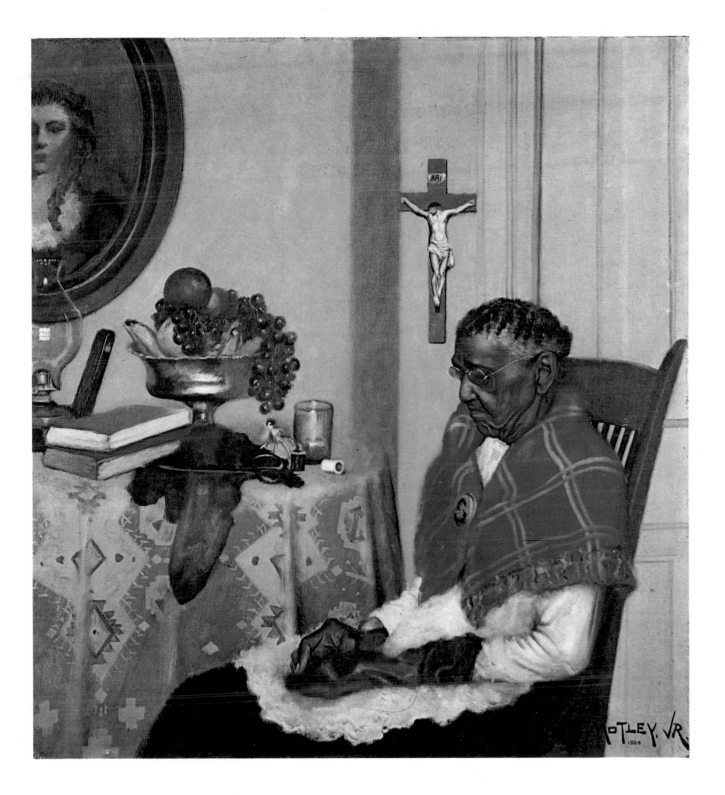

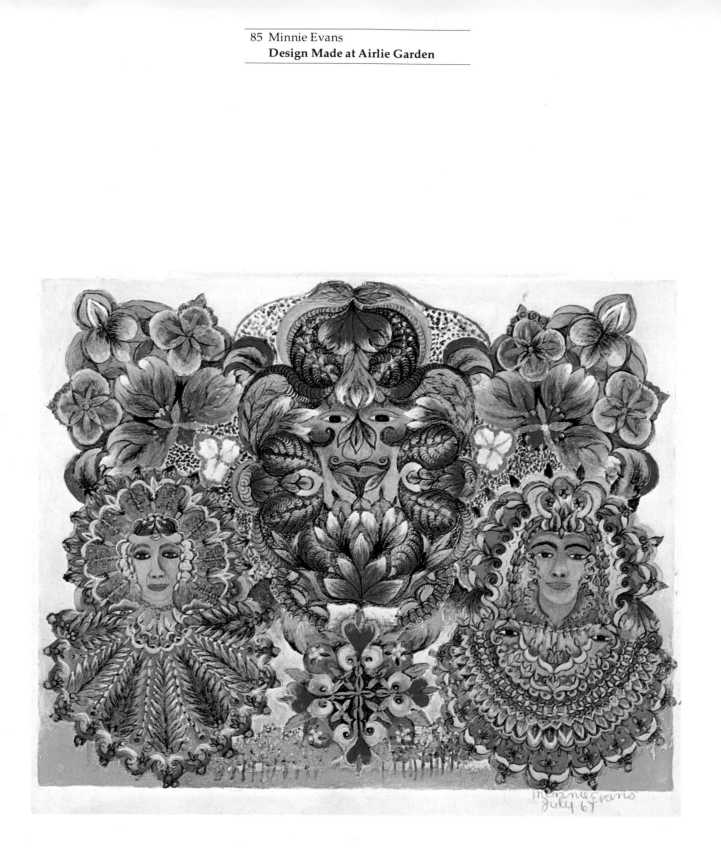

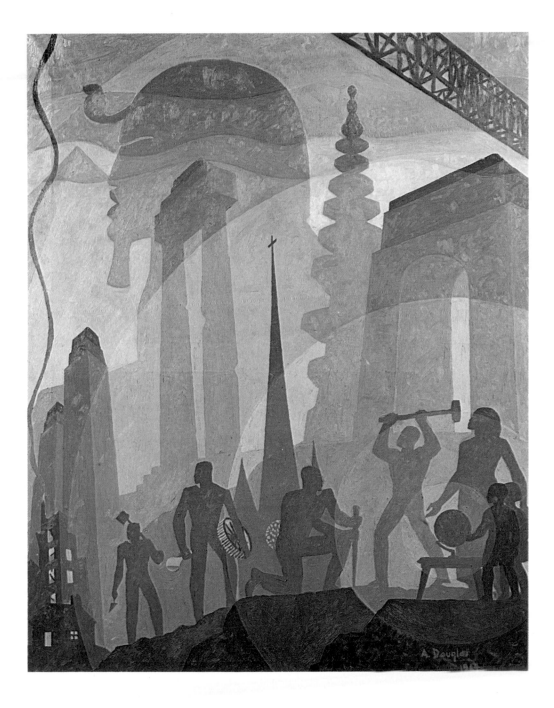

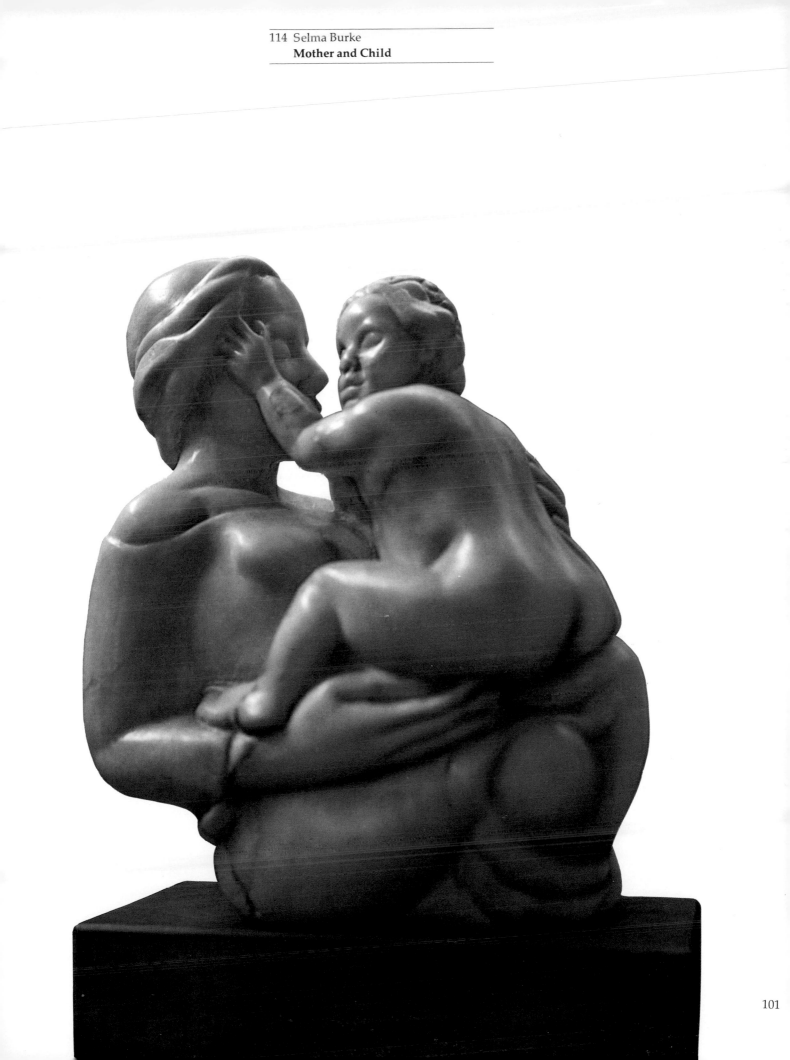

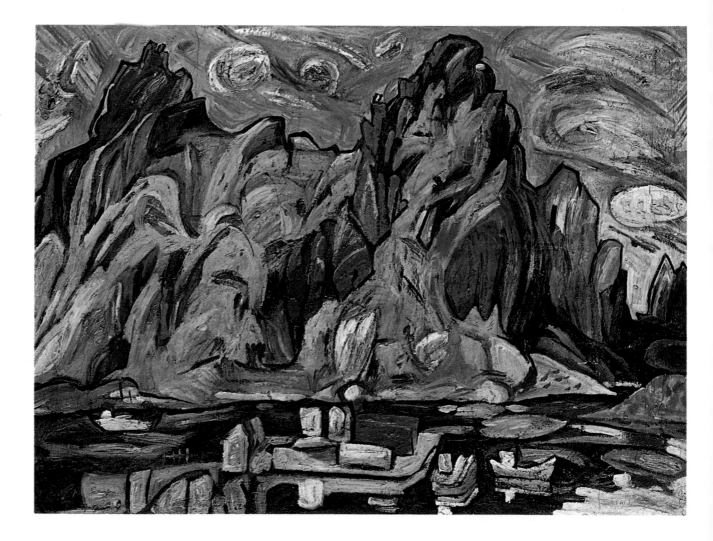

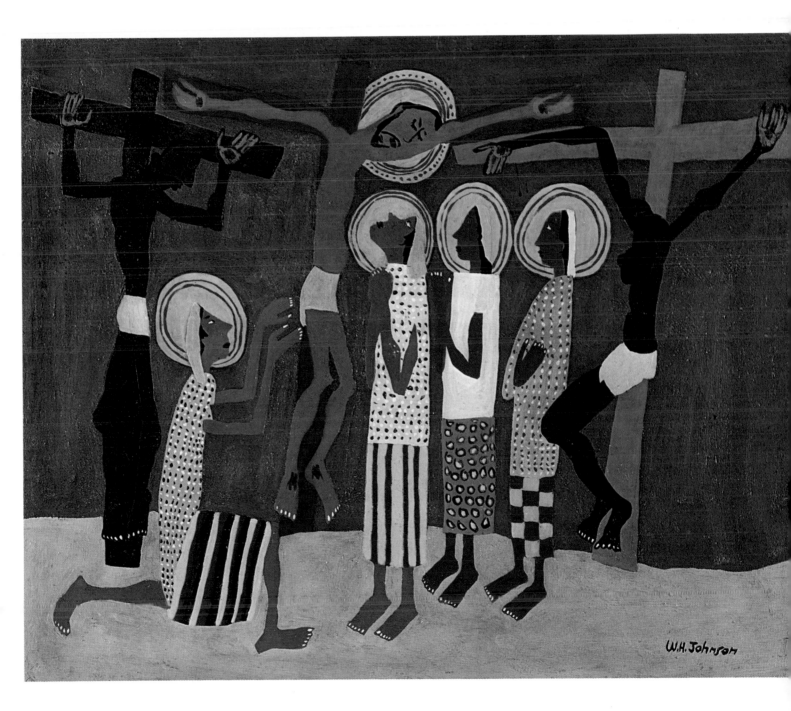

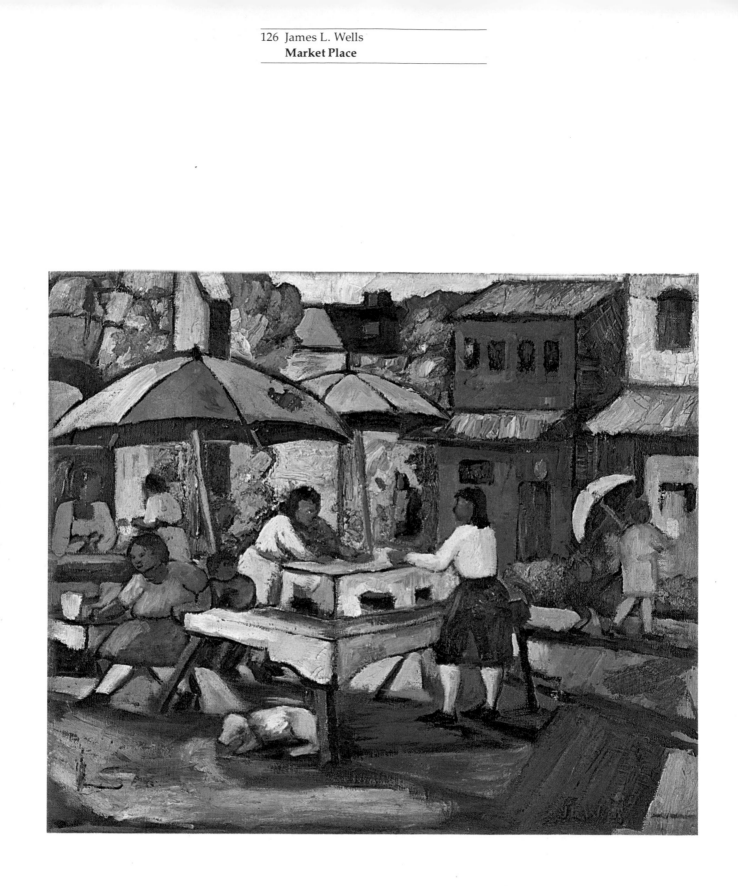

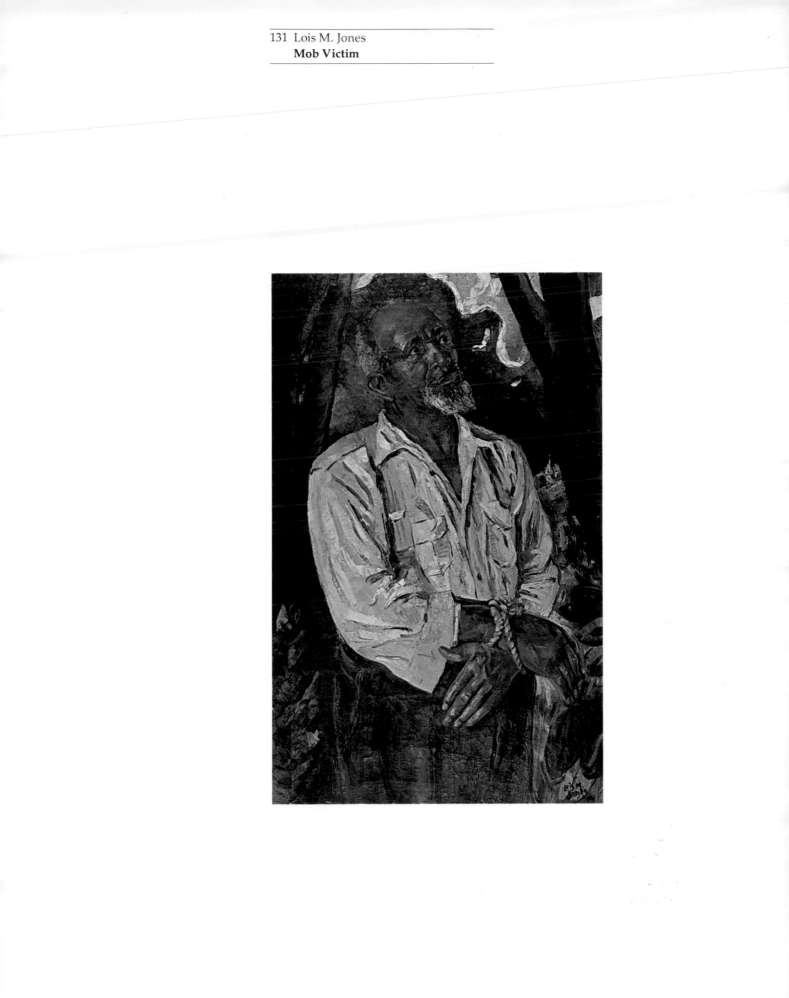

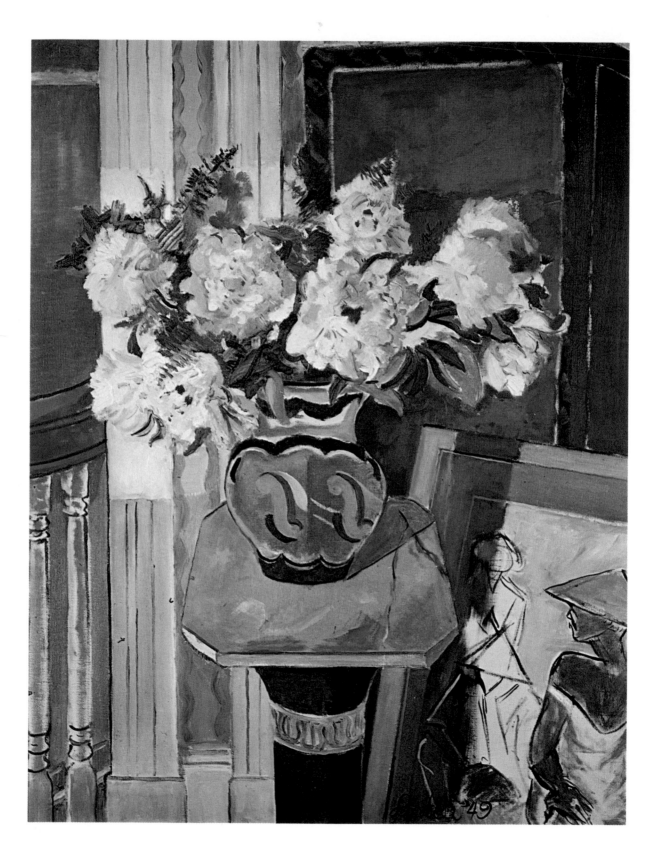

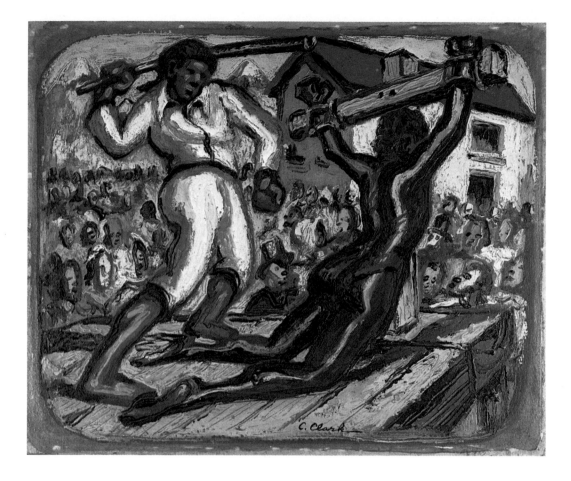

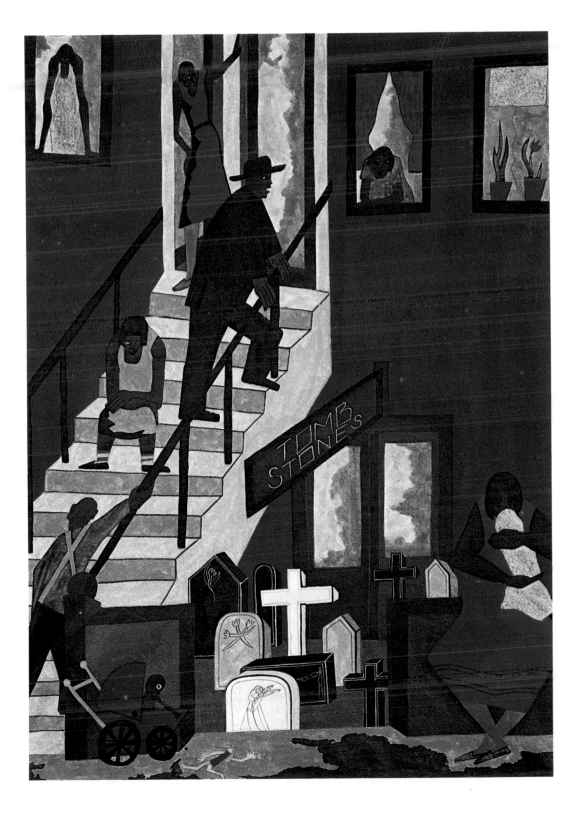

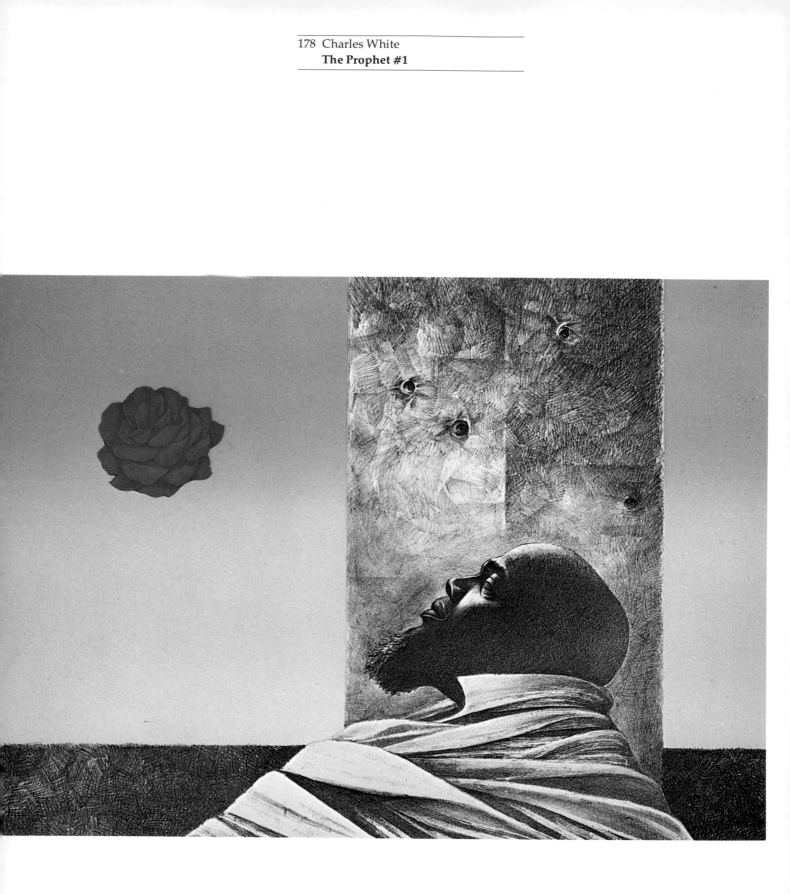

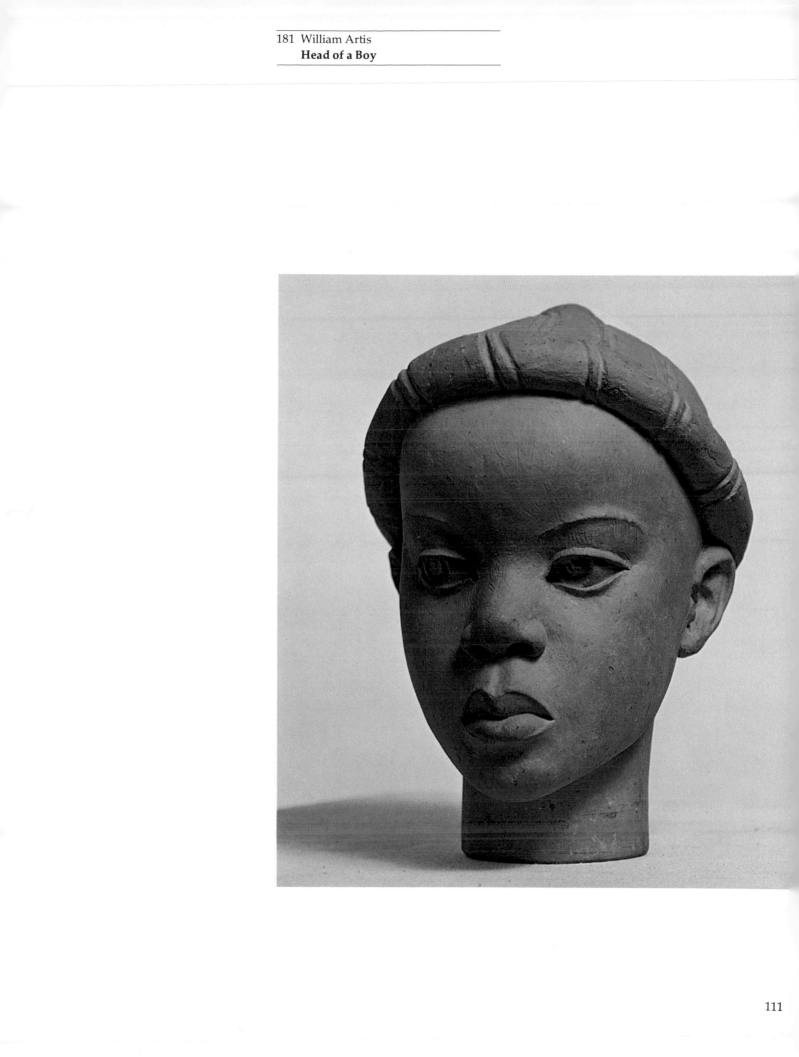

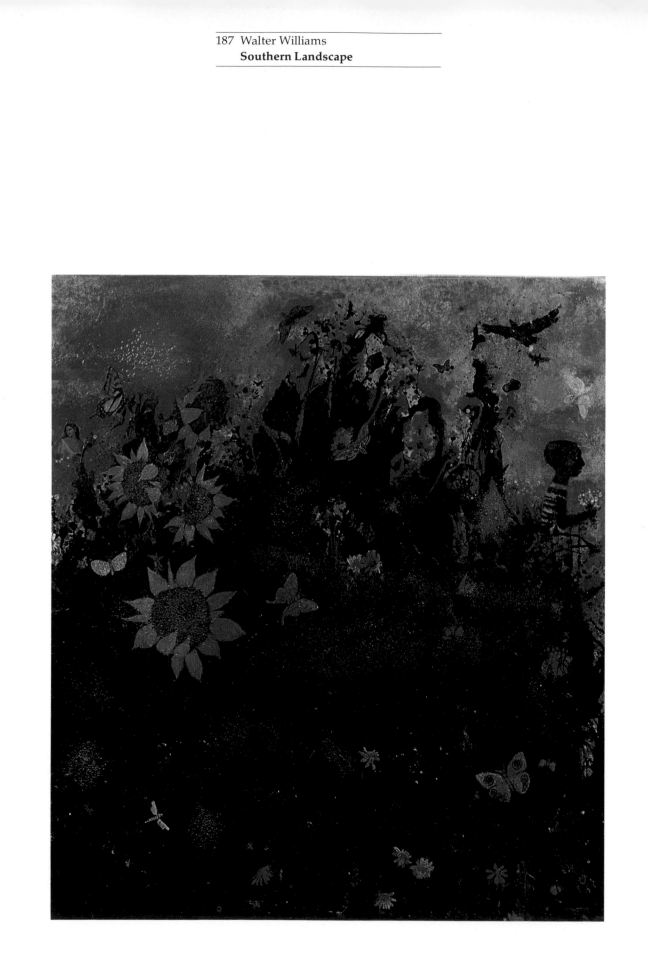

Catalog

3

8

1 (detail)

9 **Basket,** late 19th century
Made at Melrose Plantation
(Yucca House), Louisiana
Palmetto leaf (?)
Diam: 21 in. (53.3 cm.); h: 9 in.
(22.9 cm.)
George E. Jordan

10 **Carved Hand Stick**
Columbus, Georgia
Wood
h: 22⅜ in. (56.8 cm.)
Professor and Mrs. David C. Driskell

11 **Flute**
North Carolina
Reed
l: 13¼ in. (33.6 cm.)
Professor and Mrs. David C. Driskell

12 Leo Moss (mid-1800s–ca. 1932)
Thelma, ca. 1900
Papier maché with glass eyes, cloth
body, composition arms and legs
h: 20 in. (50.8 cm.)
Myla Levy Perkins

13 Leo Moss (mid-1800s–ca. 1932)
Mina, 1903
Papier maché with glass eyes, cloth
body, composition arms and legs
h: 22½ in. (57.2 cm.)
Myla Levy Perkins

14 James Butler Johnson
Jewelry Box, 1936
Wood
3¼ × 8½ × 7¼ in. (8.6 × 21.6 × 18.4
cm.)
Mr. and Mrs. Joseph L. Pierce

15 **Walking Cane,** ca. 1939
Wood
l: 33¼ in. (84.5 cm.)
Dr. and Mrs. William Bascom

Joshua Johnston
1765-1830

Painter. Born a slave in Baltimore, Maryland. Attained freedom and the privilege to paint portraits.

Major Exhibitions: Peale Museum, Baltimore, 1948; Pennsylvania Academy of the Fine Arts, Philadelphia, 1961; The Metropolitan Museum of Art, New York, 1961; Walker Art Center, Minneapolis, 1962; Municipal Art Gallery, Los Angeles, 1962; M. H. DeYoung Memorial Museum, San Francisco, 1962; Cincinnati Art Museum, 1964; Art Institute of Chicago, 1964; Carnegie Institute, Pittsburgh, 1964; Dallas Museum of Fine Arts, 1964; The Baltimore Museum of Art, 1964; Philadelphia Museum of Art, 1964; Museum of Fine Arts, Boston, 1964; Detroit Institute of Arts, 1964.

Most records indicate that Joshua Johnston was the first black American to gain fame as a portraitist. From the time he appeared as a portrait painter in the Baltimore directory for 1796 to his last appearance in the directory for 1824, Johnston was a free man, for slaves were never listed in directories. Furthermore, in at least two he is specifically listed as a free man. It is believed that he was influenced by the Peale-Polk family of artists, most probably by Charles Peale Polk. Many of Polk's mannerisms appear in Johnston's portraits, which are drawn very stiffly with eyes staring forward, mouths expressionless, hands holding studio props like watering cans or baskets of fruit or flowers. Nevertheless, there is undeniable charm in Johnston's sympathetic and compositionally ambitious portraits.

16 **The McCormick Family,** 1805
Oil on canvas
50⅞ × 69⅝ in. (129.3 × 176.8 cm.)
The Maryland Historical Society

17 **Portrait of Mrs. Barbara Baker Murphy,** ca. 1810
Oil on canvas
18 × 22 in. (45.8 × 55.9 cm.)
C. R. Babe

18 **Portrait of Captain John Murphy,** ca. 1810
Oil on canvas
18 × 22 in. (45.8 × 55.9 cm.)
C. R. Babe

19 **Young Lady on a Red Sofa,** ca. 1810
Oil on canvas
30¼ × 25½ in. (76.9 × 64.8 cm.)
Collection of Mr. and Mrs. Peter H. Tillou
(See color plate, p. 82)

20 **Girl in Garden**
Oil on canvas
31½ × 26 in. (80 × 66.1 cm.)
Museum of African Art

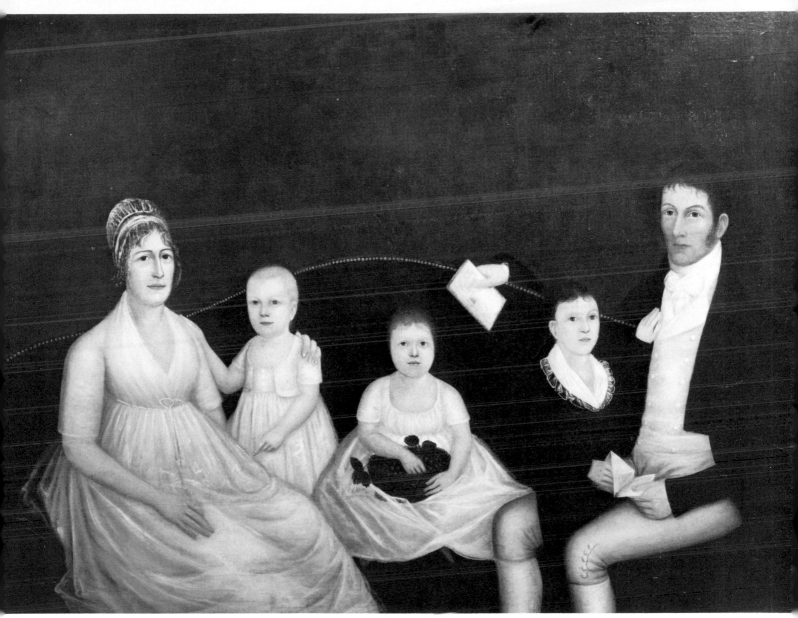

John James Audubon
1785-1851

Painter, naturalist, explorer, publisher. Born in Haiti, died in Minnie's Land, New York. Studied briefly with Jacques-Louis David and Thomas Sully. Known primarily for his sketches and watercolors of wildlife, particularly birds and reptiles, many of which were published in folio form.

Major Exhibitions: Edinburgh Royal Institution, 1826; Academy of Natural Sciences of Philadelphia, 1938; National Audubon Society, 1951; Brooks Memorial Art Gallery, Memphis, 1954; Princeton University Library, 1959; Munson-Williams-Proctor Institute, Utica, and The Pierpont Morgan Library, New York, 1965.

Unquestionably America's pre-eminent painter of North American birds and other wildlife, Audubon contributed equally to ecology and the history of art. His oils, watercolors, and pencil sketches, many of which were engraved for reproduction in both scholarly and popular journals, are of consummate artistry, and provide an invaluable record of his observations of nature.

21 **Virginian Partridge**
Engraved, printed, and colored by R. Havell, 1830
No. 16, plate 76, in **Birds of America**
24½ × 37⅛ in. (62.2 × 94.3 cm.)
Mr. and Mrs. Sidney F. Brody

Jules Lion
1810-1866

Painter, lithographer, daguerreotypist. Born in France, died in New Orleans, Louisiana. Came to America between 1836 and 1838.

Lion is listed in the 1838 city directory of New Orleans as a painter and lithographer of portraits. In 1840, he and

Pointel Duportail gave numerous lectures in New Orleans on daguerreotypes, which would indicate that they were among the first photographers in America. Little is known of Lion's career, although he apparently returned to Paris at regular intervals and is thought to have illustrated the journal *L'Artiste* in 1846. His most celebrated lithograph was his head of Audubon, which is thought to be a copy of Turner's copy of the Cruikshank miniature painted in 1831.[1]

1. From the files of George E. Jordan of New Orleans.

22 **Portrait of John J. Audubon,** 1860
Lithograph
8½ × 7⅛ in. (21.6 × 18.2 cm.)
Signed lower right
From the Collections of the Louisiana State Museum

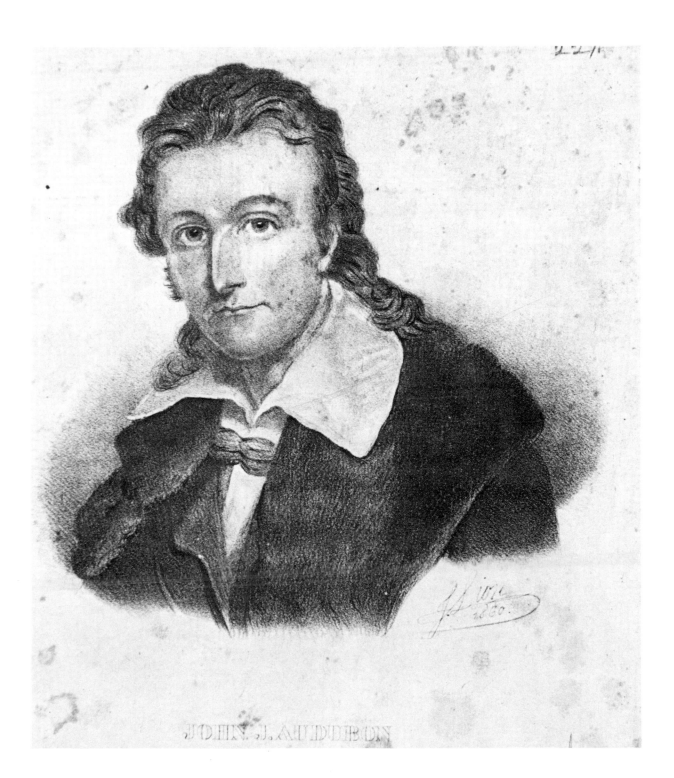

JOHN J. AUDUBON

Julien Hudson
active ca. 1830-1840

Painter. Active in New Orleans in the early nineteenth century.

What Hudson captured in *Self Portrait* was not elegance but healthy strength, good spirits, and intelligence. Drawing firmly and crisply, he modeled chiefly with clear outlines; his colors were soft local tones. He used light very broadly and simply, varying it only for emphasis. Because he eliminated all superfluous detail, his *Self Portrait* has a remote and timeless air. It seems that the bone structure of the head, the glow of life in the skin and eyes, the expression of calm and well being were what interested him and became the focus of his art.

23 **Self Portrait,** 1839
Oil on canvas
8¾ × 7 in. (22.2 × 17.8 cm.)
Signed lower right
From the Collections of the Louisiana State Museum

Patrick Reason
1817-1850

Printmaker, draftsman. Born and died in New York State. Studied at New York Free School.

Major Exhibition: Howard University Gallery of Art, Washington, D.C., 1967.

When Reason was thirteen, he designed a frontispiece for Charles C. Andrew's *History of the African Free Schools*,[1] and as a result was accepted as an apprentice by a white engraver. His works were reproduced in many periodicals and books sponsored by anti-slavery organizations. Reason's portraits of the British abolitionist Granville Sharp, Governor DeWitt Clinton of New York, James Williams, Henry Bibb, James McCune Smith, and many others were among his first works as an independent draftsman and engraver.

1. James A. Porter, *Ten Afro-American Artists of the Nineteenth Century, Howard University Gallery of Art* (Washington, D.C.: H. K. Press, 1967), p. 11.

24 **Kneeling Slave**, 1835
Engraving
3 × 2 in. (7.6 × 5.1 cm.)
Dr. Dorothy B. Porter

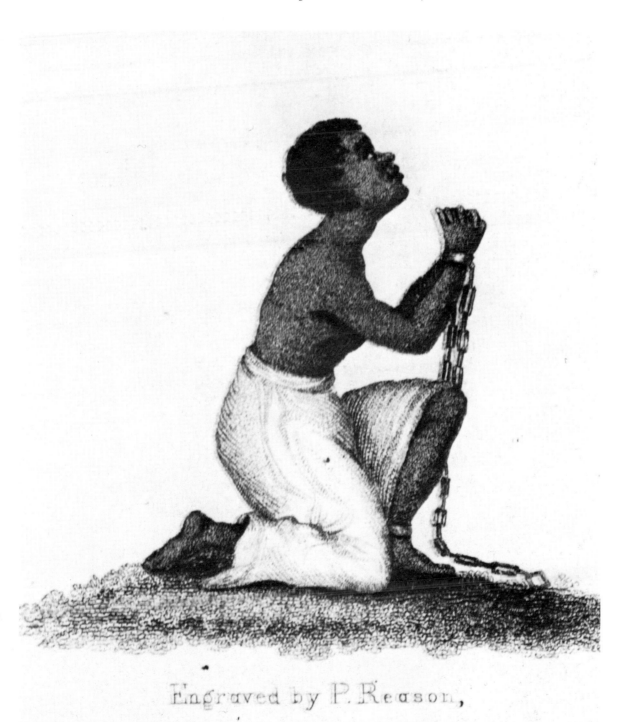

Engraved by P. Reason,

A Colored Young Man of the City of New York. 1835

Robert S. Duncanson
1821-1872

Painter. Born in New York State. Traveled to Europe in 1853, 1864, and 1870.

Major Exhibitions: Balmoral Castle, Scotland; Museum of Modern Art, New York, 1943; Detroit Institute of Arts, 1949; Denver Art Museum, 1953; Cincinnati Art Museum, 1955, 1972; Indianapolis Art Museum, 1961; Frederick S. Wight Art Gallery, UCLA, Los Angeles, 1966; Howard University Gallery of Art, Washington, D.C., 1967; La Jolla Museum of Contemporary Art, 1970; Bowdoin College Museum of Art, 1971; Museum of Fine Arts, Boston, 1972.

The first record of any activity by Duncanson is a listing of three of his paintings in an 1842 Cincinnati exhibition. Four years later William Lloyd Garrison, founder of the abolitionist journal *The Liberator*, referred to him in an article under the dateline, "Cincinnati, July 29th":

> I had a great treat last evening in the view of some portraits and fancy pieces from the pencil of a Negro, who has had no instruction or knowledge of the art. He has been working as a...house painter, and employed his leisure time in these works of art, and they are really beautiful....I saw these works in company with a lady from Nashville in whose family the wife of the artist was reared and brought up a slave.

Duncanson's passion was to translate the beauty of low, rolling hills, stretches of quiet meadow, or the poetry of the woods into a richly executed harmony of tone and color. Though the drawing is firm and knowledgeable, it remains subordinate to that overall harmony.

25 **Uncle Tom and Little Eva,** 1853
Oil on canvas
27¼ × 38¼ in. (69.3 × 97.2 cm.)
Signed lower left
The Detroit Institute of Arts
Gift of Louise Conover Butler and Grace R. Conover

26 **Portrait of Freeman G. Cary,** 1855
Oil on canvas
Mr. and Mrs. Sol Koffler

27 **Pompeii,** 1855
Oil on canvas
21 × 17 in. (53.3 × 43.2 cm.)
Signed lower left
Museum of African Art
Dr. and Mrs. Richard Frates Collection

28 **Valley Pasture,** 1857
Oil on canvas
32¼ × 48 in. (81.9 × 121.9 cm.)
Signed lower left
On loan to the Museum of African Art
From the Frank Family Collection

29 **The Rainbow,** 1859
Oil on canvas
30 × 52¼ in. (76.2 × 132.7 cm.)
Signed
Museum of African Art
Leonard Granoff Collection

30 **Falls of Minnehaha,** 1862
Oil on canvas
28 × 36 in. (71.1 × 91.4 cm.)
Museum of African Art
Lewis Glaser Collection
(See color plate, p. 83)

31 **Vale of Kashmir,** 1864
Oil on canvas
17¾ × 30 in. (45.1 × 76.2 cm.)
Signed lower left
Museum of African Art
Dr. Charles H. Mandell Collection
(See color plate, p. 84)

32 **Loch Long,** 1867
Oil on canvas
7 × 12 in. (17.8 × 30.5 cm.)
Museum of African Art
Donald J. Shein Collection

33 **Valley of Lake Pepin,** 1869
Oil on canvas
21 × 21⅝ in. (53.3 × 54.9 cm.)
Signed lower right: R.S.D.
The Cleveland Museum of Art
Gift of William Macbeth, Inc.

34 **Lough Leane,** 1870
Oil on canvas
22 × 40 in. (55.9 × 101.6 cm.)
Department of Art, Fisk University
Dr. Charles H. Mandell Collection

35 **Landscape with a View of Vesuvius and Pompeii,** 1871
Oil on canvas
10 × 18 in. (25.4 × 45.7 cm.)
Signed lower right
Museum of African Art
Lawrence H. Koffler Collection

36 **Scottish Landscape,** 1871
Oil on canvas
30 × 50¼ in. (76.2 × 127.6 cm.)
Signed
Museum of African Art
Robert H. Tessier Collection

29

36

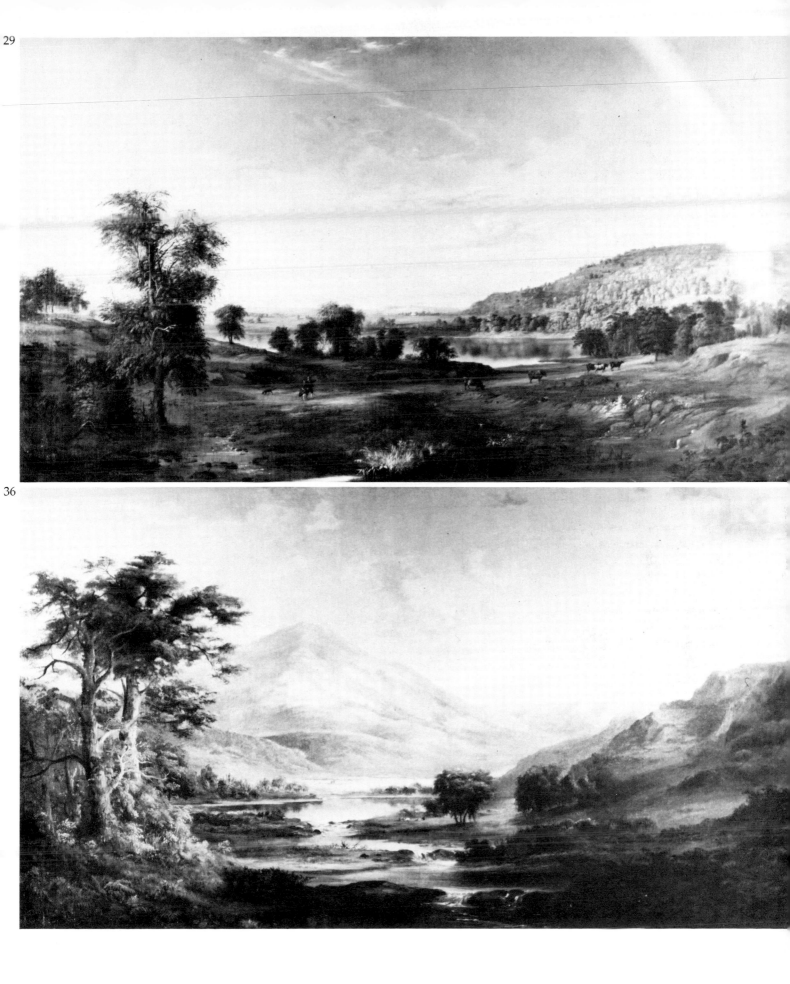

Edward Mitchell Bannister
1828-1901

Painter. Born in St. Andrews, New Brunswick. Died in Providence, Rhode Island. Studied at Lowell Institute, Boston, under William Rimmer. Went to Providence in 1871 where he opened a studio and became a regular contributor to the exhibitions of the Boston Art Club. One of the organizers of the Providence Art Club.

Major Exhibitions: Boston Art Club, 1876; Providence Art Club, 1876; Centennial Exposition, Philadelphia, 1876; Atlanta University; Rhode Island School of Design, Providence, 1913, 1971; Frederick Douglass Institute, 1966; La Jolla Museum of Contemporary Art, 1970; Howard University Gallery of Art, Washington, D.C., 1972; National Center of Afro-American Artists, New York, and Museum of Fine Arts, Boston, 1972.

W. J. Simmons declares[1] that Bannister was challenged to a professional career by a statement in the *New York Herald Tribune* of 1867 which said that "the Negro seems to have an appreciation of art, while being manifestly unable to produce it." If so, then Bannister certainly met the challenge by producing and sending to the Centennial Exposition in Philadelphia a landscape entitled *Under the Oaks*, which won a bronze medal and was later purchased by John Duff of Boston for $1500. Working primarily as a landscapist, Bannister was influenced by the painters of the Hudson River School and also those of the more lyrical Barbizon School. His works reveal the characteristics he admired in some of the traditionalist painters of the day such as William Morris Hunt (1824-1879) and William Page (1811-1885): a taste for the direct use of a heavily loaded brush; simple, broad compositions; warm but subdued color; and a somewhat generalized conception of form.

1. *William J. Simmons*, Men of Mark, Eminent, Progressive and Rising *(Cleveland: Revel, 1887), pp. 1127-31.*

37 **Newspaper Boy,** 1869
Oil on canvas
30 × 25 in. (76.2 × 63.5 cm.)
Signed lower right
Museum of African Art
Frederick L. Weingeroff Collection

38 **Oak Trees,** 1870
Oil on canvas
34 × 60 in. (86.4 × 152.4 cm.)
On loan to the Museum of African Art
From the Frank Family Collection
(See color plate, p. 85)

39 **Driving Home the Cows,** 1881
Oil on canvas
38 × 56¼ in. (101.3 × 147.1 cm.), sight
Signed and dated lower right
Museum of African Art

40 **Fishing,** 1881
Oil on canvas
30 × 50 in. (76.2 × 127 cm.)
Collection of Edward L. Shein
(See color plate, p. 86)

41 **Approaching Storm,** 1886
Oil on canvas
40 × 60 in. (101.6 × 152.4 cm.)
Museum of African Art

42 **Road to the Valley,** 1891
Oil on canvas
40 × 60 in. (101.6 × 152.4 cm.)
On loan to the Museum of African Art
From the Frank Family Collection

43 **Trees near River,** 1891
Oil on board
22 × 30 in. (55.9 × 76.2 cm.)
Signed lower right
On loan to the Museum of African Art
From the Frank Family Collection

44 **Cows**
Oil on canvas
22 × 36 in. (55.9 × 91.5 cm.)
Signed lower right
On loan to the Museum of African Art
From the Frank Family Collection

45 **Landscape**
Watercolor
Signed
Leonard Granoff

46 **Landscape**
Watercolor
Signed
Dr. Charles H. Mandell

47 **Sunny Landscape**
Oil on canvas
22 × 36 in. (55.9 × 91.4 cm.)
On loan to the Museum of African Art
From the Frank Family Collection

48 **Shepherd with Flock in Village**
Oil on canvas
30 × 50 in. (76.2 × 127 cm.)
On loan to the Museum of African Art
From the Frank Family Collection

49 **The Hay Gatherers**
Oil on canvas
18⅛ × 24⅛ in. (46 × 61.3 cm.)
Signed lower left
Dr. Norbert Fleisig

Grafton Tyler Brown
1841-1918

Painter, lithographer. Born in Harrisburg, Pennsylvania. Died in St. Paul, Minnesota.

Thought to be the first black artist in California, active from the 1860s to 1880s, working and painting mainly in California, the Nevada Territory, and the Pacific Northwest.

Major Exhibition: The Oakland Museum, 1972.

Brown is believed to have met the lithographer Charles Kuchel in Philadelphia; they later traveled to California together, where Brown joined the lithography firm of Kuchel and Dresel.

While working for the firm, Brown produced a series of lithographic views of California cities and mining towns. In 1867 he bought the Kuchel and Dresel company from Kuchel's widow, renamed it G. T. Brown & Co., and eventually sold it to W. T. Galloway in June 1879. He then traveled to Canada, painting a number of works on the way, including *Mount Tacoma (Mount Rainier)*. The primitive flatness of the figures and the reflections in the water of this landscape recall the similarities that exist between early lithography and folk art. There is little flow or sweep in Brown's *Mount Tacoma*, for each element is carefully contained within its own space. After several years in Canada, Brown traveled east, finally arriving at St. Paul, Minnesota, where he worked as a draftsman for the United States Engineers; no known lithographs or paintings have been attributed to his time there.

The above information is from The Oakland Museum archives.

50 **Mount Tacoma (Mount Rainier),** 1885
Oil on cardboard
10 × 20 in. (25.4 × 50.8 cm.)
The Oakland Museum
Gift of the Kahn Foundation

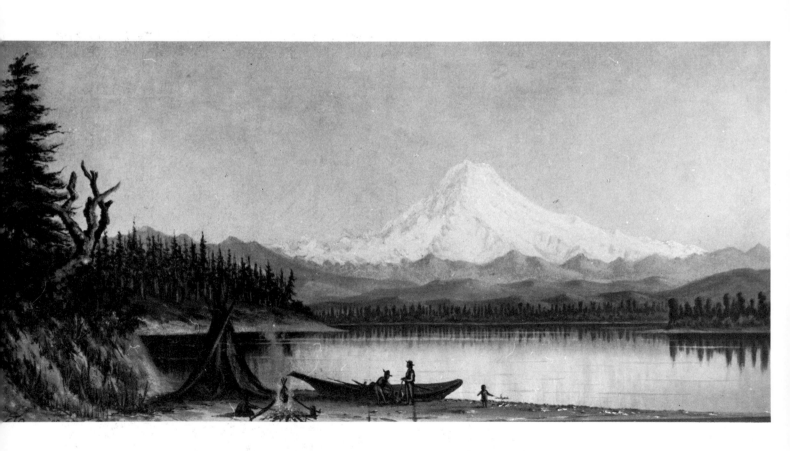

Edmonia Lewis
1843—ca. 1900

First black woman sculptor in America. Born in Albany, New York. Death date and site unknown. Studied at Oberlin College; in the studio of Edmund Brackett of Boston; in Rome under the patronage of the Story family.

Major Exhibitions: Soldiers Aid Fair, Boston, 1864; Farwell Hall Exhibition, Chicago, 1870; San Francisco Art Association, 1873; Centennial Exposition, Philadelphia, 1876; American Negro Exposition, Chicago, 1940; South Side Community Art Center, Chicago, 1945; Howard University Gallery of Art, Washington, D.C., 1967; Vassar College, Poughkeepsie, 1972.

Edmonia Lewis was half-Indian, half-black, and fiery by nature. When only fifteen years old she was falsely accused of fatally poisoning two of her white classmates at Oberlin College. The abolitionist William Lloyd Garrison came to her defense and helped her to relocate in Boston, where she opened a studio, her rebellious attitudes toward life and art unchecked. She studied in Rome with Harriet Hosmer and while there produced *Forever Free:* two figures in white marble symbolizing the meaning for black people of the abolition of American slavery. This work can properly be called the first widely publicized "propaganda art" by a black American. Although her style was neoclassical, her work incorporated both anecdotal elements and ethnological accuracies.

51 **Asleep,** 1871
Marble
h: 25 in. (63.5 cm.)
Signed on base
San Jose Public Library

52 **Awake,** 1872
Marble
h: 24 in. (60.9 cm.)
Signed on base
San Jose Public Library

53 **Hagar,** 1875
Marble
h: 52 in. (132.1 cm.)
Museum of African Art

52

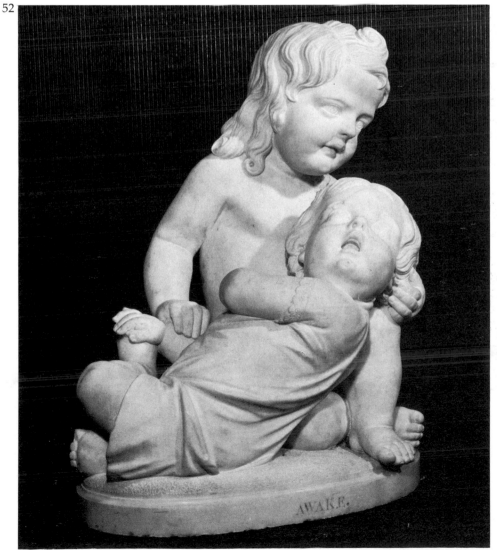

Henry Ossawa Tanner
1859-1937

Painter, illustrator, photographer, educator. Born in Pittsburgh, Pennsylvania. Died in Paris, France. Entered Pennsylvania Academy of the Fine Arts in 1880, where he was Thomas Eakins' only black student. Exhibition of his works in Cincinnati ca. 1890 arranged by Bishop and Mrs. Hartzell, who bought entire exhibition for $300. With this money and his savings left for Europe in January 1891 and studied in Paris under Jean Joseph Benjamin Constant and Jean-Paul Laurens. Returned to Philadelphia briefly in 1892 before settling in Paris permanently. Exhibited at the Salons from 1894 to 1900 and received an honorable mention for *Daniel in the Lions' Den* in the Salon of 1896. Traveled and painted throughout the Holy Land, then returned to France where he was made a Chevalier of the Legion of Honor.

Major Exhibitions: Pennsylvania Academy of the Fine Arts, Philadelphia, 1888, 1889, 1898, 1906; Methodist Headquarters, Cincinnati, 1890; National Academy of Design, New York, 1891; Earse's Galleries, Philadelphia, 1892-93; Salon des Artistes Français, Paris, 1894-1924; Paris Salon, 1894-1900; Luxembourg Gallery, Paris, 1897 (the French government purchased the *Raising of Lazarus* for the gallery in 1897); Salon de la Société des Artistes Français, Paris, 1900; Universal Exposition, Paris, 1900; 12th Annual Exhibition of the Philadelphia Art Club, 1900; Pan-American Exposition, Buffalo, 1901; Louisiana Purchase Exposition, 1904; Exhibition of the Society of American Artists, 1904; St. Louis Exposition, 1905; Carnegie Institute Annual Exhibition, Pittsburgh, 1905, 1908; Art Institute of Chicago, 1906; American Art Galleries, New York, 1908; Thurber's Gallery, Chicago, 1911; Knoedler's Gallery, New York, 1913; Anglo-American Art Exhibition, London, 1914; Panama-Pacific Exposition, San Francisco, 1915; Los Angeles County Museum, 1920; Grand Central Art Galleries, New York, 1920, 1930, 1967-68; New York Public Library, 1921; Vose Galleries, Boston, 1921; Tanner Art League, Dunbar High School, Washington, D.C., 1922; National Arts Club, New York, 1927, 1967; American Artists Professional League, Simonson Galleries, Paris, 1933; Century of Progress, Chicago, 1933-34; Howard University Gallery of Art, Washington, D.C., 1945, 1967, 1970; Philadelphia Art Alliance, 1945; Xavier University, New Orleans, 1963; Frederick S. Wight Art Gallery, UCLA, Los Angeles, 1966; City College of New York, 1967; Harlem Cultural Council, 1967; New York Urban League, 1967; Morgan State College, Baltimore, 1967; Spelman College, Atlanta, 1969; Smithsonian Institution, Washington, D.C., 1969-70; Philadelphia Civic Center, 1970; University Art Museum, Austin, 1970.

"Like Van Gogh, Tanner manipulated his artistic devices, not to copy the facts of nature, but to effect a mood. His freedom from strictly rendered naturalistic forms, his sacrifice of perspective and mass to achieve an almost flat, richly textured picture surface, and his strong interest in color and coloristic effects, is not too far removed from the style of a Van Gogh or of a Vuillard."[1]

In *The Good Shepherd*, an expressive use of light and color and the magic suggestiveness of Tanner's technique are combined with a selective simplicity of setting to help convey the full impact of the scene. By isolating the shepherd in a luminous field Tanner has focused the viewer's gaze directly on the figure.

1. *James K. Kettlewell, The Art of Henry O. Tanner (Glens Falls, N.Y.: Hyde Collection), p. 12.*

54 **The Two Disciples at the Tomb,** 1906
Oil on canvas
51 × 41⅞ in. (129.5 × 106.5 cm.)
Signed lower right
Art Institute of Chicago
Robert A. Waller Fund

55 **The Three Marys,** 1910
Oil on canvas
42 × 50 in. (106.7 × 127 cm.)
Signed lower right
Department of Art, Fisk University
(See color plate, p. 87)

56 **The Good Shepherd**
Oil on canvas
20⅛ × 24⅛ in. (51.1 × 61.3 cm.)
Signed lower right
New Orleans Museum of Art
Museum Purchase

57 **Daniel in the Lions' Den,** ca. 1916
Oil on paper, on canvas
41¼ × 50¼ in. (104.8 × 127.7 cm.)
Signed lower right
Los Angeles County Museum of Art
Mr. and Mrs. William Preston Harrison Collection
(See color plate, p. 88)

56

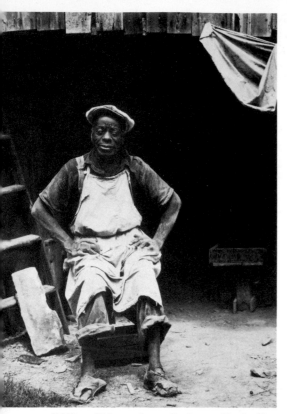

William Edmondson, Sculptor, Nashville, 1941. Photograph by Edward Weston, Los Angeles County Museum of Art.

William Edmondson
1882-1951

Stonecutter and sculptor. Born and died in Nashville, Tennessee. Worked at the Nashville, Chattanooga, and St. Louis railway shops until 1907 and at the Woman's Hospital, Nashville, until 1931 or 1932, when he began stonecutting.

Major Exhibitions: Museum of Modern Art, New York, 1937 (one-man); Tennessee Botanical Gardens and Fine Arts Center, Nashville, 1964-65; City College of New York, 1967; La Jolla Museum of Contemporary Art, 1970; The Newark Museum, 1971; Montclair Art Museum, 1975.

Edmondson often chose stones of such shape that the final sculptured form seems only barely freed from its original matrix. An affectionate warmth of feeling, almost of humor, often characterizes his unpretentious and charming sculpture. Works of naive folk artists such as Edmondson provide refreshing reminders of the magic of direct, unsophisticated expression.

"This here stone and all those out there in the yard come from God. It's the work in Jesus speaking His mind in my mind. I must be one of His disciples. These here is miracles I can do. Can't nobody do these but me. I can't help carving. I just does it. It's like when you're leaving here you're going home. Well, I know I'm going to carve. Jesus has planted the seed of carving in me."[1]

1. Edmund L. Fuller, Visions in Stone: The Sculpture of William Edmondson *(Pittsburgh: University of Pittsburgh Press, 1973), p. 3.*

58 **Eve**
Limestone
h: 32 in. (81.3 cm.)
Tennessee Botanical Gardens and Fine Arts Center
Gift of Mrs. Alfred Starr

59 **Hospital Nurse**
h: 14½ in. (36.8 cm.)
Tennessee Botanical Gardens and Fine Arts Center
Gift of John Thompson

60 **Nude Man Seated on a Stool**
Limestone
h: 21½ in. (62.2 cm.)
Tennessee Botanical Gardens and Fine Arts Center
Gift of John Thompson and Mrs. Con Ball

61 **Nude Woman Seated on a Stool**
Limestone
h: 28½ in. (72.4 cm.)
Tennessee Botanical Gardens and Fine Arts Center
Gift of Mrs. Alfred Starr

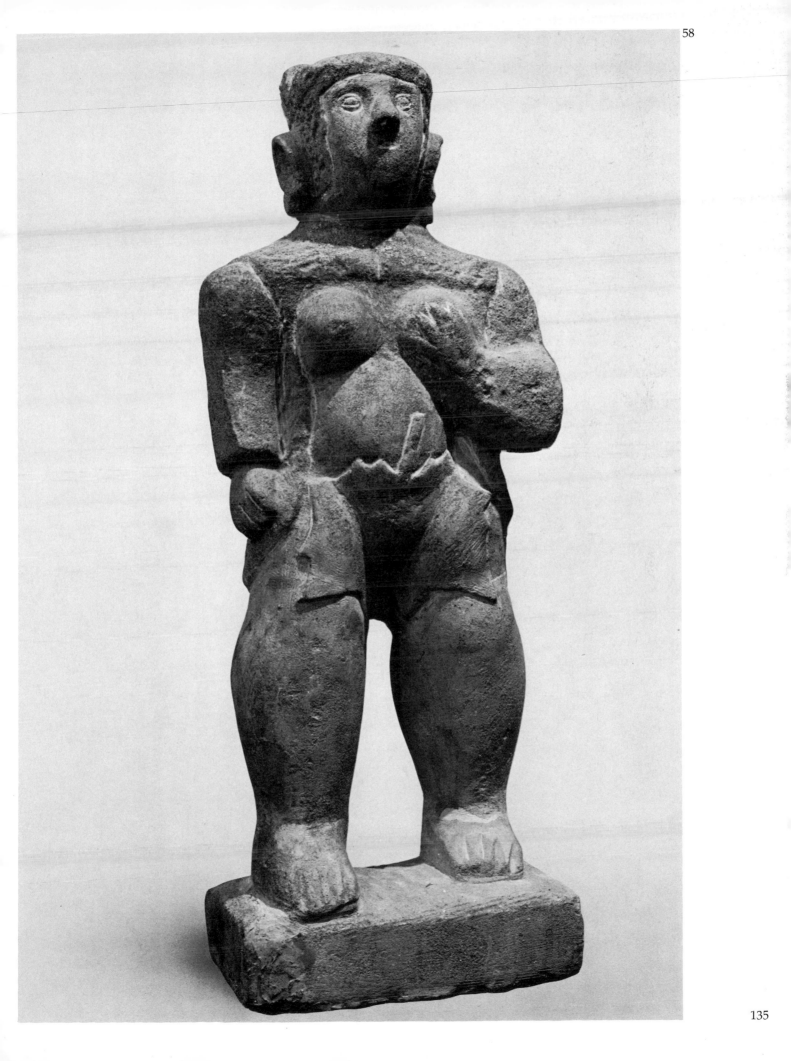

Edwin A. Harleston
1882-1931

Painter. Born and died in Charleston, South Carolina. Studied at Atlanta University, B.A., 1904; School of Museum of Fine Arts, Boston, 1906-12; Harvard University, Cambridge. Won the Locke Portrait Prize in 1930 for *The Old Servant*.

Major Exhibitions: Harmon Foundation, New York, 1928, 1931, 1936; National Gallery of Art, Washington, D.C., 1930, 1933; Howard University Gallery of Art, Washington, D.C., 1935, 1937; Texas Centennial Exposition, Museum of Fine Arts, Dallas, 1936; South Side Community Art Center, Chicago, 1941, 1945; Downtown Gallery, New York, 1942; City College of New York, 1967.

The charm of Harleston's skillfully painted genre scenes made him one of the most popular and influential black painters of his day. A facile painter, he combined in much of his work the clear color and ingenious arrangements of the Impressionists with the adroit brushwork and fresh, luminous paint of the Munich school. In *The Old Servant*, Harleston has given his introspective subject a sense of substance by firmly modeling the few simple rounded volumes of the woman's head and dress. Nevertheless the painting has a sketchlike quality, due in part to Harleston's use of a technique that sometimes blurs the contour of the figure.

62 **Portrait of Aaron Douglas,** 1930
Oil on canvas
31½ × 27½ in. (80 × 69.9 cm.)
Mrs. Edwina Harleston Whitlock

63 **The Old Servant,** 1930
Oil on canvas
24¹/₁₆ × 20⅞ in. (61.2 × 53 cm.)
Signed lower right
Mr. and Mrs. Earl Grant

63

Clementine Hunter
b. 1883

Painter. Born on Little Eva Plantation in Natchitoches, Louisiana. Began painting in the 1930s after years of picking cotton and cooking in the kitchen of the Melrose Plantation, which was then a haven for many artists.

Major Exhibitions: The Saturday Gallery, St. Louis, 1954; Delgado Art Museum, New Orleans, 1955; Grambling University, 1970; La Jolla Museum of Contemporary Art, 1971; Fisk University, Nashville, 1974; Barnwell Center, Shreveport, 1975; Louisiana State Library, permanent exhibition.

While many American artists are working in varying styles and degrees of sophistication, the folk artists continue to paint naive versions of the American scene for their own pleasure. The true folk artist speaks as a child in ideographic rather than observed and controlled images, and Clementine Hunter is such an artist. The flat, two-dimensional images and patterns of local rather than atmospheric color in her paintings trigger responses similar to those elicited by the works of William Johnson and Horace Pippin. In *The Funeral on Cane River*, Hunter's intent was to record reality as clearly and accurately as possible, avoiding any set formula. Lacking a mastery of volume and unable to convey the properties of light and color by her brushstrokes, Hunter uses linear contours to establish the essential, unbroken identity of the scene.

64 **The Funeral on Cane River,** ca. 1948
Oil on wallboard
15 × 20 in. (38.1 × 50.8 cm.)
Signed lower left: C. H.
Mrs. Ora G. Williams
(See color plate, p. 89)

65 **Cotton Ginning,** 1975
Oil on wallboard
12½ × 47½ in. (31.7 × 120.7 cm.)
Signed far right: reversed C. H.
Mrs. Ora G. Williams

65

William Edward Scott
1884-1964

Painter, illustrator, muralist. Born in Indianapolis, Indiana. Studied at the Art Institute of Chicago, 1904-8; Julian and Colarossi Academies in Paris under Tanner.

Major Exhibitions: Royal Academy, London, 1912; Harmon Foundation, New York, 1928, 1931, 1933; Autumn Salon de Paris, 1931; Salon la Tourquet, Paris, 1931; Art Institute of Chicago, 1931, 1932; Cincinnati Art Museum, 1931; San Diego Museum, 1931, Los Angeles County Museum, 1931; Port-au-Prince, 1931 (one-man); Johannesburg, South Africa, 1932; Murals for public buildings in Indiana, West Virginia, and New York

YMCA, 1932; Smithsonian Institution, Washington, D.C., 1933; Harmon Foundation—CAA Traveling Exhibition, 1934-35; Findlay Galleries, Chicago, 1935; Salon des Beaux-Arts, Toquet, 1935; New Jersey State Museum, Trenton, 1935; Texas Centennial Exposition, Museum of Fine Arts, Dallas, 1936; American Negro Exposition, Chicago, 1940; South Side Community Art Center, Chicago, 1941, 1945; Howard University Gallery of Art, Washington, D.C., 1945, 1970.

One of the many American artists to travel abroad during the twenties, William Scott went to Paris to study with Henry Tanner. He acquired from him a disciplined knowledge of traditional techniques, a love for the human figure, and a respect for direct observation. After enjoying the unrestricted life of an artist, Scott's perceptions of the life he had left were sharpened and when he returned to America, he devoted the rest of his career to portraying the people he saw—fishermen in Haiti, black workmen, children with animals—with a compassionate realism.

66 **Man with Baskets,** 1930
Oil on canvas
22 × 18 in. (55.9 × 45.7 cm.)
Signed lower left: W. E. Scott
Collection of Mr. and Mrs.
R. K. Van Zandt

67 **Haitian Market,** 1950
Oil on canvas
20 × 40 in. (50.8 × 101.6 cm.)
Department of Art, Fisk University
(See color plate, p. 90)

James V. Herring
1887-1969

Artist, educator. Born in Clio, South Carolina, died in Washington, D.C. Studied at Howard University, Washington, D.C.; Syracuse University; Crouse College of Fine Arts, Syracuse University; Columbia College, Columbia University, New York; Fogg Museum, Harvard University, Cambridge. In 1930 at Howard University organized the first American art gallery to be directed and controlled by blacks; also founded the art department at that university. With Alonzo Aden opened the Barnett-Aden Gallery in Washington, D.C., in 1943.

Like Manet, Degas, and other French painters, including Daubigny (1817-1878), Cogniet (1794-1880), and Monet (1840-1926), Herring painted the colorful aspects of life around him without stressing symbolic or moral values. This is most evident in *Campus Landscape*, which exemplifies the highly personal style of his oils—a mosaic of flat planes that are built up into a tapestrylike surface of rich color. In *Campus Landscape* the composition relies on strong vertical and horizontal relationships, with a generalized simplification of form. For Herring the world was a rich visual fabric in which the human element was only part of a vast pattern.

68 **Campus Landscape,** 1924
Oil on canvas
12 × 10 in. (30.5 × 25.4 cm.)
Professor and Mrs. David C. Driskell
(See color plate, p. 91)

Sargent Johnson
1887-1967

Sculptor, ceramist, printmaker. Born in Boston, Massachusetts, died in San Francisco, California. Studied at California School of Fine Arts, San Francisco; Boston School of Fine Arts; A. W. Best School of Art, San Francisco; studied under Benjamino Bufano and Ralph Stackpole.

Major Exhibitions: Harmon Foundation, New York, 1926, 1928, 1933, 1935; Harmon Foundation—CAA Traveling Exhibition, 1927, 1931; National Gallery of Art, Washington, D.C., 1929; San Francisco Art Association, 1929, 1935, 1936, 1938, 1952; Oakland Municipal Art Gallery, 1930, 1931; Harlem Art Center, 1933; California Palace of the Legion of Honor, San Francisco, 1940; San Francisco Museum of Art, 1945; M. H. DeYoung Memorial Museum, San Francisco, 1965; La Jolla Museum of Contemporary Art, 1970.

Working with wood, terra cotta, fired clay, and, in the piece *Forever Free*, lacquered cloth, Johnson approaches the human figure with a passionate desire to realize the uniqueness of each subject. His highly individualized figures communicate his belief in the separate identity of each living being, regardless of contemporary pressure toward conformity. *Forever Free* has a strength and a validity, evoking compassionate concern as we realize how little of beauty, grace, and heroism make up the tenor of daily existence. Seldom are attitudes and gestures caught with such strength.

69 **Mask,** ca. 1930
Copper, wood base
15½ × 13½ × 6 in. (39.4 × 34.3 × 15.2 cm.)
National Collection of Fine Arts
Smithsonian Institution

70 **Forever Free,** 1933
Lacquered cloth over wood
h: 36 in. (91.5 cm.)
San Francisco Museum of Art
Gift of Mrs. E. D. Lederman
(See color plate, p. 92)

71 **Standing Woman,** ca. 1934
Terra cotta
h: 15⅜ in. (39 cm.)
Collection of The Oakland Museum
Lent by the WPA Department of the U.S. Government Service Administration, Courtesy of the M. H. DeYoung Memorial Museum

72 **The Walking Man, He's Going Places,** ca. 1965
Black fired clay, on wood base
h: 11½ in. (29.2 cm.)
The Oakland Museum
Matthew Pemberton Collection

72

Laura Wheeler Waring
1887-1948

Painter, illustrator, educator. Born in Hartford, Connecticut, died in West Chester, Pennsylvania. Studied at the Pennsylvania Academy of the Fine Arts, Philadelphia, 1918-24; Grand Chaumière, Paris, 1924-25.

Major Exhibitions: Philadelphia Civic Center and Harmon Foundation, 1927-28, 1930-31; Art Institute of Chicago, 1933; Smithsonian Institution, Washington, D.C., 1933; Pennsylvania Academy of the Fine Arts, Philadelphia, 1935, 1938; Texas Centennial Exposition, Museum of Fine Arts, Dallas, 1936; Howard University Gallery of Art, Washington, D.C., 1937, 1939; American Negro Exposition, Chicago, 1940; Corcoran Gallery of Art, Washington, D.C.; New York Watercolor Exhibition.

Laura Wheeler Waring painted with a realism revealing not only her scrupulous objectivity, but the serene affection with which she regarded her subjects. In fact, it is this projection of regard and warmth as well as her flair for depicting colorful personalities that distinguishes her work from that of other black portraitists of her day. Her most characteristic paintings are direct, rather broadly brushed portraits. In her compassionate portrait of the artist Alma Thomas, Waring's usual preference for full color has given way to a use of dramatic dark tonalities.

73 **Alma,** 1945
Oil on canvas
39 × 29½ in. (99.1 × 74.9 cm.)
Alma W. Thomas
(See color plate, p. 93)

Horace Pippin
1888-1946

Sculptor, painter. Born and died in West Chester, Pennsylvania. Completed his first painting at forty-three years of age.

Major Exhibitions: West Chester Community Center, 1937; Museum of Modern Art, New York, 1938; Carlen Galleries, Philadelphia, 1940; Bignou Gallery, New York, 1940; American Negro Exposition, Chicago, 1940; Arts Club of Chicago, 1941; Downtown Gallery, New York, 1941; South Side Community Art Center, Chicago, 1941; San Francisco Museum of Art, 1942; Carnegie Institute, Pittsburgh, 1944; Atlanta University, 1944; Howard University Gallery of Art, Washington, D.C., 1945; Knoedler Galleries, New York, 1947; Walker Art Center, Minneapolis, ca. 1950.

After spending fourteen months in the trenches during World War I, Horace Pippin was wounded in his right shoulder, and his arm was considered useless. However, using his left hand to prop up his right, he began to paint, and in three years had completed his first painting: *End of the War–Starting Home.* His first group of paintings all dealt with his striking memories and impressions of the war. They have the simplicity of the self-taught artist, with the color applied mostly in flat areas. There is also a very obvious feeling for design that characterizes work by most of the better "primitives." Pippin's later works are regimented into precisely patterned areas that are intensified by accents of pure white. "Pictures just come to my mind," he once explained, "and I tell my heart to go ahead,"[1] a description of his innocent art that needs no further comment.

1. *E. P. Richardson,* Painting in America: The Story of 450 Years, *exhibition at the Detroit Institute of Arts (Cornwall, N.Y.: Cornwall Press, Inc., 1956), p. 389.*

74 **Fall Landscape,** 1940
Oil on wood with woodburning
10 × 19⅝ in. (25.4 × 49.9 cm.)
Signed lower right
Hirshhorn Museum and
Sculpture Garden
Smithsonian Institution

75 **Domino Players,** 1943
Oil on panel
12¾ × 22 in. (32.5 × 55.9 cm.)
Signed lower right
The Phillips Collection

76 **Christmas Morning Breakfast,** 1945
Oil on canvas
21 × 26¼ in. (53.4 × 66.7 cm.)
Signed lower right
Cincinnati Art Museum
The Edwin and Virginia Irwin
Memorial Fund
(See color plate, p. 94)

77 **Holy Mountain No. 3,** 1945
Oil on canvas
25¼ × 30¼ in. (64.1 × 76.9 cm.)
Signed lower right
Hirshhorn Museum and
Sculpture Garden
Smithsonian Institution

78 **Saturday Night Bath,** 1945
Oil on canvas
25 × 30 in. (63.5 × 76.3 cm.)
Signed lower right
University of California, Los Angeles
Gift of Arthur Freed

79 **Night Call**
Oil on canvas
28 × 32 in. (71.1 × 81.3 cm.)
Signed lower right
Museum of Fine Arts, Boston
Abraham Shuman Fund

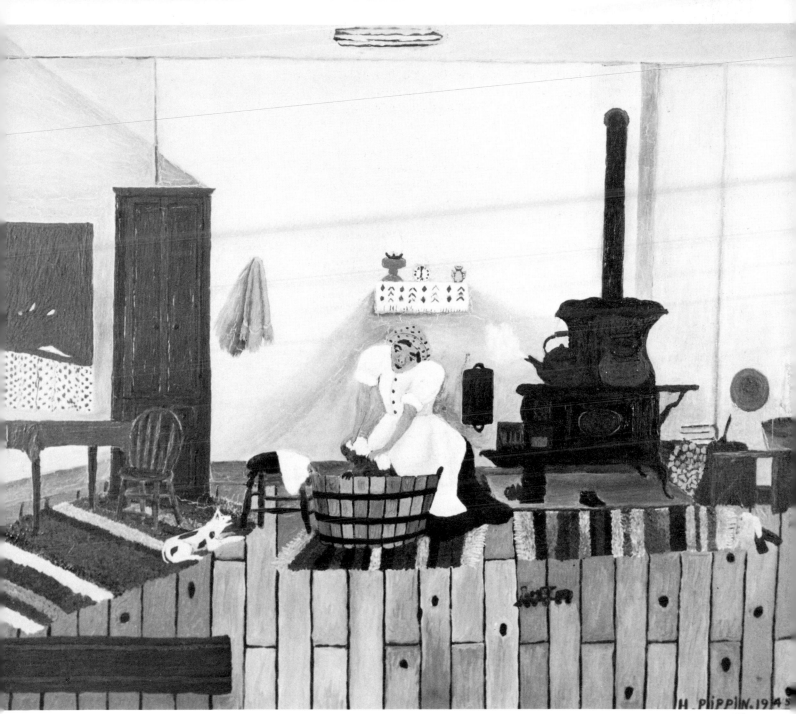

78

Archibald J. Motley, Jr.
b. 1891

Painter. Born in New Orleans, Louisiana. Studied under Karl Buehler, and Norton and Krehbiel at the Art Institute of Chicago.

Major Exhibitions: Harmon Foundation, New York, 1929, 1931; Guggenheim Fellows Exhibition, New York, 1931, 1933; American Scandinavian Exhibition, 1931; Art Institute of Chicago, 1932, 1934; Smithsonian Institution, Washington, D.C., 1933; Toledo Museum, 1934; Corcoran Gallery of Art, Washington, D.C., 1934; Howard University Gallery of Art, Washington, D.C., 1937, 1938, 1945; The Baltimore Museum of Art, 1939; Library of Congress, Washington, D.C., 1940; La Jolla Museum of Contemporary Art, 1970.

Archibald Motley's deep need to create an art of intense reality out of the familiar world led him to abandon international styles of experimental painting for genre scenes of black people. Even after he found the subject matter of his mature years in the life of the city, Motley's sensitivity to the quality of light, whether electrical, dawn, or dusk, remained one of the elements of his art. Architecture, too, plays a role in Motley's work by providing a setting for the drama that is always implied in his paintings. Never melodramatic, they describe the routines of everyday living, with the human factor ever present. This distinguishes Motley's paintings from those of most of his contemporaries and gives them an added importance. One is keenly aware of life going on behind the facades of his buildings—life in all its loneliness, ugliness, affection, and nobility. Archetypes of commonplace existence, each Motley painting sums up myriad familiar visual experiences and from them creates a powerful work of art.

80 **Portrait of My Grandmother,** 1922
Oil on canvas
24 × 38 in. (60.9 × 96.5 cm.)
Signed lower right
Collection of the artist

81 **Mending Socks,** 1924
Oil on canvas
43¾ × 40 in. (111.2 × 101.6 cm.)
North Carolina Museum of Art
North Carolina Collection
University of North Carolina Library
(See color plate, p. 95)

82 **Stomp,** 1927
Oil on canvas
30 × 36 in. (76.2 × 91.5 cm.)
Collection of the artist

83 **Brown Girl after the Bath**
Oil on canvas
48⅜ × 36 in. (122.9 × 91.5 cm.)
Signed lower left
Collection of the artist

84 **Bronzeville at Night,** 1949
Oil on canvas
30 × 40 in. (76.2 × 101.6 cm.)
Collection of the artist

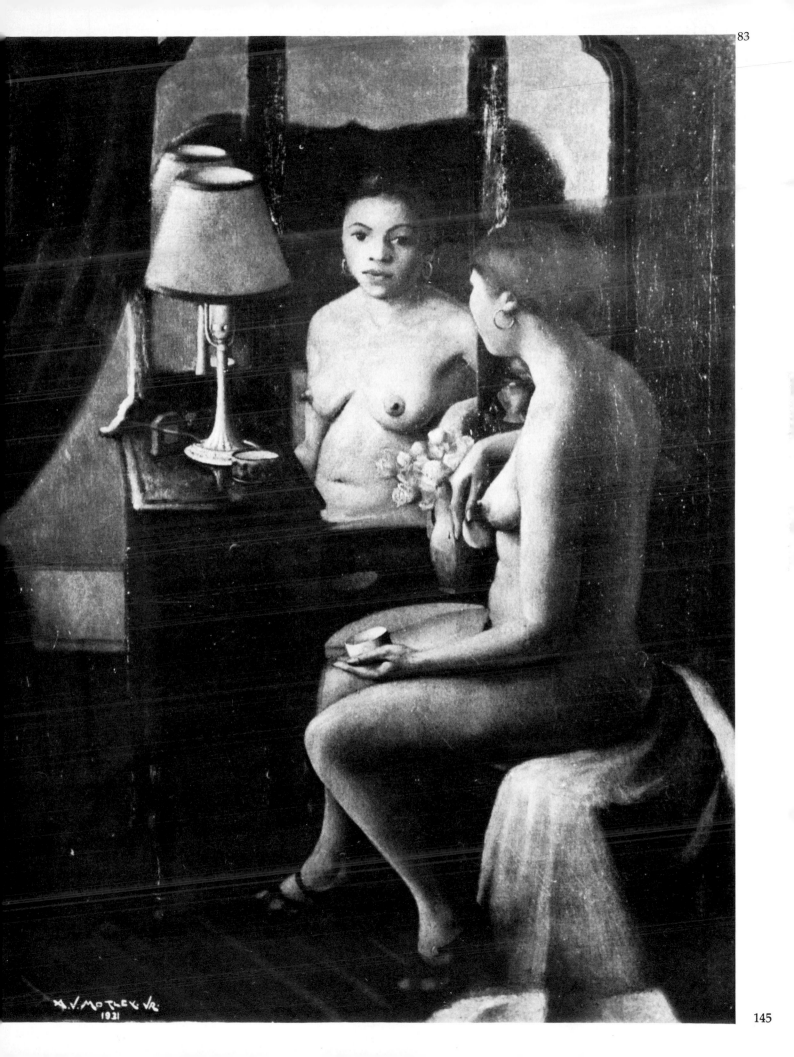

A.V. MOTLEY JR.
1931

Minnie Evans
b. 1892

Painter. Born in a log cabin in Long Creek, Pender County, North Carolina. Completed her first work in 1935.

Major Exhibitions: Little Gallery in Wilmington, North Carolina, 1966; Church of the Epiphany and St. Clement's Episcopal Church, New York, 1966; The Art Image, New York, 1969; Wesleyan University, Middletown, Connecticut, 1969; Portal Gallery, London, 1970; Indianapolis Museum of Art, 1970; St. John's Art Gallery, North Carolina, 1970; American Federation of the Arts circulating exhibition, 1970-72; Museum of Modern Art, New York, 1972; Studio Museum, Harlem, 1973; Whitney Museum of American Art, New York, 1975.

"Minnie Evans has scant explanation for any of her imagery or symbols. In fact she has said 'My work is just as strange to me as they are to someone else.'"[1] In *Design Made at Airlie Garden*, she has used some of her familiar elements: faces with large eyes, flowers, multicolored mandalalike frames of scalloped foliage. All of these are characteristic images used to enforce the symmetry of her work. Her love for the Bible, particularly the book of Revelations with its colorful descriptions of all manner of natural and supernatural phenomena, provides at least a clue to some of her imagery.

1. *Nina Howell Starr,* Minnie Evans, *Whitney Museum of American Art, July 3-August 3, 1975, p. 2.*

85 **Design Made at Airlie Garden,** 1967
Oil and mixed media on canvasboard
19¾ × 23¾ in. (50.2 × 60.4 cm.)
Signed lower right corner
National Collection of Fine Arts
Smithsonian Institution
(See color plate, p. 96)

Palmer Hayden
1893-1973

Painter. Born in Widewater, Virginia, died in New York City. Studied at Cooper Union, New York; Boothbay Colony, Maine, under Asa G. Randall; under M. Clivett LeFevre in Brittany, France, 1927-32.

Major Exhibitions: Civic Club, New York, 1926; Harmon Foundation, New York, 1928-33; Smithsonian Institution, Washington, D.C., 1929, 1933; Independent Artists in New York, 1933; Colonial Exposition, Paris, 1933; Cooperative Art Market, New York, 1933; Harlem Art Center, New York, 1933; Commodore Hotel, New York, 1934; Nicholas Roerich Museum, New York, 1934; Texas Centennial Exposition, Museum of Fine Arts, Dallas, 1936; Howard University Gallery of Art, Washington, D.C., 1937; Galerie Bernheim-Jeune, Paris, 1937 (one-man); The Baltimore Museum of Art, 1939; American Negro Exposition, Chicago, 1940; Atlanta University, 1940, 1944; City College of New York, 1967; Whitney Museum of American Art, New York, 1967.

Midsummer Night in Harlem is not comfortably clear-cut geometry, but rather the shabby rectangularity of everyday life, with its chipped corners, leaning verticals, and prophetically sagging horizontals. Yet there is nothing depressing in the vision, for Hayden was not cynical about life; this commonplace world is seen with dignity and enriched with feeling. The ponderous mass of figures establishes the actual scale of the exterior. The figures and spaces are solid realities, weighty, voluminous, tangible. It is the light that provides the drama, the mood, the human dream. Many ordinary impressions register in one's mind each day, where they remain dormant, unanalyzed, potentially a reservoir of deep feeling. Palmer Hayden, like Archibald Motley, has the rare ability to cast these impressions into memorable, monumental images.

86 **Blue Nile**, 1964
 Watercolor
 19 × 26½ in. (48.3 × 67.3 cm.)
 Signed lower right
 Mrs. Palmer Hayden

87 **Midsummer Night in Harlem**
 Oil on canvas
 25 × 30 in. (63.5 × 76.2 cm.)
 Signed lower left
 Mrs. Palmer Hayden
 (See color plate, p. 97)

88 **When Trickey Sam Shot Father Lamb**
 Oil on canvas
 30½ × 39⅞ in. (77.5 × 101.3 cm.)
 Signed lower left
 Mrs. Palmer Hayden

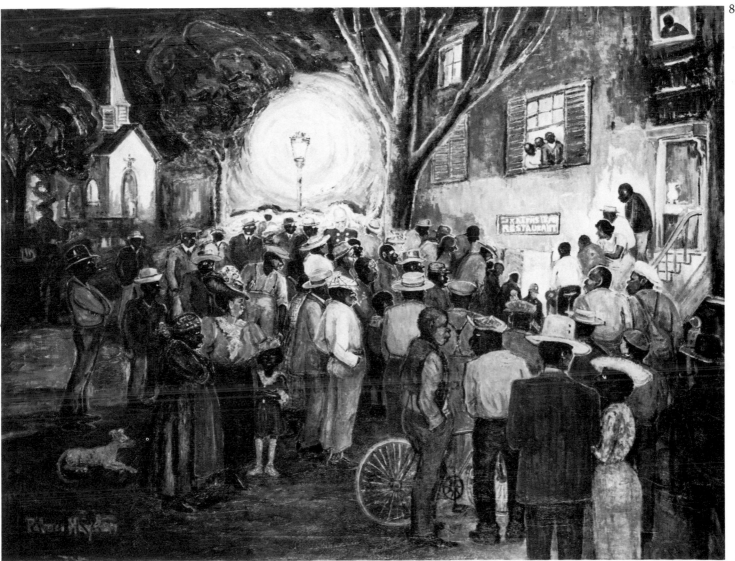

88

Dox Thrash
b. 1893

Painter, printmaker, co-inventor of the carborundum print process. Born in Griffin, Georgia. Studied art through correspondence school until 1909. After the war, studied at the Art Institute of Chicago, 1919-22, under Seyffert, Naughton, and Poole. Also studied black and white media under Earl Horter of Graphic Sketch Club, Philadelphia. Worked on Pennsylvania Federal Art Project, 1939-40.

Major Exhibitions: Graphic Sketch Club, Philadelphia, 1933, 1934, 1935; Pennsylvania Academy of the Fine Arts, Philadelphia, 1934, 1935, 1938, 1939; Federal Art Project Exhibition, Corcoran Gallery of Art, Washington, D.C., 1935; Carnegie Institute, Pittsburgh, 1937, 1938; Philadelphia Civic Center Museum, 1939; New York World's Fair, 1939-40; American Negro Exposition, Chicago, 1940; South Side Community Art Center, Chicago, 1941; Atlanta University, 1942; Howard University Gallery of Art, Washington, D.C., 1970.

In *Untitled,* an etching of a navy ship christening during World War II, a variety of vital points are accented: the white area to the right of center signifying the breaking of the champagne bottle; the battle shield on top of the ship, representing the country; the rather menacing scowl of the ship itself; the animated figures surrounding the ship, heightening the air of excitement.

Despite the bustling activity and festive atmosphere there is an underlying sense of the ship's real purpose and the grimness of its future duties.

89 **Untitled**
Carborundum etching
10⅞ × 8 in. (27.7 × 20.3 cm.)
Private collection

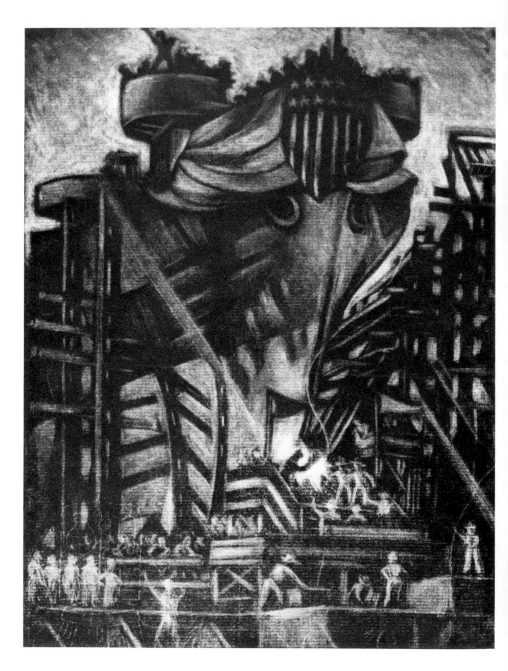

Malvin Grey Johnson
1896-1934

Painter. Born in Greensboro, North Carolina. Studied at National Academy of Design, New York, under F. C. Jones.

Major Exhibitions: Harmon Foundation, New York, 1928, 1929, 1931, 1933, 1935; Smithsonian Institution, Washington, D.C., 1929; Anderson Galleries, 1931; Washington Square Outdoor Exhibition, New York, 1932; Cooperative Art Market, New York, 1933; Salons of America, New York, 1934; Corcoran Gallery of Art, Washington, D.C., 1934; Nicholas Roerich Museum, New York, 1934; New Jersey State Museum, Trenton, 1935; Texas Centennial Exposition, Museum of Fine Arts, Dallas, 1936; Howard University Gallery of Art, Washington, D.C., 1939; The Baltimore Museum of Art, 1939; American Negro Exposition, Chicago, 1940; Library of Congress, Washington, D.C., 1940; Institute of Contemporary Art, Boston, 1943.

Johnson's deceptively simple canvases, radiating a serenely sensuous charm, attracted a loyal following among critics and collectors.[1] His paintings are typically composed with human figures dominating all other elements. Johnson learned much about color and the power of simplification, and his angular forms and strongly organized compositions are carefully calculated and less frankly decorative than those by many of his contemporaries. His *Self Portrait* is enriched by the piquant, slightly ominous slit-eyed masks in the background which, with their primitive, almost cubistic rendering, exemplify the artist's own African heritage and seem to duplicate his countenance.

1. *James A. Porter,* Negro Artists, *Harmon Foundation, April-May, 1935, pp. 6-9.*

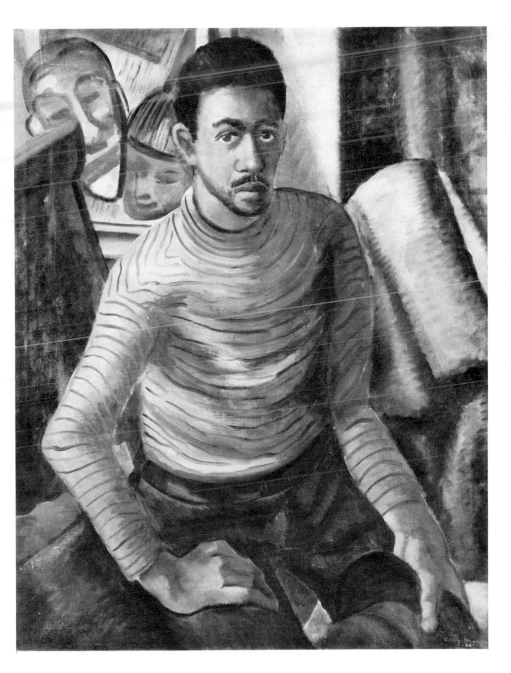

90 **Self Portrait,** 1934
Oil on canvas
38¼ × 30 in. (97.2 × 76.2 cm.)
National Collection of Fine Arts
Smithsonian Institution

Alma W. Thomas
b. 1896

Painter, educator, gallery director. Born in Columbus, Georgia. Studied at Howard University, Washington, D.C., and was the first, and only, student to graduate in 1924 from the Art Department. Columbia University, New York, M.F.A., 1934; American University, Washington, D.C.; Creative Painting, under Summerford, Gates, and Kainen, 1950-60.

Major Exhibitions: Howard University Gallery of Art, Washington, D.C., 1966 (retrospective), 1970; Museum of Fine Arts, Boston, 1970; Nordness Galleries, New York, 1970; La Jolla Museum of Contemporary Art, 1970; State Armory, Wilmington, 1971; Whitney Museum of American Art, New York, 1971; Anacostia Neighborhood Museum, Washington, D.C., 1971; National Collection of Fine Arts, Washington, D.C., 1971; Ringling Museum of Art, Sarasota, 1971; The Baltimore Museum of Art, 1971; Corcoran

Gallery of Art, Washington, D.C., 1971; Wesleyan University Center for the Arts, Middletown, 1971; Carnegie Institute, Pittsburgh, 1971; United Negro College Exhibition, Washington, D.C., Art Association, 1971; Jackson State College, 1971; Society of Washington Artists, Washington, D.C., 1971; Franz Bader Art Gallery, New York, 1971 (one-woman); Margaret Dickey Gallery, Washington, D.C., 1971; DuPont Theatre Art Gallery, Washington, D.C., 1971; and over 70 other exhibitions from 1951 to 1970.

Concentrating on the interaction of vivid, flat colors, Alma Thomas composes her paintings in small brushstrokes that establish the direction of the canvas. Multicolored patches arranged in horizontal bands evoke a sense of light and rhythm. The mood is poetic, the effect exhilarating, an impact that can be fully experienced only by viewing the canvas itself.

"My life in art has been divided into decades," said Alma Thomas. "In the twenties I was interested in sculpture...then representational art in the thirties, along with marionettes, which I studied [with Tony Sarg]. My master's thesis was on the making of marionettes in 1934....In the forties and fifties I taught, had clubs of children, and started my move into purer color formations. During the sixties I started my own personal style."[1] At the age of eighty, with countless paintings behind her, and new and exciting ideas yet to come, Miss Thomas' life is still devoted to art.

1. *Taped interview with Leonard Simon, November 1975.*

91 **Red Rose Sonata,** 1972
Acrylic on canvas
60 × 54 in. (152.4 × 137.2 cm.)
The Metropolitan Museum of Art

92 **White Dogwood,** 1972
Acrylic on canvas
68 × 55 in. (172.7 × 139.8 cm.)
Martha Jackson Gallery

93 **Flowers at Jefferson Memorial**
Acrylic on canvas
60 × 50 in. (152.4 × 127 cm.)
Department of Art, Fisk University
(See color plate, p. 98)

David Butler
b. 1898

Sculptor. Born in Saint Mary Parish in the town of Good Hope, near Patterson, Louisiana. First public showing of his work at the New Orleans Museum of Art in February 1976.

A folk artist without formal training, Butler spent much of his youth drawing the scenes he saw around him—the fields where he worked and lived, the cotton and the pickers, the boats on the water. As an adult, he continued his art while working for the sawmills until an accident in the early sixties left him partially disabled. Forced to retire, he decided to spend all his time creating sculptures and other works of art. His house is a maze of his fantastic creations: windmills with moving parts; flat cutouts on stakes in the ground; decorated lawn benches. Animals, real or imaginary, seem to be the subject he prefers, and his yard is populated with birds, dogs, alligators, skunks, fish, snakes, dinosaurs, and seven-headed sea monsters. Living in an area that has a rich folk tradition seems to have helped Butler produce his special art, which has long been appreciated by both critics and the public.

94 **Ship,** ca. 1950
Painted tin
25¼ × 39½ in. (64.2 × 100.3 cm.)
Willie Starbuck

95 **Windmill,** ca. 1950
Painted tin, wood, and plastic
27 × 57 × 24 in. (68.6 × 144.8 × 60.9 cm.)
William A. Fagaly

94

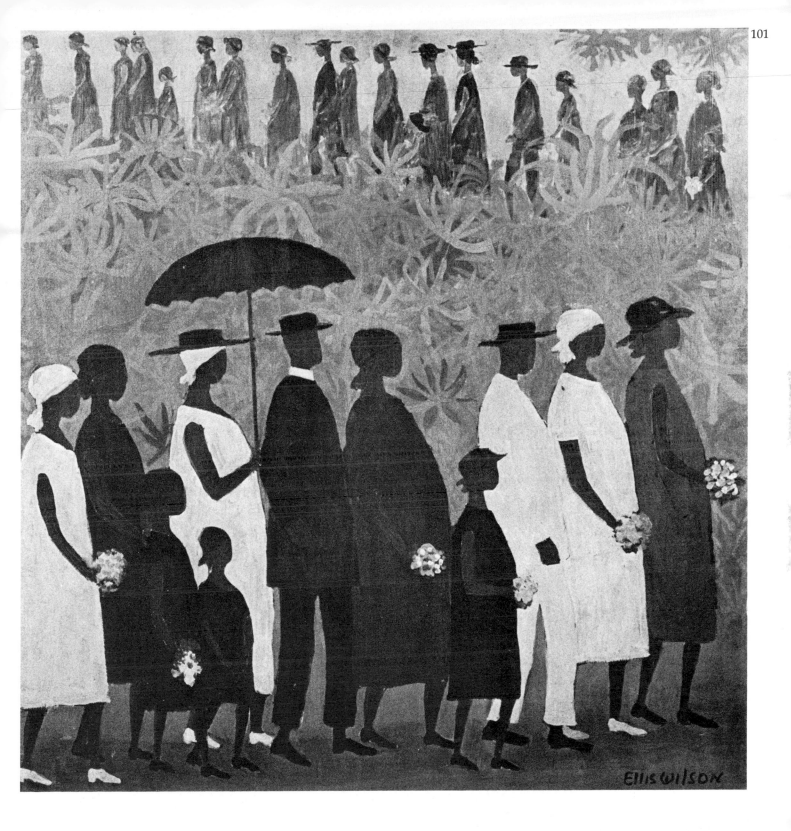

Edward Webster
b. ca. 1900

Born in Florence, South Carolina. Worked as a mail carrier in New York for thirty years while painting.

Major Exhibitions: Parke-Bernet, New York; Burr Gallery, New York; Rockefeller Center, New York; St. Patrick's Cathedral, New York; Hudson River Museum of Yonkers; Kunstforening, Oslo, Norway; School of Nobles and Belles Artes de San Eloy, Salamanca, Spain; Zagreb, Yugoslavia.

Edward Webster was a childhood friend and schoolmate of William H. Johnson's, and one of their games was drawing on sidewalks. Webster left South Carolina in 1917 and went to New York City where he painted, working as a postman to support himself. *The Nativity*, painted in 1956, is one of the twenty-two paintings on the life of Christ that he has produced during the past twenty years. In 1957 Webster sailed to Malaga, the capital of the Costa del Sol in Spain. He still lives in Spain and from 1962 has devoted his time exclusively to painting. During a great part of the last ten years he has painted the Spanish countryside, depicting in particular the lives of the Spanish gypsies.

104 **The Nativity,** 1957
Oil on canvasboard
21¾ × 27¾ in. (55.3 × 75 cm.)
Signed lower left
National Collection of Fine Arts
Smithsonian Institution

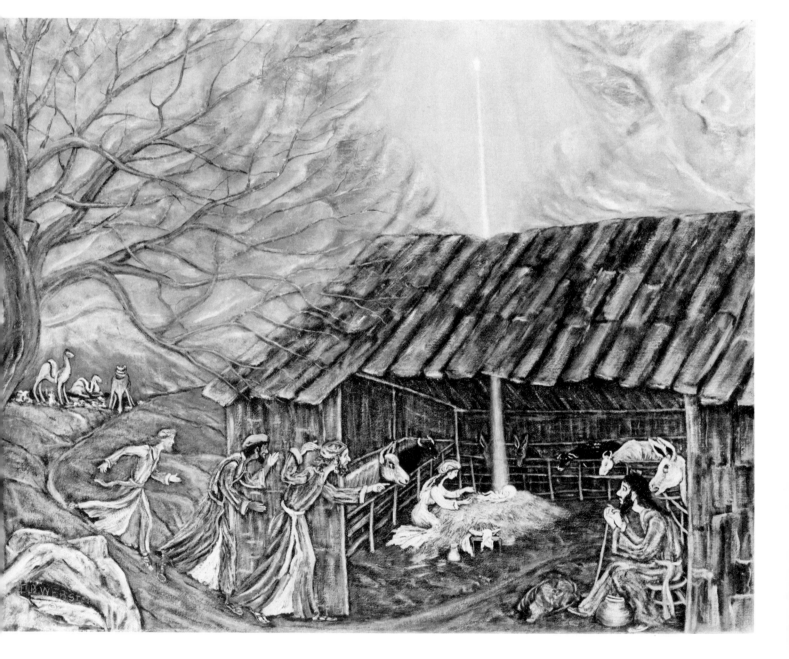

Hale Woodruff
b. 1900

Painter, printmaker, muralist, educator. Born in Cairo, Illinois. Studied at the John Herron Art Institute, Indianapolis; Fogg Art Museum, Harvard University, Cambridge; Academie Scandinave, Paris; Academie Moderne, Paris. Studied with Tanner in Paris, ca. 1931, and studied fresco painting in Mexico with Diego Rivera in 1936.

Major Exhibitions: John Herron Art Institute, 1923-24, 1926; Art Institute of Chicago, 1927; Harmon Foundation, New York, 1928-29, 1931, 1933, 1935; Downtown Gallery, New York, 1929, 1931; Pacquereau Gallery, Paris, 1930; Valentine Gallery, New York, 1931; Feragil Gallery, New York, 1931; The High Museum of Art, Atlanta, 1935, 1938; Texas Centennial Exposition, Museum of Fine Arts, Dallas, 1936; The Baltimore Museum of Art, 1939; New York World's Fair, 1939-40; American Negro Exposition, Chicago, 1940; Grace Horne Galleries, Boston, 1944; Whitney Museum of American Art, New York, 1967; Los Angeles County Museum of Art, 1967; San Diego Art Museum, 1967; Museum of Fine Arts, Boston, 1967; Howard University Gallery of Art, Washington, D.C., 1967; New York University, 1967.

Hale Woodruff's attitude toward his work is direct and pragmatic; he does not veil his methods or motives. In the thirties and forties he painted traditional forms such as flowers and fruits as well as landscapes that reflected the inspiration he found in the quiet streets of southern towns. In the fifties he began experimenting with brush drawings that were free interpretations of figures: he magnified the brushstrokes into enormous, abstract images that filled his canvases. In Woodruff's paintings contours are opened to allow flesh and environment to flow into one another, and anatomical forms are fragmented. Line is permitted to function independently of form; its normal role of describing contours is minimized in the interest of an allover rhythm of swiftly executed dramatic movement.

105 **Celestial Gate**
Oil on canvas
60 × 46 in. (152.4 × 116.8 cm.)
Signed lower right
Spelman College
(See color plate, p. 100)

106 **Four Figurations**
Oil on canvas
48 × 50 in. (121.9 × 127 cm.)
Signed lower right
Spelman College

107 **Spatial Forms**
Crayon
33½ × 26 in. (85.1 × 66.1 cm.)
Signed lower right
Hans Bhalla

Richmond Barthé
b. 1901

Sculptor, painter. Born in Bay St. Louis, Missouri. Studied at the Art Institute of Chicago, ca. 1920-24; Art Students League, New York, 1931. Studied under Charles Schroeder and Albin Polasek.

Major Exhibitions: Delphic Studios, New York, 1925 (one-man); Caz-Delbos Gallery, New York, 1925 (one-man); Women's City Club, Chicago, 1927; Harmon Foundation, New York, 1929, 1931, 1933; Whitney Museum of American Art, New York, 1933, 1935, 1939; Century of Progress, Chicago, 1933-34; Salons of America, New York, 1934 (one-man); Harmon Foundation—CAA Traveling Exhibition, 1934; Howard University Gallery of Art, Washington, D.C., 1934, 1970; New Jersey State Museum, Trenton, 1935 (one-man); Texas Centennial Exposition, Museum of Fine Arts, Dallas, 1936; Arden Gallery, New York, 1938 (one-man); Pennsylvania Academy of the Fine Arts, Philadelphia, 1938, 1939; New York World's Fair, 1939-40; The Baltimore Museum of Art, 1939; American Negro Exposition, Chicago, 1940; Philadelphia Museum of Art, 1940; Grand Central Gallery, New York, 1947; Margaret Brown Gallery, Boston, 1947; The Newark Museum, 1971; City College of New York; Rankin Gallery, Washington, D.C. (one-man); University of Wisconsin, Madison (one-man).

Richmond Barthé turned from painting to sculpture when two clay heads that he had modeled purely for his own pleasure were exhibited at the Chicago Women's City Club in 1927 and received immediate praise. His sculptures, mostly of black subjects, evidence his great technical ability for working in bronze. *Boxer* reveals the strong emotional effect the artist achieved through elongation of the form, articulation of anatomical details, and an animated treatment of the carefully finished surface. Because movement carries through all parts of the body, the total effect is unlabored and free.

108 **Blackberry Woman,** 1932
Bronze
h: 34⅛ in. (86.8 cm.)
Whitney Museum of American Art

109 **Head of a Woman,** ca. 1933
Plaster
h: 13 in. (33 cm.)
Department of Art, Fisk University

110 **Boxer,** 1942
Bronze
h: 16 in. (41.2 cm.)
The Metropolitan Museum of Art
Rogers Fund, 1942

111 **Awakening of Africa,** ca. 1968
Bronze, casting #1
Signed Barthé
Private collection

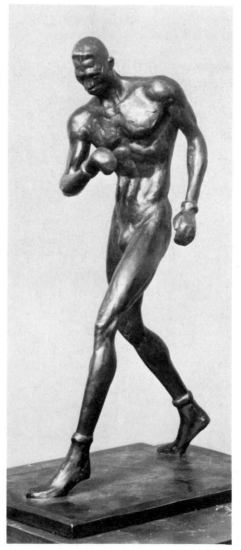

110

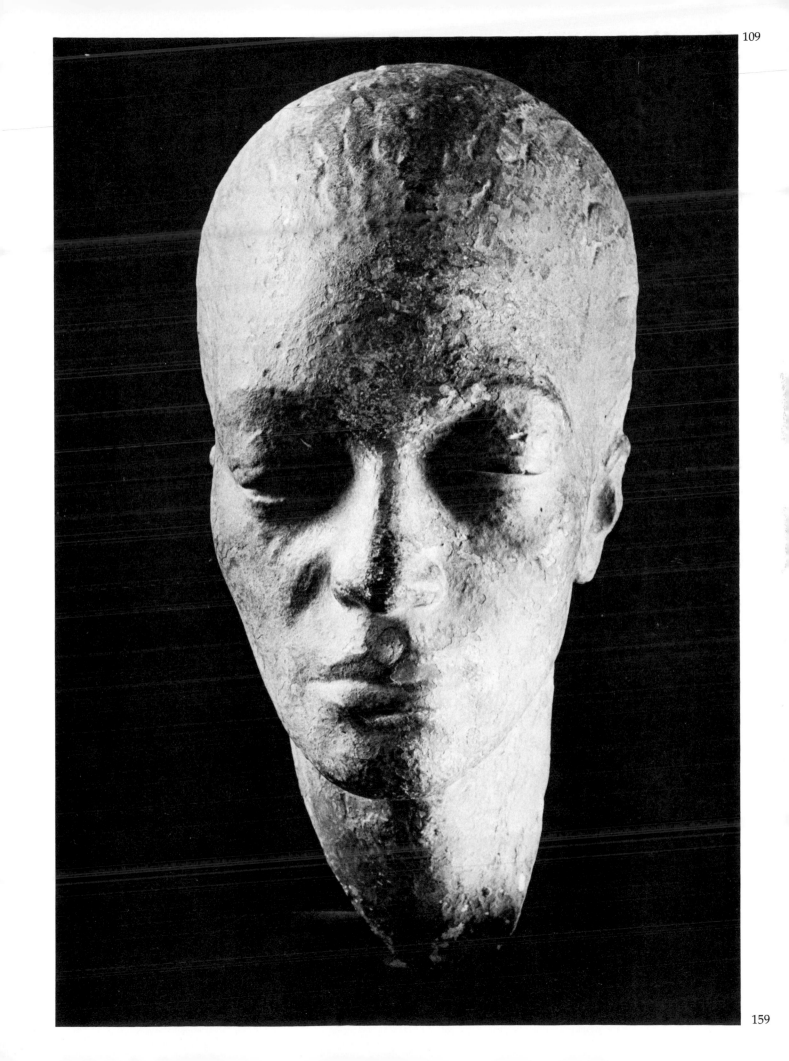

Selma Burke
b. 1901

Sculptor. Born in Mooresville, North Carolina. Before becoming an artist studied at St. Agnes Training School for Nurses in Raleigh, North Carolina; Women's Medical College, North Carolina; and Columbia University, New York, Ph.D., 1936-41. Studied sculpture under Maillol in Paris and Povolney in Vienna.

Major Exhibitions: Carlen Galleries, Philadelphia, 1945; Julian Levy Galleries, New York, 1945; Atlanta University, 1945; McMillen, Inc., Galleries, New York, 1945; Modernage Art Gallery, New York, 1945 (one-woman); Rainbow Sign Gallery, Berkeley, 1972.

In *Mother and Child* the facile perfection of the figures is accented by the interplay of smooth skin and drapery. The relationship of the two figures becomes increasingly complex as the viewer's eye moves from the base to the heads. The rhythms of the figures are parallel, and as the forms rise, there is a sense of quickening motion. Though *Mother and Child* is conventional in theme, the intelligence and skill of the artist help convey strong emotion. Selma Burke's lifelong dedication to that most classical subject—the human body—and her awareness of her race contributed to the character of her art, but there were artistic sources for it as well, particularly the theories and practices of late nineteenth-century French Symbolism. Nevertheless, her sculpture possesses a timeless monumentality.

112 **Torso,** 1937
Brass
h: 18 in. (45.7 cm.)
Collection of the artist

113 **Temptation,** 1938
Indiana limestone
h: 12 in. (30.5 cm.)
Collection of the artist

114 **Mother and Child,** 1968
Pink alabaster
h: 30 in. (76.2 cm.)
Collection of the artist
(See color plate, p. 101)

115 **Mother and Two Children,** 1972
Black walnut
h: 84 in. (213.4 cm.)
Collection of the artist

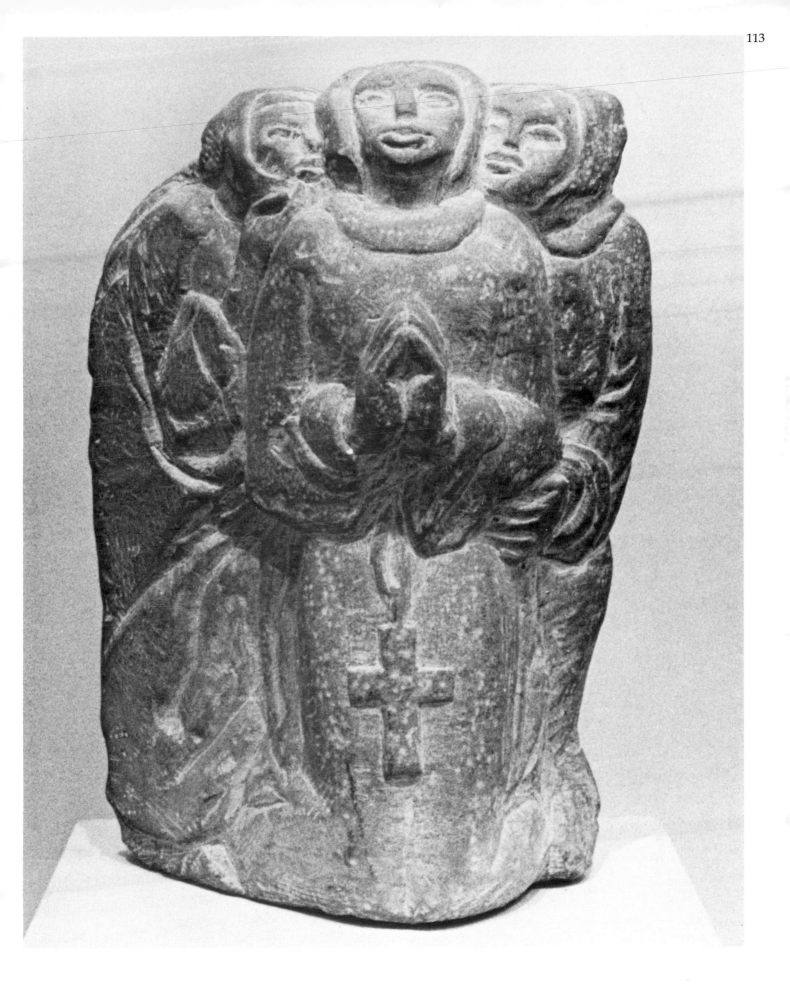

William H. Johnson
1901-1970

Painter, graphic artist. Born in Florence, South Carolina, died on Long Island, New York. Studied at the National Academy of Design, New York; Cape Cod School of Art, under Charles Hawthorne; in Paris; southern France; North Africa; and Scandinavia. Taught at Harlem Art Center, Federal Art Project, 1930-40.

Major Exhibitions: Paris, 1927; Nice, 1928-29; Harmon Foundation, New York, 1930-33; Copenhagen, 1931-33; Esbjerg, Denmark, 1934; Auhus, Denmark, 1934; Oslo, Norway, 1935; Volda, Norway, 1936; National Museum, Stockholm, 1937; Trondhjem Museum, Norway, 1937; Gavle Museum, Sweden, 1938; Artists Gallery, New York, 1939 (one-man); Harlem Art Center, 1940; Alma Reed Gallery, New York, 1941; Wakefield Gallery, New York, 1943-44; Smithsonian Institution, Washington, D.C., 1971.

William H. Johnson aspired to be an artist at an early age, in spite of his poverty and lack of education. At seventeen he went to New York and worked at various jobs to pay for his training at the National Academy of Design. In 1924, after winning a number of prizes he went to Paris to study. He traveled throughout Europe, North Africa, and Scandinavia for twenty years. After abandoning his earlier impressionistic style of painting for a more lyrical, coloristic approach, he became one of the first black painters to affirm his faith in his own imagery, elevating the image of the black American to a subject worthy of visual consideration.[1] For the most part, Johnson was a painter of America; in texture, character, and tempo his paintings suggest American life. Confined to basic hues his cheerful paintings frequently reveal surprising juxtapositions of color, and the ingenious interlocking patterns reveal wit and originality. The simplification of form and free style of execution in Johnson's work recall similar elements in paintings by the Fauves.

1. Alain L. Locke, ''The Negro Takes His Place in Art,'' in Exhibition of Productions by Negro Artists (New York: Harmon Foundation, 1933), p. 12.

116 **Harbor under the Midnight Sun,**
ca. 1935-1938
Oil on burlap
27½ × 37¼ in. (69.9 × 95.3 cm.)
National Collection of Fine Arts
Smithsonian Institution
(See color plate, p. 102)

117 **Lamentation,** ca. 1939
Oil on board
29⅛ × 33¼ in. (74 × 84.5 cm.)
Signed lower right: W. H. Johnson
National Collection of Fine Arts
Smithsonian Institution

118 **Mt. Calvery,** ca. 1939
Oil on board
27¾ × 33⅜ in. (70.5 × 84.8 cm.)
National Collection of Fine Arts
Smithsonian Institution
(See color plate, p. 103)

119 **Chain Gang,** 1939-1940
Oil on board
45½ × 38⅜ in. (115.6 × 97.5 cm.)
Signed lower left; inscribed on verso:
W. H. Johnson/27 15th St.
N.Y.C./Chain Gang
National Collection of Fine Arts
Smithsonian Institution

120 **Nude,** 1939-1940
Oil on burlap
29¼ × 38 in. (74.4 × 96.5 cm.)
Signed lower left:
W. H. Johnson/Mahlinda
National Collection of Fine Arts
Smithsonian Institution

121 **I Baptize Thee,** ca. 1940
Oil on burlap
38 × 44⅛ in. (96.5 × 112.4 cm.)
Signed lower left: W. H. Johnson
National Collection of Fine Arts
Smithsonian Institution

122 **At Home in the Evening,**
ca. 1940-1941
Gouache
22½ × 23½ in. (57.2 × 59.7 cm.)
Signed lower right: W. H. Johnson
Alma W. Thomas

123 **Early Morning Work,** ca. 1940-1941
Oil on burlap
38¼ × 44 in. (97.2 × 111.8 cm.)
Signed lower left: W. H. Johnson
National Collection of Fine Arts
Smithsonian Institution

124 **Woman Ironing,** ca. 1944
Oil on board
29 × 24¼ in. (73.8 × 62.3 cm.)
National Collection of Fine Arts
Smithsonian Institution

James Lesene Wells
b. 1902

Painter, printmaker, educator. Born in Atlanta, Georgia. Studied at Lincoln University, Pennsylvania; National Academy of Design, New York, under Frank Nankerville; Teacher's College, Columbia University, New York, B.S.

Major Exhibitions: New York Public Library, 1921; Montclair YWCA, 1930; Harmon Foundation, New York, 1931, 1933; Delphic Studios, New York, 1932 (one-man); Downtown Gallery, New York, 1932; The Brooklyn Museum, 1932 (one-man); Barnett-Aden Gallery, Washington, D.C., 1932 (one-man); Philadelphia Museum of Art, 1933; Tyler Museum, Philadelphia, 1933; Fisk University, Nashville, 1933; Spelman College, Atlanta, 1933; Atlanta University, 1933; Harlem Art Center, 1933; Studio House, Washington, D.C., 1935; New Jersey State Museum, Trenton, 1935; Texas Centennial Exposition, Museum of Fine Arts, Dallas, 1936; Howard University Gallery of Art, Washington, D.C., 1937, 1945, 1970; Smithsonian Institution, Washington, D.C., 1940; American Negro Exposition, Chicago, 1940; Smith College, Northampton, 1943; Institute of Contemporary Art, Boston, 1943; New Age Gallery, New York, 1947-50, 1960-61; Society of American Graphic Artists, New York, 1950-59; Artists Mart, Washington, D.C., 1957; Washington Printmaker Annuals, 1957-62; African Traveling Exhibition of Paintings and Prints by International Group, Washington, D.C., 1961; Sheraton Hotel, Philadelphia, 1968; Weyhe Gallery, New York, 1971; Philadelphia Print Club, 1971; Dydensing Gallery, New York, 1971; Dallas Exposition, 1971; The Baltimore Museum of Art, 1971; Albright-Knox Art Gallery, Buffalo, 1971; State Armory, Wilmington, 1971; Smith-Mason Gallery of Art, Washington, D.C., 1971.

The name of James L. Wells has appeared consistently on every list of notable black artists of the twentieth century. Biblical themes, mythology, and nature have been the major sources of his imagery, providing him with significant artistic forms to express his Christianity. Wells' figures, almost exclusively black, represent his intensely religious attitude toward life. In works like *Market Place,* his colors are applied layer upon layer, and the effect of depth thus created replaces perspective in his figural compositions which sometimes become two-dimensional. Certain aspects of his painting were derived from German Expressionism and Cubism, and the intensity of his work in even his tenderest studies is truly Expressionist.

125 **Fishermen of Bethlehem,** 1957
 Color lithograph
 10 × 15 in. (25.4 × 38.1 cm.)
 Signed lower right
 Collection of the artist

126 **Market Place,** ca. 1958
 Oil
 24⅜ × 27½ in. (61.9 × 69.9 cm.)
 Signed lower right
 Alma W. Thomas
 (See color plate, p. 104)

127 **Salome,** 1963
 Oil
 36 × 50 in. (91.5 x 127 cm.)
 Signed lower right
 Collection of the artist

128 **Saint Anthony,** 1965
 Wood engraving
 16¾ × 10 in. (42 6 × 25.4 cm.)
 Signed lower right
 Collection of the artist

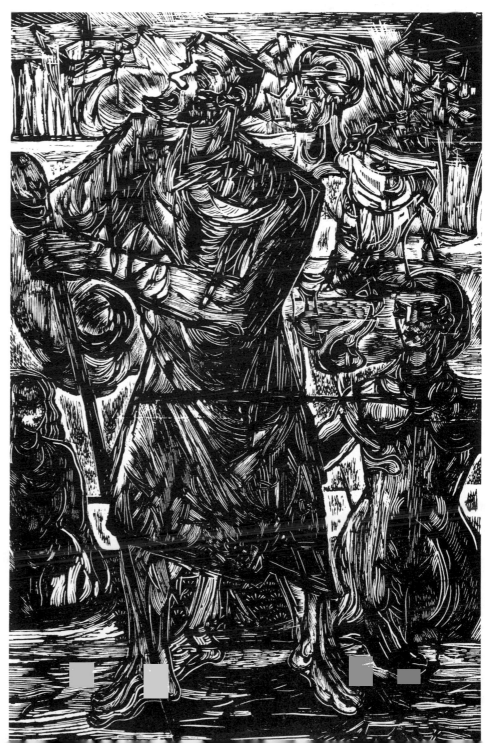

128

Joseph Delaney
b. 1904

Painter. Born in Knoxville, Tennessee. Studied at the London School of Art, Washington, D.C., and at the Art Students League in New York, under Thomas Hart Benton. Worked on the New York Federal Art Project, 1936-39.

Major Exhibitions: Washington Square Shows, New York, 1937-40; McMillen, Inc., Galleries, New York, 1941; Atlanta University, 1942; Greenwich House, New York, 1944.

Most of Joseph Delaney's paintings appear to be telling a story, presenting aspects of contemporary life in America. His style, with its freshness and directness, is that of a man who looks at people more than art, for he paints what he observes in life, not what he has been taught. In *Penn Station at Wartime*, a potentially sentimental scene, he portrays his subjects with a matter-of-fact realism. There is a free and fluid movement among the figures. The painting displays a wonderful outburst of feeling, with spontaneous and energetic brushwork both in the figural groups and background details.

129 **Penn Station at Wartime,** 1943
Oil on canvas
36 × 50 in. (91.4 × 127 cm.)
National Collection of Fine Arts
Smithsonian Institution

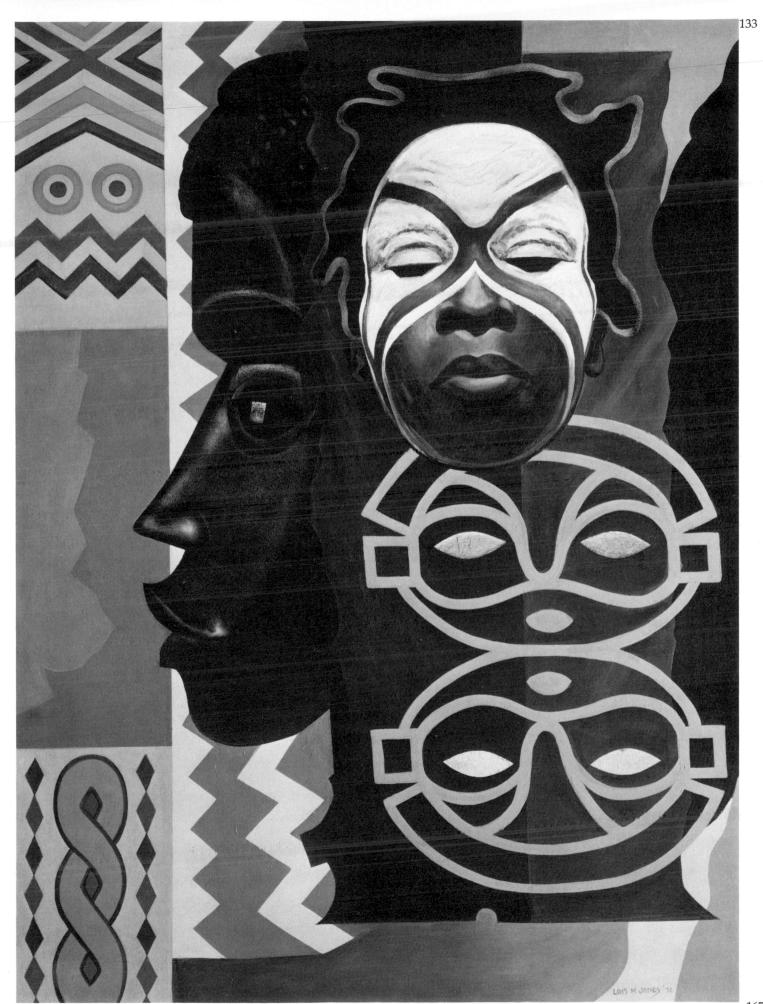

James A. Porter
1905-1971

Painter, educator, author, art historian. Born in Baltimore, Maryland, died in Washington, D.C. Studied at Howard University, Washington, D.C., B.S.; Teachers College, Columbia University, New York; Art Students League, New York; Sorbonne, Paris; New York University, M.A.; pupil of Dimitri Romanovsky.

Major Exhibitions: Harmon Foundation, New York, 1928, 1930, 1933; Smithsonian Institution, Washington, D.C., 1929, 1933; American Watercolor Society, 1932; National Gallery of Art, Washington, D.C., 1933; Detroit Institute of Arts, 1935; New Jersey State Museum, Trenton, 1935; Corcoran Gallery of Art, Washington, D.C., 1936; Museum of Modern Art, New York, 1936; Institute of Contemporary Art, Boston, 1936; The Baltimore Museum of Art, 1936; Howard University Gallery of Art, Washington, D.C., 1937, 1939, 1945; Fine Arts Gallery of San Diego, 1971; The Oakland Museum, 1971.

James A. Porter spent his life teaching, studying, and documenting the history of black art in this country and throughout the world. While chairman of the Art Department at Howard University he wrote what many consider the basic book on black art, *Modern Negro Art*, which discusses the iconography of African art and its relationship to black culture. He was an extraordinary teacher, and probably no other black American has taught so many pupils. As an artist, he created works in a dark, warm, realistic style, beautiful in their direct, if modest observation. That he also admired the decorative qualities of the Fauves is evident in his *Still Life*. Seduced by the brilliance of their color, he created a work of great visual delight.

134 **Still Life,** 1949
Oil on canvas
46 × 36 in. (116.8 × 91.4 cm.)
Dr. Dorothy B. Porter
(See color plate, p. 106)

135 **Self Portrait,** 1957
Oil on canvas
35 × 28 in. (88.9 × 71.2 cm.)
Dr. Dorothy B. Porter

136 **Portrait of Dorothy,** 1957
Oil on canvas
36 × 30 in. (91.4 × 76.2 cm.)
Dr. Dorothy B. Porter

Charles H. Alston
b. 1907

Painter, sculptor, graphic artist, illustrator, educator. Born in Charlotte, North Carolina. Studied at Columbia University, B.A., M.A.; New York University; Pratt Institute, Brooklyn; Art Students League, New York. Produced covers for *The New Yorker, Collier's,* and the *American Magazine* and illustrated novels for Scribner's.

Major Exhibitions: The High Museum of Art, Atlanta, 1933-34; Frederick S. Wight Art Gallery, UCLA, Los Angeles, 1933-34; Oppenheimer Gallery, Chicago, 1933-34; Dunbarton Gallery, Boston, 1933-34; Gallery of Modern Art, New York, 1933-34; Harmon Foundation, New York, 1933-34; ACA Gallery, New York, 1936; Museum of Modern Art, New York, 1936; The Baltimore Museum of Art, 1937-39; American Negro Exhibition, Chicago, 1940; Pennsylvania Academy of the Fine Arts, Philadelphia, 1941; Downtown Gallery, New York, 1941; La Jolla Museum of Contemporary Art, 1941; Dillard University, New Orleans, 1941; The Metropolitan Museum of Art, New York, 1950; Whitney Museum of American Art, New York, 1952; Pyramid Club, Philadelphia, 1952; Howard University Gallery of Art, Washington, D.C., 1970.

Charles Alston has stated, "Depending on how I feel, I work either figuratively or abstractly. Some things I react abstractly to, some figuratively. I've never held with the 'consistency' the critics are so hipped on. After I've solved a problem, I can't get interested in repeating it."[1] Alston avoids idealized figures, stylized grace, and superficial overtones of charm in his paintings. In *Family* he presents the inner and external characteristics of his subjects with a straightforward realism.

1. *Edmund B. Gaither,* The Barnett-Aden Collection *(Washington, D.C.: Smithsonian Institution Press for the Anacostia Neighborhood Museum, 1974), p. 163.*

137 **Family,** 1955
 Oil on canvas
 48¼ × 35¾ in. (122.6 × 90.8 cm.)
 Whitney Museum of American Art
 Artists and Students Assistance Fund

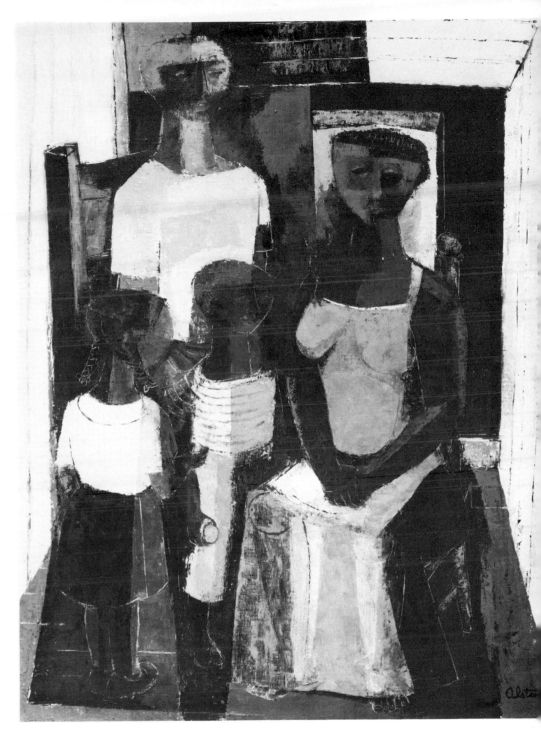

Marion Perkins
1908-1961

Sculptor. Born in Marche, Arkansas, died in Chicago, Illinois. Studied under Cy Gordon; won the Art Institute of Chicago Purchase Award in 1951.

Major Exhibitions: Art Institute of Chicago, 1940; Howard University Gallery of Art, Washington, D.C., 1940; Evanston (Illinois) Country Club, 1940; Hull House, Chicago, 1940; South Side Community Art Center, Chicago, 1945; Xavier University, New Orleans, 1963; Rockford College (Illinois), 1965.

Because he seems to have preferred the immediacy of form and expression found in the art of Africa and other primitive cultures, Perkins' sculptures seem tied to his feelings for his own people and other minorities. In *Man of Sorrows*, we see a contemplative, unshaven head, constricted and self-contained, which sets the tone of Perkins' mature productions. Within the simple form, there is a feeling of quiet intensity and psychological constraint. The compact unity of the head represents an essentially sculptural approach to expressive form seldom seen in the fifties when animated figures and broken contours were the standard devices used to convey emotion.

138 **Man of Sorrows,** 1950
Marble
h: 18 in. (45.8 cm.)
Signed and dated on reverse
Art Institute of Chicago
Pauline Palmer Purchase Prize

139 **The Musician,** ca. 1950
Limestone
h: 16½ in. (41.9 cm.)
Collection of Professor and
Mrs. Earl J. Hooks

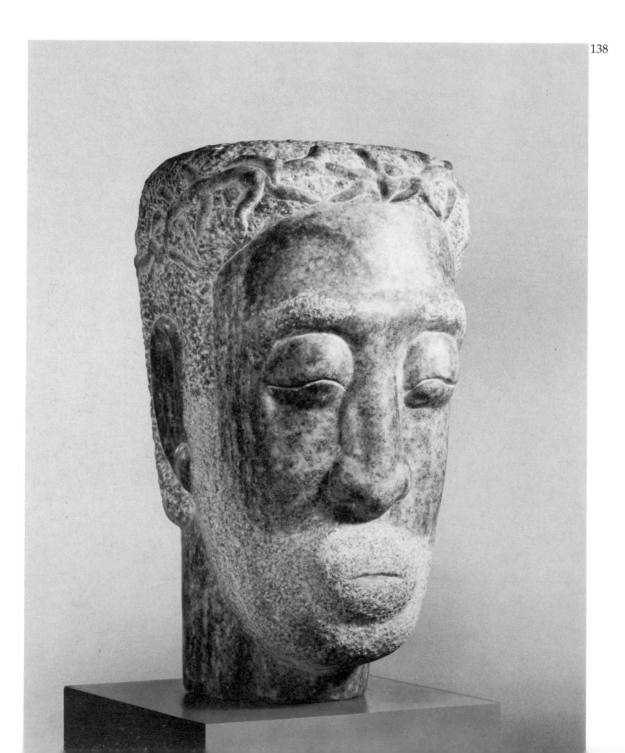

138

Norman Lewis
b. 1909

Painter. Born in New York City. Studied at Columbia University and under Augusta Savage, Raphael Soyer, Vaclav Vytacil, Angela Streater. Taught at Harlem Art Center, Federal Art Project, 1936-39.

Major Exhibitions: Harlem Artists Guild, 1936, 1937; Harlem Art Center, 1937-39; Fisk University, Nashville, 1939; The Baltimore Museum of Art, 1939; American Negro Exposition, Chicago, 1940; Albany Institute of History and Art, 1945; South Side Community Art Center, Chicago, 1945; The Metropolitan Museum of Art, New York, 1970; Whitney Museum of American Art, New York, 1970; Art Institute of Chicago, 1970; Museum of Fine Arts, Boston, 1970; The Brooklyn Museum, 1971; Museum of Modern Art, New York, 1971; Corcoran Gallery of Art, Washington, D.C., 1971; Venice Biennale, 1971; Musée de Peinture et de Sculpture, Grenoble, France, 1971.

Norman Lewis is a painter intent on capturing—as opposed to merely representing—fleeting atmospheric effects. He creates optical effects of great splendor: interpenetrating layers of color appear to spread and coalesce. Without resorting to sharp edges he structures color by drawing boundaries near the periphery of his paintings, almost parallel to the edges. "...A painting should always be doing something when it is being looked at, but something of itself, not words or musical notes."[1]

1. *Norman Lewis in* The Barnett-Aden Collection *(Washington, D.C.: Smithsonian Institution Press for the Anacostia Neighborhood Museum, 1974), p. 175.*

140 **Composition,** 1952
Oil
38 × 52 in. (96.5 × 132.1 cm.)
Signed lower left
Louis K. Rimrodt

One of Our Exhibitions and Teas

*impressions from exhibition of
oils + watercolors —*

*Lois M Jones EAAR Murphy
under the auspices of the
A K A Sorority*

142

Allan Rohan Crite

b. 1910

Painter, illustrator. Born in New Jersey. Studied at Boston Latin and English High School; School of the Museum of Fine Arts, Boston; Massachusetts School of Art; Children's Art Centre, Boston, under Charles H. Woodburry; Harvard University, B.A. in Extension Studies, 1968. Awarded the Boston Museum School Scholarship, 1935, and the Boit Prize, 1935.

Major Exhibitions: Boston Society of Independent Artists, 1929; Harmon Foundation, New York, 1930-32, 1935; Texas Centennial Exposition, Museum of Fine Arts, Dallas, 1936; Howard University Gallery of Art, Washington, D.C., 1939; Dillard University, New Orleans, 1939, 1940; American Negro Exposition, Chicago, 1940; Corcoran Gallery of Art, Washington, D.C., 1939; Grace Horne Galleries, Boston, 1943.

Allan Crite recorded many of the black social events in Boston during the thirties; in *One of Our Exhibitions and Teas* he portrayed some of the guests at a reception in Boston's south end for the artist Lois Jones. His love of humanity and his realization that life contains hardship and suffering as well as serenity and beauty is evident in Crite's work. It is characterized by a sparseness that reduces each composition to its essence. The sharply focused precision of his technique is admirably adapted to communicate both his objectivity of vision and depth of feeling.

141 **A Neighborhood Madonna,** 1934-39
 Pencil drawing
 18 × 12 in. (45.8 × 30.5 cm.)
 Signed and dated lower right
 Angus Whyte Gallery

142 **One of Our Exhibitions and Teas,**
 1939
 Pencil drawing
 18 × 12 in. (45.8 × 30.5 cm.)
 Signed and dated lower right
 Angus Whyte Gallery

Wilmer Jennings
b. 1910

Painter, printmaker, educator, designer, jeweler. Born in Atlanta, Georgia. Studied at Morehouse College, Atlanta, B.S., 1931, under Hale Woodruff; Rhode Island School of Design, Providence.

Major Exhibitions: Harmon Foundation, New York, 1933, 1935; Harmon Foundation—CAA Traveling Exhibition, New York, 1934-35; New Jersey State Museum, Trenton, 1935; Texas Centennial Exposition, Museum of Fine Arts, Dallas, 1936; Art Institute of Chicago, 1939; New York World's Fair, 1939-40; American Negro Exposition, Chicago, 1940; Library of Congress, Washington, D.C., 1940; Atlanta University, 1942; The Newark Museum, 1971; The Baltimore Museum of Art, 1939.

Jennings' knowledge and control of linocut enabled him to produce a print in which the dramatic figures are enriched by bold contrasts of velvety blacks and sharp whites. In *De Good Book Says*, a tremendous richness of texture has been produced by parallel straight lines as well as by flowing sequences of curves and elongated dots that move in varying directions and rhythms to suggest form as well as surface. It is a demonstration of brilliant technical virtuosity in one of the most difficult of artistic media. The print is a genuinely moving work of art; neither undue sentiment nor false idealization distorts the authenticity of the image.

143 **De Good Book Says,** ca. 1931
Linocut
10 × 8 in. (25.4 × 20.3 cm.)
Department of Art, Fisk University

Romare Bearden
b. 1912

Painter. Born in Charlotte, North Carolina. Studied at New York University, B.S.; University of Pittsburgh; American Artists School; Art Students League, New York under George Grosz; Columbia University, New York, 1943; Sorbonne, Paris, 1950-51.

Major Exhibitions: Carnegie Museum, Pittsburgh, 1937; American Art Gallery, New York, 1938; Harlem Art Center, 1939; McMillen, Inc., Galleries, New York, 1941; Downtown Gallery, New York, 1941; Institute of Contemporary Art, Boston, 1943; Smith College, Northampton, 1943; Atlanta University, 1944; G Place Gallery, Washington, D.C., 1945 (one-man); Corcoran Gallery of Art, Washington, D.C., 1965; Rockford College, 1965; Fine Arts Gallery of San Diego, 1966; The Oakland Museum, 1967; Bundy Art Gallery, Waitsfield, Vermont, 1967; American Academy of Arts and Letters, New York, 1966, 1972; J. L. Hudson Gallery, Detroit, 1968; Spelman College, Atlanta, 1968; Williams College, Williamstown, Massachusetts, 1969; Dartmouth College, Hanover, 1969; Rhode Island School of Design, Providence, 1969; San Francisco Museum of Art, 1969; Cordier and Ekstrom Gallery, New York, 1970; Tricia Karliss Gallery, Provincetown, Massachusetts, 1970;

Howard University Gallery of Art, Washington, D.C., 1970; Museum of Fine Arts, Boston, 1970; Contemporary Arts Museum, Houston, 1970; Minneapolis Art Gallery, 1971; Columbus (Ohio) Museum of Art, 1971; Albany Institute of History, 1971; The Newark Museum, 1971; University of Iowa, Iowa City, 1971-72; Sidney Janis Gallery, New York, 1972; Pace Gallery, New York, 1972.

"It would seem to me that what the young black painter has that is unique is that he has experiences and a way of looking at them that is unique."[1] Romare Bearden's life is a justification of that statement. Recognized since the forties as one of America's leading abstractionists, he had begun his career in the early thirties. "...Bearden's artistry is not the black content of his work, which is often laden with Neo-African symbols, instead it is his ability to express in a catholic sense those humanizing characteristics of blackness that are synonymous with universal man."[2] Bearden uses elements like photographs and fragments of paper that seem both related and unrelated to the painting; these ready-made materials are all incorporated into a freely painted matrix which at times obscures and then reveals them. The effect is no more chaotic, meaningful, or meaningless than the welter of sights, sounds, debris, and movement that attacks the senses as one travels through the streets of a large city. Probably one of the unique aspects of Bearden's art is the sense of unity he achieves despite the seemingly haphazard, sometimes whimsical, accumulation of juxtaposed objects.

1. *Elton Fax*, Seventeen Black Artists *(New York: Dodd, Mead, 1971), p. 145.*
2. *David Driskell*, Amistad II: Afro-American Art *(New York: American Missionary Association, 1975), p. 50.*

144 **Death in the Afternoon,** 1946
Watercolor
16⅝ × 23½ in. (42.3 × 59.7 cm.)
Mr. and Mrs. Sid Wallach

145 **Thirst Goes Away with Drinking,** 1946
Oil on canvas
12½ × 8¼ in. (31.8 × 21 cm.)
Signed in upper right: R. B.
Collection of Mrs. Morton Goldsmith

146 **Trojan War Series: At the Oracle,** 1949
Watercolor
18½ × 24¼ in. (47 × 61.6 cm.)
Mr. and Mrs. Sid Wallach

147 **Gardens of Babylon,** 1955
Oil on canvas
56 1/16 × 44 11/16 in. (142.4 × 113.6 cm.)
Mr. and Mrs. Sid Wallach
(See color plate, p. 107)

148 **Sermons: The Walls of Jericho,** 1964
Collage
11⅞ × 9¾ in. (30.3 × 24.8 cm.)
Hirshhorn Museum and Sculpture Garden
Smithsonian Institution

149 **The Woodshed,** 1969
Collage on board
40½ × 50½ in. (102.8 × 128.3 cm.)
The Metropolitan Museum of Art
George A. Hearn Fund

Charles Sebree
b. 1914

Painter. Born in Madisonville, Kentucky. Studied at the Art Institute of Chicago. Worked for Illinois Federal Art Project (Easel Division), 1936-38.

Major Exhibitions: International Watercolor Society, Washington, D.C., 1935; Katharine Kuh Gallery, Chicago, 1936; Federal Art Project, Chicago, 1937; Breckenridge Gallery, 1938; Grace Horne Galleries, Boston, 1939; American Negro Exposition, Chicago, 1940; McMillen, Inc., Galleries, New York, 1941; South Side Community Art Center, Chicago, 1941, 1945; Howard University Gallery of Art, Washington, D.C., 1941, 1970; Institute of Contemporary Art, Boston, 1943; Roko Gallery, New York, 1949; City College of New York, 1967.

The nation was deep in economic gloom when the WPA Federal Art Projects were born in the 1930s. Black artists needed work no less than whites, and among those employed on the projects were Romare Bearden, Selma Burke, Margaret Burroughs, Claude Clark, Eldzier Cortor, Norman Lewis, Charles White, and Charles Sebree, who also illustrated Countee Cullen's book, *Lost Zoo*. In *Harlem Saltimbanques* and other paintings by Sebree interwoven patterns of flattened figures with rhythmic contours are created by a direct use of color. His ability to eliminate detail and to organize masses as flat areas of color, dividing the canvas into zones of brilliant hues, mark Charles Sebree as one of the outstanding black American painters of recent years.

152 **Harlem Saltimbanques**
Oil and tempera on masonite
30⅛ × 18³/₁₆ in. (76.5 × 46.3 cm.)
National Collection of Fine Arts
Smithsonian Institution

Elizabeth Catlett
b. 1915

Sculptor, painter, printmaker. Born in Washington, D.C. Studied at Howard University, Washington, D.C., B.A., 1936; University of Iowa, Iowa City, M.F.A., 1940; under Ossip Zadkine and Grant Wood; Art Institute of Chicago; Art Students League, New York; Painting and Sculpture School of the Secretariat of Public Education, Mexico City.

Major Exhibitions: University of Iowa, Iowa City, 1939; Downtown Gallery, New York, 1940; American Negro Exposition, Chicago, 1940; Atlanta University, 1942, 1943, 1951; Institute of Contemporary Art, Boston, 1943; The Baltimore Museum of Art, 1944; University of Chicago, 1944; The Newark Museum, 1944; Brockman Gallery, Los Angeles, 1967 (one-woman); La Jolla Museum of Contemporary Art, 1970; Solar Exhibition, Olympic Villa, Mexico, 1971.

It was in 1946 that Elizabeth Catlett made her first trip to Mexico, little suspecting how closely her life would be tied to that country and to the art of its great masters; she has now lived there for nearly thirty years. Between 1941 and 1969 she won eight prizes and honors, four in Mexico and four in America where she competed exclusively with black artists. The meaning of her *Black Unity* is clear beyond any possible misunderstanding, a straightforward communication of a symbol and a truth. African sources are very noticeable in her work, which conveys something of the mood of ritual mystery one feels in the presence of African objects. In her sophistication and inventive primitivism, she stands apart from other sculptors. "A woman critic here [Mexico] once told me that whenever I do Mexicans in sculpture they always turn out to be black....My art does, after all, speak for both my peoples."[1]

1. *Elton C. Fax,* Seventeen Black Artists *(New York: Dodd, Mead, 1971), p. 31.*

153 **Black Unity,** 1968
Cedar
h: 21 in. (53.4 cm.)
Signed lower part of fist
Courtesy of Brockman Gallery
Productions

154 **Target Practice,** 1970
Bronze
h: 13½ in. (34.3 cm.)
Department of Art, Fisk University

155 **Mother and Child,** 1972
Wood
h: 23 in. (58.4 cm.)
Private collection

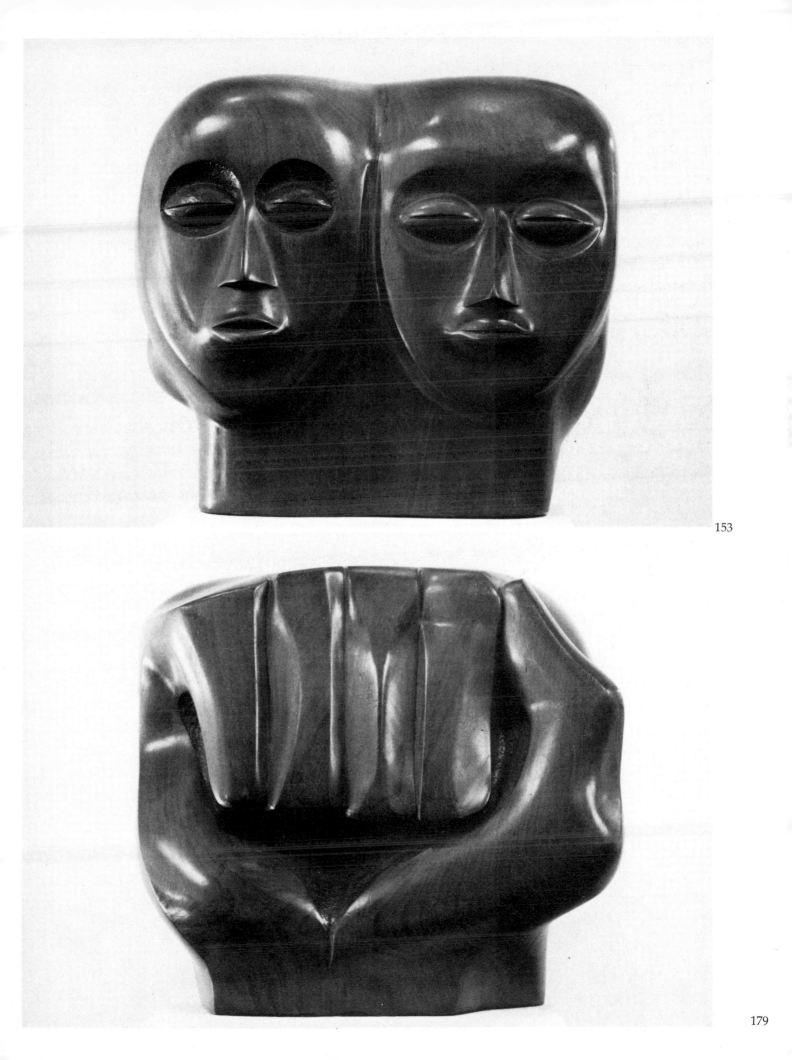

153

179

Claude Clark
b. 1915

Born in Rickingham, Georgia. Studied at Philadelphia Museum School, Barnes Foundation, Philadelphia; California State College, Sacramento, B.A., 1958; University of California, Berkeley, M.A., 1962.

Major Exhibitions: New York World's Fair, 1939-40; Atlanta University, 1942-44; Sorbonne, Paris; San Juan, Puerto Rico; Mexico City; The Oakland Museum; Downtown Gallery, New York; Rhode Island School of Design, Providence; E. B. Crocker Gallery, Sacramento; New York Public Library; Colgate University, Hamilton; The Brooklyn Art Museum; Montclair Art Museum.

"The subject matter in a Claude Clark painting is usually black genre, folk activity, in both rural and urban communities. There are character studies, figure compositions, still lifes, landscapes and seascapes. To avoid misinterpretation, each painting contains no more than a simple story, and employs methods of basic design and color in each format for a clear and precise statement."[1] Clark's work achieves a tactile reality by means of the solidity of paint piled in ropes and mounds on the canvas with a palette knife. He uses a kind of neo-baroque approach to describe the lives of ordinary people—workers, people on the beach, children playing. The more intense subject of his *Slave Lynching* has best been described in the words of both the artist and David Driskell. "The truth of Claude Clark's art is not meant to please the appetite of romantic nomads. But his art is meant to mirror societal ideals and values...."[2] "Today, [the black artist] has reached the phase of Political Realism where his art becomes even more functional. He not only presents the condition but names the enemy, and directs us toward a plan of action in search of our own roots and eventual liberation."[3]

1. *Alice Lockhart, "Content and Method Used in Claude Clark Paintings," in* A Retrospective Exhibition, 1937-1971: Paintings by Claude Clark *(Nashville: Fisk University, 1972), p. 7.*
2. *Ibid., foreword by David Driskell, p. 4.*
3. *Claude Clark in a letter to David Driskell, March 1972, p. 4.*

156 **Gossip,** 1946
Oil
15 × 11½ in. (38.1 × 29.3 cm.)
Signed lower right
Department of Art, Fisk University

157 **Slave Lynching,** 1946
Oil on board
14¼ × 17 in. (36.3 × 43.2 cm.)
Collection of the artist
(See color plate, p. 108)

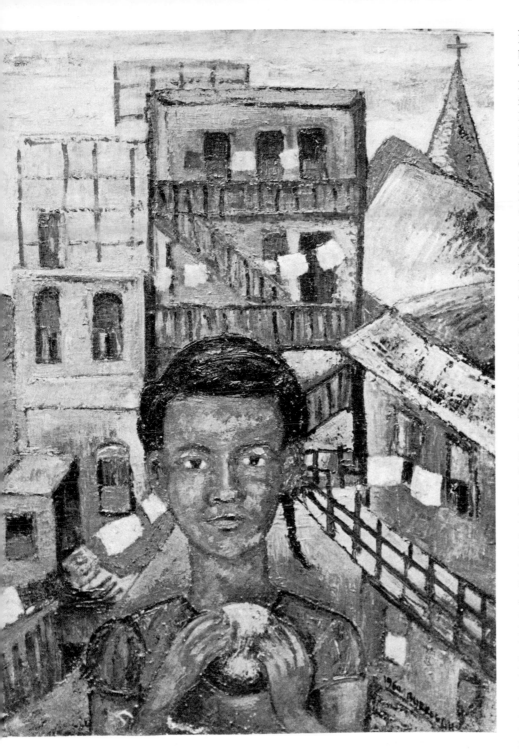

Margaret T. Burroughs
b. 1917

Painter, sculptor, educator, writer, illustrator, graphic artist. Born in St. Rose Parish, Louisiana. Studied at Chicago Normal School; Art Institute of Chicago, B.A.E., M.A.E.; Teacher's College, Columbia University, New York; Northwestern University, Chicago; in Mexico City. Founder of National Conference of Artists.

Major Exhibitions: American Negro Exposition, Chicago, 1940; Illinois State University, Chicago, 1942; Atlanta University, 1943, 1945; Winston-Salem Teacher's College, 1945; San Francisco Civic Museum, 1949; Market Place Gallery, New York, 1950; Kenosha Public Museum, Wisconsin, 1953; Hull House, Chicago, 1955; Mexico City, 1955; Poland, 1965; International Kook Art Exhibit, Leipzig, Germany, 1965; House of Friendship, Moscow, 1967.

One of the most versatile and distinguished black women in American art, Margaret Burroughs is a founder of the South Side Community Art Center in Chicago; originator of Chicago's Lake Meadows Outdoor Art Fair; founder and director of the Ebony Museum of Negro History and Art in Chicago. In addition to publishing two juvenile books titled *Jasper the Drummin' Boy* (1947) and *Did You Feed My Cow?* (1955), she has also served as art director and research assistant for the Negro Hall of Fame. In *Slum Child* Burroughs hints that the girl faces a hopeless, "ready-made" life, suggested by the curtained windows of the dreary apartments behind her. Although the filtered light lends a kind of poetry to the drab surroundings, the viewer cannot ignore the squalor that is softened only by the artist's vision.

159 **Slum Child,** 1950
 Oil
 28½ × 37 in. (72.4 × 94 cm.)
 Collection of the artist

Jacob Lawrence
b. 1917

Born in Atlantic City, New Jersey. Studied at the Art Workshop, Harlem, under Charles Alston and Henry Bannarn; Harlem Art Center and American Artists School, 1937-39; Harlem Workshop, 1932.

Major Exhibitions: Alston-Bannarn Studios, Harlem, 1935-37; Harlem Art Center, 1936-39; Detroit Institute of Arts, 1938; Dillard University, New Orleans, 1938; Fisk University, Nashville, 1938; The Baltimore Museum of Art, 1939; New York Federal Art Project, 1938-40; Museum of Modern Art, New York, 1963; The Metropolitan Museum of Art, New York, 1963; Art Institute of Chicago, 1963; Museum of Fine Arts, Boston, 1970.

Lawrence, like so many other artists of social protest in the thirties and forties, began his career in a settlement house art class and was supported by the Depression-born W.P.A. in his early years.

"Jacob Lawrence has looked at history with the discerning eye of a sensitive critic. He has recorded a visual record which touches upon our national and ancestral interests. It is obviously noticeable that his paintings contain some of the visual symbols associated with man's protest against the intolerable conditions that often beset him, but they also present to us a segment of reality which ties our own lives to history that is reflected in the immediate drama of contemporary living. This is the reason why his style in art cannot be crammed into the usual bag of modern isms. Thus, he distinguishes himself as an artist who is highly sensitive to the conditions of life that face all mankind."[1]

1. *David Driskell*, The Toussaint L'Ouverture Series by Jacob Lawrence (*Nashville: Fisk University, 1968*), p. 2.

160 **Toussaint L'Ouverture Series,** 1938
Numbers 11, 17, 20, 23, 26
Tempera on paper
18¼ × 24¼ in. (46.4 × 61.6 cm.)
Department of Art, Fisk University

161 **Tombstones,** 1942
Gouache on paper
23¾ × 20½ in. (60.4 × 52.1 cm.)
Whitney Museum of American Art
(See color plate, p. 109)

162 **War Series: Prayer,** 1947
Egg tempera on composition board
16 × 20 in. (40.6 × 50.8 cm.)
Whitney Museum of American Art
Gift of Mr. and Mrs. Roy R. Neuberger

163 **Subway Acrobats,** 1959
Tempera on paper
20 × 24 in (50.8 × 61 cm.)
Signed lower right
Private collection

164 **Parade,** 1960
Tempera with pencil
28⅞ × 30⅛ in. (73.5 × 76.6 cm.)
Hirshhorn Museum and Sculpture Garden
Smithsonian Institution

160

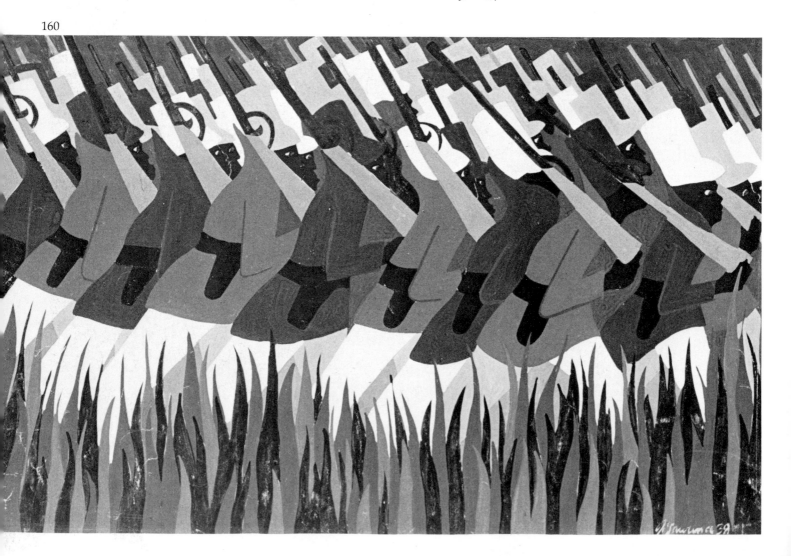

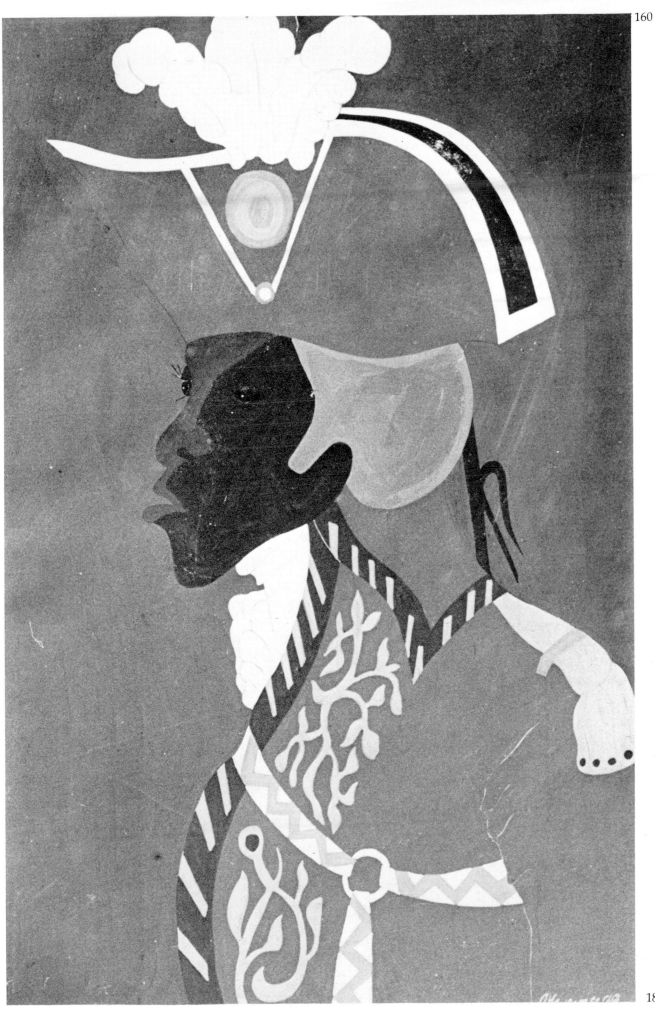

Felrath Hines
b. 1918

Painter. Born in Indianapolis, Indiana. Studied at the Art Institute of Chicago, 1944; New York University, 1953-55; Pratt Institute, Brooklyn, 1962; currently a conservator at the National Collection of Fine Arts, Washington, D.C.

Major Exhibitions: John Herron Institute of Art, Indianapolis, 1959; Riverside Museum, New York, 1959; Parma Galleries, New York, 1960, 1962; Hudson River Museum at Yonkers, Inc., 1968; The Minneapolis Institute of Arts, 1968; The High Museum of Art, Atlanta, 1969; Rhode Island School of Design, Providence, 1969; San Francisco Museum of Art, 1969.

Hines' paintings are ordered areas of discrete shapes, with disciplined brushwork creating coherent structures. In *Transition*, he seems to capture an emotional tone with an almost mystic quietude. The division of the canvas into a few basic areas, the subtle relationships of color, and the quiet, diffused textures suggest an almost obsessive desire to reduce the art of painting to its essentials.

165 **Transition,** 1953
 Oil on canvas
 36 × 48 in. (91.5 × 121.9 cm.)
 Collection of the artist

John Rhoden
b. 1918

Sculptor. Born in Birmingham, Alabama. Studied at the School of Painting and Sculpture, Columbia University, New York; and under Hugo Robus, Oronzio Maldareli, Richmond Barthé, William Zorach. Executed commissions for the Harlem Hospital (*Monumental Bronze*, 1966) and the Metropolitan Hospital (*Monumental Abstraction*, 1968). Visited more than twenty countries as an artist on tour through the Department of State.

Major Exhibitions: Fisk University, Nashville, 1969; The Frick Collection, New York, 1969; Brooklyn College, 1969; Atlanta University, 1970; The Metropolitan Museum of Art, New York, 1970; Pennsylvania Academy of the Fine Arts, Philadelphia, 1970; Art Institute of Chicago, 1970; Museum of Fine Arts, Boston, 1970; Whitney Museum of American Art, New York, 1971; National Academy of Arts and Letters, American Academy of Arts and Letters, New York, 1971; Schneider Galleria, Rome, 1971; Fairweather-Harden Gallery, Chicago, 1971; Audubon Annual, 1971; Saidenberg Gallery, New York, 1971; American Academy, Rome, 1971; Howard University Gallery of Art, Washington, D.C., 1971; Camino Gallery, Rome, 1971; Brooklyn College, 1971; University of Pittsburgh, 1971.

"Sculpture has to have a form, it has to have some movement, something to excite you one way or the other. When I look at sculpture, I wonder, what is it that that fellow has done that I can get something out of."[1] In his home, which also serves as his studio, there are many pieces in varying styles that show Rhoden to be very aware of both the classic and romantic elements of art. He is a brilliantly skillful craftsman in metal, whose work always reveals his keen eye for the nature and possibilities of the material, captivating the viewer with its richness.

1. Taped interview with Leonard Simon, November 1975.

166 **Safari,** 1958
Bronze
27 × 38 in. (68.6 × 96.5 cm.)
Collection of the artist

167 **Population Explosion,** 1962
Teakwood
h: 60 in. (152.4 cm.)
Collection of the artist

168 **Confrontation,** 1969
Bronze
h: 96 in. (243.8 cm.)
Collection of the artist

169 **Abstraction,** 1975
Bronze, jewel glass
h: 48 in. (121.9 cm.)
Collection of the artist

170 **Richanda,** 1975
Bronze
h: 90 in. (228.6 cm.)
Collection of the artist

171 **Sphere of Life,** 1975
Bronze
48 × 60 in. (121.9 × 152.4 cm.)
Collection of the artist

170

Charles White
b. 1918

Painter, graphic artist, educator. Born in Chicago. Studied at the Art Institute of Chicago; Art Students League, New York; Taller de Grafica, Mexico.

Major Exhibitions: ACA Gallery, New York, 1941; Palace of Culture, Warsaw, 1967; Howard University Gallery of Art, Washington, D.C., 1967; Morgan State College, Baltimore, 1967; Fisk University, Nashville, 1968; University of Dayton, 1968; Central State College, Xenia, Ohio, 1968; Whitney Museum of American Art, New York, 1968, 1971; Wilberforce College, Xenia, Ohio, 1968; Wright State University, 1968; Dayton Art Institute, 1968; Otis Art Institute, Los Angeles, 1968; Kunstnernes Hus, Oslo, 1968; Pushkin Museum, Moscow, 1968; Heritage Museum, Leningrad, 1968; Heritage Gallery, Los Angeles, 1968; Museum of Fine Arts, Boston, 1969; Claremont College, 1969; La Jolla Museum of Contemporary Art, 1970; The Metropolitan Museum of Art, New York, 1971; Smithsonian Institution, Washington, D.C., 1971; and over 80 other exhibitions.

Charles White has been a force in black American art since he shared his early days in Chicago with other soon-to-be-known artists such as Charles Sebree, Eldzier Cortor, Archibald Motley Jr., and with writers Richard Wright, Gwendolyn Brooks, Willard Motley, and Lorraine Hansberry. So stimulating was his association with these young black creative artists that Charles White was moved to make his own personal statement by painting his people as he saw them—"Charles White is one of the great voices among those black Americans who during the past thirty years have been the real interpreters of the American Negro."[1] By many standards, Charles White's work is extremely traditional, for he works with the old materials—pen and ink, lithography, oil on canvas—and he accepts the discipline of the old formats. But in other ways he is far from orthodox; he teaches his students to work within the contemporary context, using the materials and subjects they see around them. White stands out among his contemporaries

because he is endowed with a very special versatility, having worked in a variety of media and styles.

1. James A. Porter, "The Art of Charles White: An Appreciation," in Charles White, Fisk University, September-October, 1967, p. 4.

172 **Sojourner Truth and Booker T. Washington,** 1943
Wolf pencil on paper
30 × 20 in. (76.3 × 50.8 cm.)
The Newark Museum

173 **Exodus #1,** 1949
Linocut
31½ × 28¾ in. (80 × 73 cm.)
Signed
Private collection

174 **Take My Mother Home,** 1950
Chinese ink and colored ink
44 × 62 in. (11.8 × 157.5 cm.)
Signed
Private collection

175 **I Have a Dream #11,** 1968
Oil on board
Diameter: 16 in. (40.6 cm.)
Signed
Private collection

176 **The Brother,** 1968
Ink drawing
43 × 66 in. (109.3 × 167.7 cm.)
Courtesy of The Afro-American Collection
Golden State Mutual Life Insurance Company

177 **Seed of Love,** 1969
Ink drawing
51 × 36 in. (129.6 × 91.5 cm.)
Los Angeles County Museum of Art
Museum Associates Purchase

178 **The Prophet #1,** 1975-76
Color lithograph
27 × 37 in. (68.6 × 94 cm.)
Signed lower right
The Heritage Gallery
(See color plate, p. 110)

179 **The Prophet #2,** 1975-76
Color lithograph
27 × 37 in. (68.6 × 94 cm.)
Signed lower right
The Heritage Gallery

William E. Artis
b. 1919

Born in Washington, North Carolina. Studied at Nebraska State Teachers College, Chadron, B.S.; Syracuse University, B.F.A., M.F.A.; New York State University; New York State College of Ceramics; California State College, Long Beach; Pennsylvania State University, College Park; Art Students League, New York, 1933-35; Greenwich House Ceramics Center, New York; with Augusta Savage. Taught at Harlem YMCA and Nebraska State Teachers College, Chadron. Received John Hope Prize in Sculpture, Harmon Exhibition, 1933; received honorable mention for *Weariness* in Salons of America exhibition, Radio City, New York, 1934.

William Artis is entirely a twentieth-century artist, using images of black people to communicate his political and personal beliefs. Although the faces of his models often present a rather introverted impassivity, his work has a primitive strength of originality and a romantic, almost spiritual appeal. His restatement of the values and traditions derived from his culture's history is far more than simple repetition; it is the accomplishment of an artist whose pride in his racial heritage is equaled by his skill.

180 **African Youth,** 1940
Ceramic
9½ × 5 in. (24.2 × 12.7 cm.)
Louis K. Rimrodt

181 **Head of a Boy,** 1940
Terra cotta
h: 10 in. (25.4 cm.)
Department of Art, Fisk University
(See color plate, p. 111)

182 **Michael**
Terra cotta
h: 10 in. (25.4 cm.)
North Carolina Museum of Art, Mary Duke Biddle Gallery for the Blind Gift of the National Endowment for the Arts and the North Carolina Art Society (Robert F. Phifer Funds)

180

Calvin Burnett
b. 1921

Painter. Born in Cambridge, Massachusetts. Studied at Massachusetts School of Art, B.F.A.; School of the Museum of Fine Arts, Boston; Massachusetts College of Art, B.S.; Boston University, M.F.A.; Impressions Graphic Workshop, Boston, University Extension. Taught at DeCordova Museum, Lincoln, Massachusetts, and Massachusetts College of Art.

Major Exhibitions: Children's Art Centre, Boston, 1953, 1957; Lowell State College, Boston, 1955; Village Studio, New York, 1955; Joseph Gropper Gallery, Boston, 1955; Massachusetts Institute of Technology, Boston, 1955; National Center of Afro-American Artists, New York, 1972 (one-man).

In some of Calvin Burnett's paintings there is an element of hedonism, of sensual delight in the beauties and pleasures of nature and people. In others, however, he makes no attempt to alleviate the menace or brighten the brooding darkness of his subjects. He is basically a moralist, painting images of capitalist corruption. In *I've Been in Some Big Towns*, he seems to have plotted the canvas as an abstraction, later turning it into a figurative expression of the defensiveness of a country boy afraid of being taken by the city slickers.

183 **I've Been in Some Big Towns**, 1942
Egg tempera on board
13 × 11 in. (33 × 27.9 cm.)
Collection of the artist

184 **Self Portrait as Jim Crow**, 1945-48
Gouache
27 × 23 in. (68.6 × 58.4 cm.)
Collection of the artist

185 **Four-Part Black Political Poem**, 1960-74
Oil, vinyl-acrylic and collage on canvas
48 × 110 in. (121.9 × 279.5 cm.), four panels
Collection of the artist

183

Walter Williams
b. 1921

Painter, printmaker. Born in Brooklyn, New York. Studied at Brooklyn Museum Art School; Skowhegan School of Painting and Sculpture, Sweden.

Major Exhibitions: Roko Gallery, New York, 1954, 1962, 1963 (all one-man); Whitney Museum of American Art, New York, 1955, 1958, 1963; Gallery Noa Poa, Copenhagen, 1956 (one-man); Texas Southern University, Houston, 1962; Mexican-North American Cultural Institute, Mexico City, 1963 (one-man); The Brooklyn Museum, 1963; Gallery Brinken, Stockholm, 1965 (one-man); Studio 183, Sydney, Australia, 1965 (one-man); The Little Gallery, Philadelphia, 1966 (one-man); The White House, Washington, D.C., 1966; Frederick S. Wight Art Gallery, UCLA, Los Angeles, 1966; Gallery Marya, Copenhagen, 1967 (one-man); Fisk University, Nashville, 1967-68, 1969 (one-man), 1975 (one-man).

What is impressive about Williams' paintings, however traditional his formal devices may sometimes appear, is the fact that what he produces is always completely contemporary. His spontaneous discoveries of new uses of media are seen in the rhythmic marks of paint and collage. The marks, one feels, could at any moment rearrange themselves but would retain a sense of ordered harmony. This is not an art straining against its own limitations, but one that is exploring newly discovered and infinitely flexible means of expression.

186 **Poultry Market,** 1953
Oil on canvas
46 × 38 in. (116.8 × 96.5 cm.)
Signed lower left
Whitney Museum of American Art

187 **Southern Landscape,** 1963-64
Oil collage
39 × 34¾ in. (99.1 × 88.3 cm.)
Terry Dintenfass, Inc.
(See color plate, p. 112)

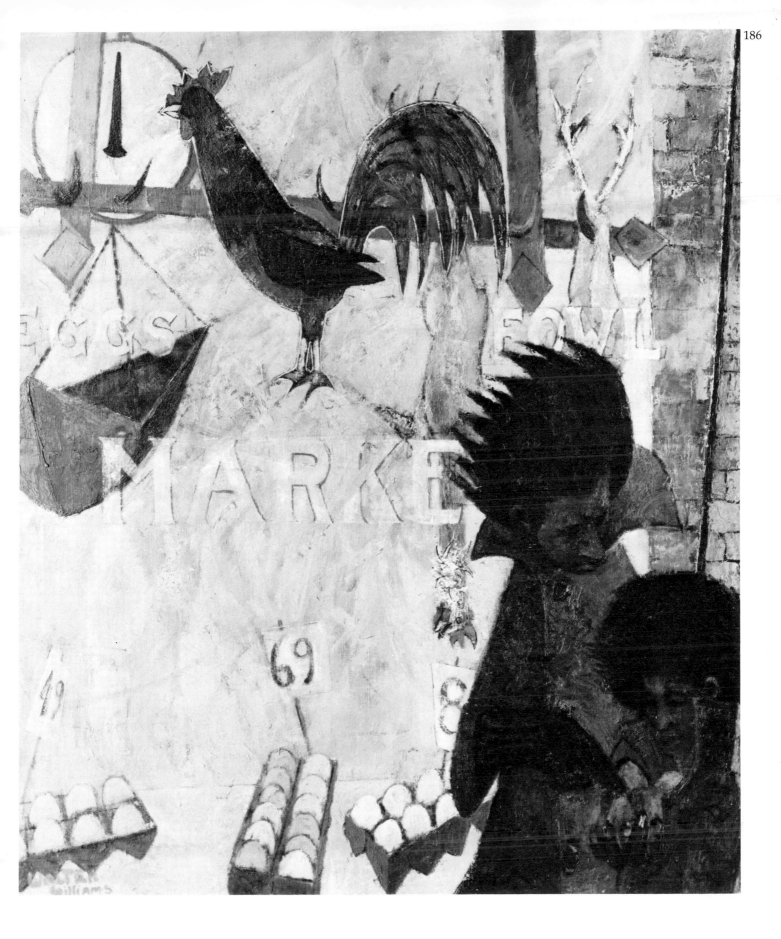

John Wilson
b. 1922

Painter, printmaker, illustrator, educator. Born in Boston, Massachusetts. Studied at the School of the Museum of Fine Arts, Boston, 1944; Tufts University, Medford, 1947; The Fernand Leger School, Paris, 1949; The Institute Politecnico, Mexico City, 1952; Esmerelda School of Art, Mexico City; La Escuela de las Artes del Libro, Mexico City, 1954-55. Taught at Pratt Institute, Brooklyn, 1958; Boston University.

Major Exhibitions: Library of Congress National Print Exhibition, Washington, D.C., 1943; Library of Congress International Print Exhibition, Washington, D.C., 1943; Institute of Contemporary Art, Boston, 1943; Boris Mirski Art Gallery, 1943; Addison Gallery, New York, 1943; Pepsi-Cola Annual, 1943; Society of American Etchers, Engravers, Lithographers and Woodcutters, Cincinnati Art Museum, 1943; Boston Printmakers Annual, 1943; Art Wood Gallery, 1943; Exchange Exhibition of American Prints in Italy, 1943; The Brooklyn Museum, 1943; 10th Annual South Shore Art Festival, Chicago, 1943; Joseph Gropper Gallery, Boston, 1943; National Academy of Design, New York, 1943; The Metropolitan Museum of Art, New York, 1943; Museum of Modern Art, New York, 1943; Atlanta University, 1943, 1944, 1951; Albany Institute, 1943; Bibliothèque Nationale, Paris, 1952; Musée des Beaux-Arts, Rouen, 1952; The Museum of Fine Arts, Boston, 1970; The Newark Museum, 1971; Boston Public Library, 1973; Detroit Institute of Arts.

The subject of John Wilson's *My Brother* is brought into close intimacy with the surface plane and consequently with the viewer. The melancholy single head, isolated in almost anonymous surroundings, seems to reflect the introspection of both artist and sitter and to celebrate a sympathetic bond of deep feeling between them. Wilson seems to make the limbo of empty space around the head function as both surface and depth. The painting is a kind of reinterpretation of primitive style: the spatial conventions; the strictly linear composition; the frontal approach, all seem to project a quality of design predominant in most primitive paintings.

188 **My Brother,** 1942
Oil on panel
10⅝ × 12 in. (27 × 35 cm.)
Smith College Museum of Art

189 **Self Portrait,** 1945
Oil
14¾ × 18¾ in. (37.5 × 47.7 cm.)
Mrs. Julia Wilson

190 **Mother and Child,** 1965
Oil
32 × 36½ in. (81.3 × 92.8 cm.)
Collection of the artist

191 **Erica,** 1975
Bronze
h: 7 in. (17.8 cm.)
Collection of the artist

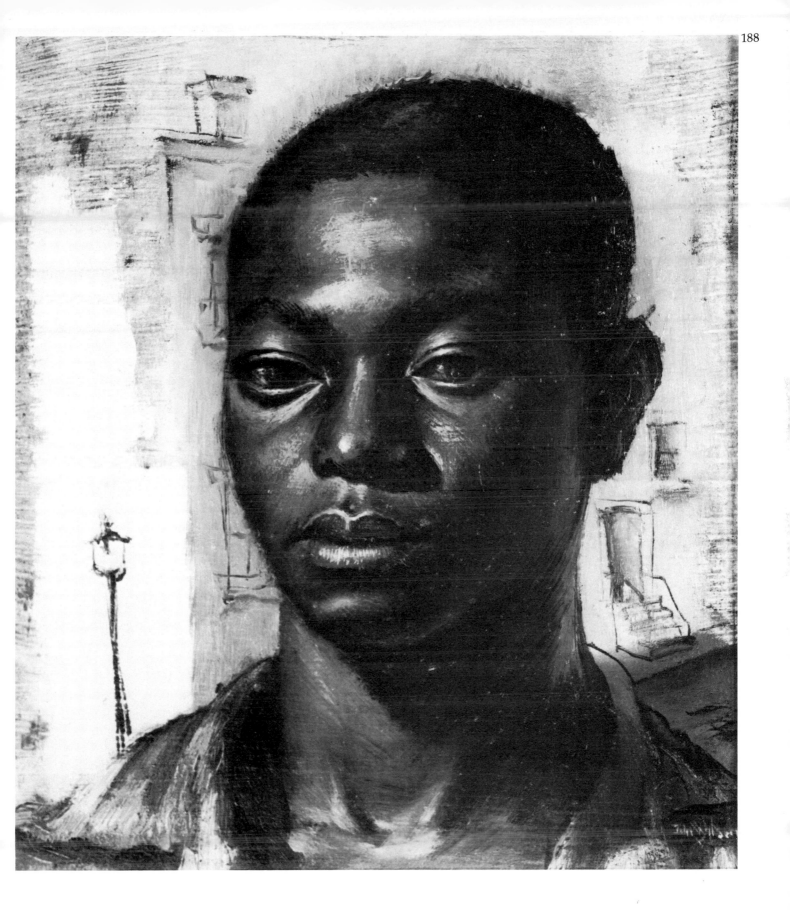

John Biggers
b. 1924

Painter, sculptor, graphic artist, educator, and muralist. Born in Gastonia, North Carolina. Studied at Hampton Institute, Virginia; Pennsylvania State University, College Park. Included in his many awards is the Harbison Award for Distinguished Teaching, 1968. Presently Chairman of the Art Department at Texas Southern University, Houston, Texas.

Major Exhibitions: Atlanta University, 1944; won purchase prizes at Houston Museum, 1950; Atlanta University Annuals, 1950-53; Dallas Museum, 1952.

"In America," Biggers says, "the black artist is influenced, I think, by his total environment, but underneath it all, even from the womb, he was shaped as a black artist. It is almost genetic....I would say black art can be recognized for its warmth, its fertility, its visceral qualities."[1] Biggers still sees in the American black culture traces of "Africanisms" that many artists do not recognize, and this is reflected in the strong sense of African composition and design evident in *The Cradle*. As in Johnson's *Forever Free*, a weary, frustrated mother cradles her faceless children, giving strength and support to their battle for life.

1. *Ann Holmes, "It Is Almost Genetic,"* The Art Gallery Magazine, *April 1970, p. 38.*

192 **The Cradle,** 1950
Charcoal
22⅜ × 21½ in. (56.9 × 54.6 cm.)
Signed lower left
Museum of Fine Arts, Houston

193 **The Man,** 1965
Charcoal drawing
49½ × 37 in. (125.8 × 94 cm.)
Courtesy of The Afro-American Collection
Golden State Mutual Life Insurance Company

194 **Family Series,** 1975
Conte crayon
42 × 30½ in. (106.8 × 77.5 cm.)
Signed bottom right
Collection of the artist

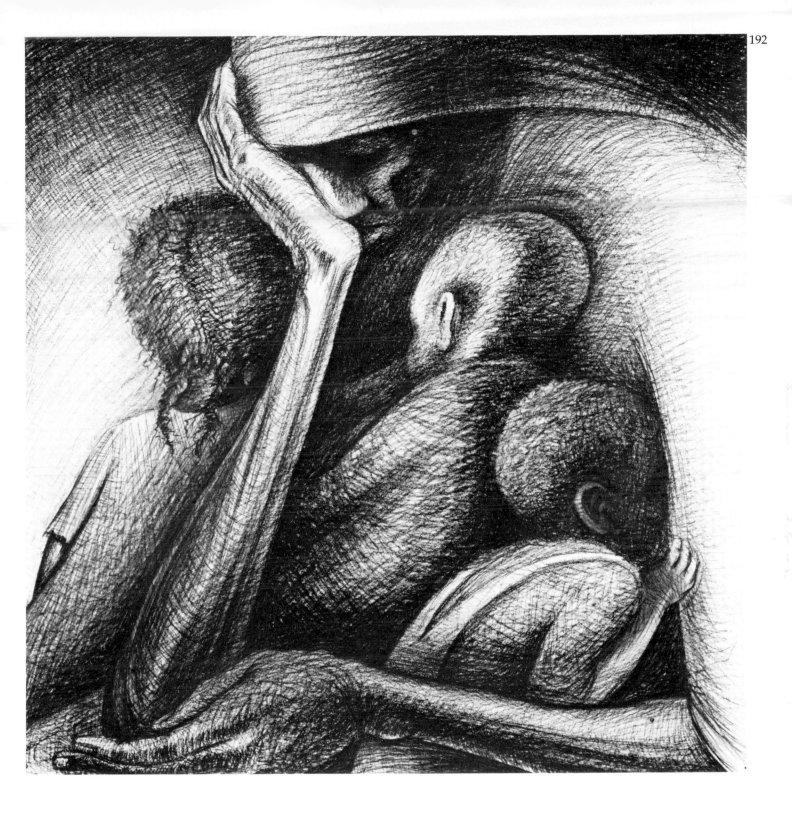

Richard Mayhew
b. 1924

Painter. Born in Amityville, New York. Studied at The Brooklyn Museum Art School; Art Students League, New York; Pratt Institute, Brooklyn.

Major Exhibitions: Morris Gallery, New York, 1957; The Brooklyn Museum, 1967; Art Institute of Chicago, 1967; National Academy of Design, New York, 1967; Carnegie Institute, Pittsburgh, 1967; Frederick S. Wight Art Gallery, UCLA, Los Angeles, 1967; Gallery of Modern Art, New York, 1967; Whitney Museum of American Art, New York, 1969; San Francisco Museum of Art, 1969; The High Museum of Art, Atlanta, 1969; Museum of Fine Arts, Boston, 1970.

In *Rockland*, Richard Mayhew seems to be stressing the dynamics of movement and countermovement, of positive and negative space, of advancing and receding color. No self-conscious shapes or sharp contours inhibit the mysterious flow. The superimposed colors stain directly into each other, never hardening into separate planes. Because the successive layers of paint sink into the canvas and become identified with it, foreground and background are one.

195 **Rockland,** 1969
 Oil
 50 × 50 in. (127 × 127 cm.)
 Signed lower right
 Midtown Galleries

Gregory Ridley, Jr.
b. 1925

Sculptor, painter, educator. Born in
Smyrna, Tennessee. Studied at Fisk
University, Nashville; Agriculture and
Industrial State University of Louisville,
M.A.

Major Exhibitions: Atlanta University
Summer Festival of Art; Exhibition of
American Vet's Society of Artists, New
York; Fisk University, Nashville, 1945-72;
Xavier University, New Orleans, 1963;
Sheraton Hotel, Philadelphia, 1968;
Museum of Fine Arts, Boston, 1970;
University of Iowa, Iowa City, 1971-72;
Smith-Mason Gallery of Art,
Washington, D.C., 1971.

When viewing *African Mask,* one must
remember that the artist, a black man,
is heir to both African and American
traditions of painting. The tendency of
the features to slip from their natural
positions and to slide toward and even
into each other as well as the angular
treatments on both the left and right sides
create the specifically cubist effect of this
painting. There is no original, unoccupied
space in which the mask has been
discovered. Such space as there is has
been generated by the angles and the
intervals between them, and it is further
broken into jagged shapes as though the
space were a palpable substance.

196 **African (Ashanti) Mask,** 1964
 Oil
 30 × 40 in. (76.2 × 101.6 cm.)
 Signed lower right
 Department of Art, Fisk University

Ed Wilson
b. 1925

Sculptor, illustrator. Born in Baltimore, Maryland. Studied at University of Iowa, Iowa City, B.A., 1950, M.A., 1951; University of North Carolina, Greensboro, 1961. Vice Chairman for Studio Art at State University of New York at Binghamton.

Major Exhibitions: University of Iowa, Iowa City, 1951, 1954; North Carolina Agriculture and Technical College, Greensboro, 1955; Duke University, Durham, 1956; The Baltimore Museum of Art, 1956, 1962; Madison Square Garden, New York, 1958; Detroit Institute of Arts, 1958; Pennsylvania Academy of the Fine Arts, Philadelphia, 1960; Harlem School of the Arts, New York, 1960; Howard University Gallery of Art, Washington, D.C., 1961, 1970; Frederick S. Wight Art Gallery, UCLA, Los Angeles, 1966; Fine Arts Gallery of San Diego, 1967; The Oakland Museum, 1967; The High Museum of Art, Atlanta, 1969; Rhode Island School of Design, Providence, 1969; San Francisco Museum of Art, 1969.

Based on sound technical principles, Ed Wilson's sculptures are constructed with a great sense of volume, solidity, and weight. In the magnificently realized *Cybele*, a sympathetic observation of human anatomy has been simplified and generalized to create a unique combination of monumentality and voluptuousness. With its subtly adjusted geometry, *Cybele* is reminiscent of Edmonia Lewis' neoclassical *Asleep* (cat. no. 51), but in some of Wilson's later works the anatomical forms become semi-abstract rhythmic elements. *Seven Seals of Silence*, for example, is an almost confessional statement of the spiritual unrest of the sixties.

197 **The Cybele,** 1954
Marble
h: 32½ in. (82.5 cm.)
Collection of the artist

198 **Seven Seals of Silence,** 1966
Bronze
Signed on the edges
Collection of the artist
The Invisible, h: 13½ in. (34.3 cm.)
The Maimed and the Ignorant, h: 8 in. (20.3 cm.)
The Conformists, h: 12½ in. (31.8 cm.)
The Uninspired, h: 14⅜ in. (36.5 cm.)
The Rejected, h: 8½ in. (21.6 cm.)
The Depraved, h: 13 in. (33 cm.)
The Dead, h: 11¼ in. (28.6 cm.)

199 **The Board of Directors,** 1969
Bronze and chrome-plated steel
h: 16 in. (40.6 cm.)
Collection of the artist

198

Earl J. Hooks
b. 1927

Sculptor, ceramist. Born in Baltimore, Maryland. Studied at Howard University, Washington, D.C.; Catholic University of America, Washington, D.C.; Rochester Institute of Technology; School of American Craftsmen, New York. Presently a professor of art at Fisk University, Nashville.

Major Exhibitions: Smithsonian Institution, Washington, D.C., 1954; Howard University Gallery of Art, Washington, D.C., 1954; Miami National, 1954, 1955, 1958; Atlanta University, 1954; Rochester Memorial Art Gallery, 1954; American House, New York, 1954; Young American Show, 1954; Art Institute of Chicago, 1957.

"Pottery provides all the ways in which a person may express himself. Here you have form, design, color, balance, rhythm, harmony, all in one. For me the sculptural aspects of pottery have always been the overriding thing. Pottery, unlike painting, is constant in that the materials are basic. Pottery is earthy. It has undergone few changes. And it has not been invaded and bombarded by modern chemical changes."[1] Earl Hooks has been teaching and producing art for the past twenty years, and every day he brings to his work new energy, new life, and new forms.

1. Elton C. Fax, Seventeen Black Artists (New York: Dodd, Mead, 1971), p. 218.

200 **Man of Sorrows,** 1950
Marble
h: 13 in. (33 cm.)
Department of Art, Fisk University

201 **Campus Forms**
Ceramic
h: 15½ in. (39.4 cm.)
Department of Art, Fisk University

200

Sam Middleton
b. 1927

Painter, printmaker. Born in New York City. Studied at the Instituto Allende at San Miguel de Allende in Mexico.

Major Exhibitions: Galerie Excelsior, Mexico City, 1957 (one-man); Associated Artists Studio, New Orleans, 1957, 1959; Contemporary Arts, New York, 1958, 1960, 1962; Whitney Museum of American Art, New York, 1958-62; The Brooklyn Museum, 1959-61; Galerie Silo, Madrid, 1960; Galerie Passepartout, Copenhagen, 1961; Galerie Arta, The Hague, 1963, 1964; Stedelijk Museum, Amsterdam, 1966.

Sam Middleton paints forms that drift in undefined space. Both delicate and expressive, his work incorporates swelling shapes as well as organic, often visceral symbols floating through gelatinous spaces. His paintings appear to be spontaneous improvisations using a flow of images from memory, dreams, still lifes, and other works of art. Fragments of anatomy described by fine lines seem bound into their own spaces; yet some dynamic, explosive force seems to invade their isolation. Middleton's nervous calligraphy dances wildly and brilliantly across the canvas surface.

202 Composition
Mixed media
20¾ × 31 in. (52.7 × 78.8 cm.)
Department of Art, Fisk University

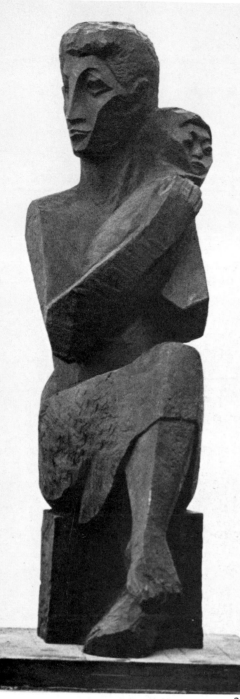

205

William (Bill) Taylor
b. 1927

Sculptor. Born in Atlantic City, New Jersey. Studied at Washington Institute of Contemporary Arts; Catholic University of America, Washington, D.C.

Mother and Child is characteristic of Taylor's work, with its figures developed from a block of wood that provides a unifying element. He carves directly into the wood, staying close to its natural contours. *Mother and Child* evokes a nostalgic sentiment, but at the same time exudes an uncanny authenticity, creating a fresh image of a theme that has recurred throughout the history of art.

203 **Posed Woman,** 1950
Wood
h: 27½ in. (69.9 cm.)
Signed on right arm
Louis K. Rimrodt

204 **Descent from the Cross,** 1961
Walnut
h: 68 in. (172.7 cm.)
Signed right side
Collection of the artist

205 **Mother and Child,** 1962
Walnut
h: 40 in. (101.6 cm.)
Signed right side
Collection of the artist

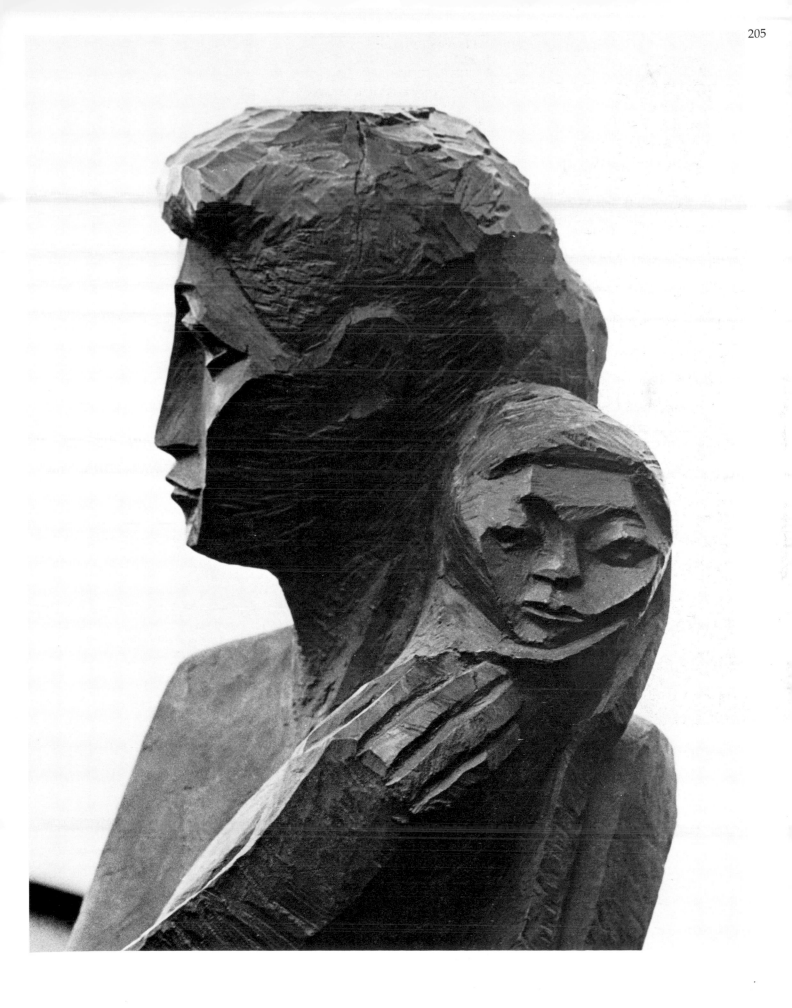

Selected Bibliography

Books

Adams, Russell.
Great Negros Past and Present.
Chicago: Afro-American Publishing Co.,
1969.

American Artists' Congress.
*First American Artists' Congress against War
and Fascism.*
New York, 1936.

American Institute of Architects.
American Architects Directory.
New York: R. R. Bowker, 1956-70.

Aptheker, Herbert, ed.
*Documentary History of the Negro People in
the United States.*
2 vols. 2nd ed. New York: Citadel Press,
1964.

Arnold, John W.
Art and Artists of Rhode Island.
Providence: Rhode Island Citizen's
Association, 1905.

*Art of the Americas from before Columbus to
the Present Day: A Pictorial Survey.*
Reprint from the *Art News Annual*, no. 18.
New York: Simon and Schuster, 1948.

Artists/USA, 1972-1973.
Feasterville, Pa.: Artists/USA Inc., 1972.

Atkinson, J. Edward, comp. and ed.
*Black Dimensions in Contemporary American
Art.*
New York: New American Library, 1971.

Bardolph, Richard.
The Negro Vanguard.
Reprint. Westport, Conn.: Negro
Universities Press, 1959.

Barr, Alfred, ed.
*Painting and Sculpture in the Museum of
Modern Art*
New York: Museum of Modern Art, 1942.

Bartran, Margaret.
A Guide to Color Reproductions.
Metuchen, N.J.: Scarecrow Press, Inc.,
1971.

Baur, John I. H., ed.
*New Art in America: 50 Painters of the 20th
Century.*
Greenwich, Conn.: New York Graphic
Society, 1957.

Bearden, Romare, and Henderson, Harry.
Six Black Masters of American Art.
New York: Zenith Books, 1972.

Benezit, Emmanuel.
*Dictionnaire des Peintres, Sculpteurs,
Dessinateurs et Graveurs.*
France: Librairie Gründ, 1948.

Bergman, Peter M.
*The Chronological History of the Negro in
America.*
New York, Evanston, London: Harper
and Row, 1969. A Bergman Book.

Bethers, Ray.
Pictures, Painters, and You.
New York: Pitman Pub. Co., 1948.

*Black American Artists of Yesterday and
Today.*
Black Heritage Series. Dayton, Ohio:
George A. Pflaum, Publisher, 1909.

The Black Photographers Annual 1973.
Brooklyn: Black Photographers Annual,
Inc.

Bone, Robert.
The Negro Novel in America.
New Haven. Yale University Press, 1958.

Boning, Richard A.
Profiles of Black Americans.
Rockville Centre, N. Y.: Dexter and
Westbrook, Ltd., 1969.

Boswell, Peyton, Jr.
Modern American Painting.
New York: Dodd, Mead, 1939.

Brawley, Benjamin.
*The Negro in Literature and Art in the United
States.*
Rev. ed. New York: Dodd, Mead, 1934.

Brawley, Benjamin.
Negro Builders and Heroes.
Chapel Hill, University of North Carolina
Press, 1937.

Brawley, Benjamin.
A Short History of the American Negro.
4th rev. ed. New York: Macmillan Co.,
1939.

Brawley, Benjamin.
*The Negro Genius, A New Appraisal of the
Achievement of the American Negro in
Literature and the Fine Arts.*
New York: Biblo and Tannen, 1965.

Brawley, Benjamin.
The Negro Genius.
2nd ed. New York: Biblo and Tannen,
1966.

Brown, Sterling.
The Negro Caravan.
New York: Dryden Press, 1942.

Bryan, Michael.
Bryan's Dictionary of Painters and Engravers.
5 vols. New York: Macmillan Co., 1903-5.

Bullock, Ralph W.
In Spite of Handicaps.
New York: Association Press, 1967.

Burroughs, Margaret, et al.
National Conference of Negro Artists.
Atlanta: Atlanta University, 1959.

Burton, E. Milby.
South Carolina Silversmiths, 1690-1800.
Charleston: Charleston Museum, 1942.

Butcher, Margaret J.
The Negro in American Culture.
New York: Alfred A. Knopf, 1967.

Butts, Porter.
Art in Wisconsin.
Madison: Madison Art Association,
Wisconsin Centennial Committee, and
University of Wisconsin Division of Social
Education, 1936.

Cahill, Holger, et al.
Masters of Popular Painting.
New York: Museum of Modern Art, 1938.

Cahill, Holger, and Barr, Alfred, Jr., eds.
Art in America in Modern Times.
New York: Reynal and Hitchcock, 1934.

Cahill, Holger, and Barr, Alfred, Jr., eds.
New Horizons in American Art.
New York: Museum of Modern Art, 1936.

Callaway, Thomas J.
"The American Negro Exhibits at the Paris
Exposition." In *Hampton Negro Conference,*
pp. 74-80.
Hampton, Va.: Hampton Institute Press,
1901.

*Celebrating Negro History and Brotherhood:
A Folio of Prints by Chicago Artists.*
Chicago: Seven Arts Workshop, 1956.

Chase, George Henry, and Post,
Chandler R.
A History of Sculpture.
New York and London: Harper and
Brothers Publishers, 1925.

Chase, Judith W.
Afro-American Art and Craft.
New York: Van Nostrand Reinhold
Company, 1971.

Clapp, Jane.
Art Reproductions.
New York: Scarecrow Press, Inc., 1961.

Clapp, Jane.
Sculpture Index.
vol. 2. Metuchen, N.J.: Scarecrow Press,
1970.

Clarke, John H.
Harlem USA.
New York: Collier Books, 1971.

Clement, Clara E., and Hutton, Laurence.
*Artists of the Nineteenth Century: Their
Works.*
Boston: Osgood, 1885.

Coen, Rena N.
The Black Man in Art.
Minneapolis: Lerner Publications Co.,
1970.

Cole, Natalie R.
Arts in the Classroom.
New York: John Day, 1940.

Craven, Thomas, ed.
A Treasury of American Prints.
New York: Simon and Schuster, 1939.

Cummings, Paul.
*A Dictionary of Contemporary American
Artists.*
New York: St. Martin's Press, 1966.

Dabney, Wendell P.
Cincinnati's Colored Citizens.
Cincinnati: Dabney Publishing Co., 1926.

Dannett, Sylvia G. L.
Profiles of Negro Womanhood.
2 vols. Negro Heritage Library. Yonkers,
N.Y.: Educational Heritage, Inc., 1964,
1966.

David, Jay.
Black Joy.
Chicago: Bill Adler Books, Inc., 1971.

Davis, John P., ed.
*The Public Library and Reference Material on
the American Negro.*
New York: Phelps-Stokes Fund, 1963.

Davis, John P., ed.
The American Negro Reference Book.
Negro Heritage Library. Yonkers, N.Y.:
Educational Heritage, Inc., 1966.

Davison, Ruth M., and Legler, April,
comps.
*Government Publications on the American
Negro in America, 1948-1968.*
Focus: Black America Bibliography Series.
Bloomington: Indiana University, 1969.

Diamond Jubilee Exposition Authority.
Cavalcade of the American Negro.
Chicago: Illinois Writers' Project, 1940.

Dixon, Vernon J., and Foster, Badi.
Beyond Black or White.
Boston: Little, Brown & Co., 1971.

Dover, Cedric.
American Negro Art.
Greenwich, Conn.: New York Graphic
Society, 1960.

Dow, George F.
*The Arts and Crafts in New England,
1704-1775.*
Topsfield, Mass.: Wayside Press, 1927.

DuBois, W. E. B.
The Philadelphia Negro: A Social Study.
Philadelphia: University of Pennsylvania,
1899.

DuBois, W. E. B.
The Negro Artisan.
Atlanta: Atlanta University Press, 1902.
Reprint. New York: Arno Press and The
New York Times, 1969.

DuBois, W. E. B., ed.
*A Selected Bibliography of the Negro
American.*
Atlanta: Atlanta University Press, 1905.

DuBois, W. E. B.
The Gift of Black Folk.
Boston: Stratford Co., 1924.

DuBois, W. E. B.
Black Folk—Then and Now.
New York: H. Holt, 1939.

DuBois, W. E. B.
Encyclopedia of the Negro.
2nd ed. New York: Phelps-Stokes Fund,
1946.

DuBois, W. E. B.
The Souls of Black Folk.
New York: Fawcett Publication, 1961.

Dunbar, Ernest, ed.
The Black Expatriates.
New York: E. P. Dutton and Co., Inc.,
1968.

Editors of *Ebony.*
The Negro Handbook.
Chicago: Johnson Publications Co., 1966.

Fax, Elton C.
Seventeen Black Artists.
New York: Dodd, Mead, 1971.

Franklin, John Hope.
From Slavery to Freedom.
3rd ed. New York: Vintage Books, 1969.

French, H.W.
Art and Artists of Connecticut.
Boston: Lee and Shephard, 1879.

Fuller, Thomas O.
Pictorial History of the American Negro.
Memphis, Tenn.: Pictorial History, Inc.,
1933.

Gayle, Addison.
The Black Aesthetic.
Garden City, N.Y.: Doubleday, 1971.

Geldzahler, Henry.
American Painting in the Twentieth Century.
New York: The Metropolitan Museum of
Art, 1965.

George Cleveland Hall Branch Library.
*The Special Negro Collection at the George
Cleveland Hall Branch Library.*
Chicago: n.p., 1968.

Greene, Lorenzo Johnson.
*The Negro in Colonial New England,
1620-1776.*
New York: Columbia University Press,
1942.

Hale, R. B., ed.
*One Hundred American Painters of the
Twentieth Century.*
New York: The Metropolitan Museum of
Art, 1950.

Haley, James T.
*Afro-American Encyclopedia: Or, the
Thoughts, Doings, and Sayings of the Race.*
Nashville, Tenn.: Haley and Florida, 1896.

Harvard University Library.
*Afro-American Studies: A Guide to Resources
of the Harvard University Library.*
Preliminary edition. Cambridge: Harvard
University Press, 1969.

Harvard University Library.
*Resources of the Harvard University Library
for Afro-American and African Studies.*
Cambridge: Harvard University Press,
1969.

Howard University Graduate School,
Division of Social Science.
*The New Negro Thirty Years Afterward:
Papers Contributed to the 16th Annual Spring
Conference, April 20, 21, and 22, 1955.*
Washington, D.C.: Howard University
Press, 1955.

Huggins, Nathan.
The Harlem Renaissance.
New York: The Oxford University Press,
1971.

Hughes, Langston.
A Pictorial History of the Negro in America.
New York: Crown, 1956.

Hunter, Sam.
American Art of the Twentieth Century.
New York: Harry N. Abrams, Inc., 1972.

Jackson, Giles B. and Davis, D. Webster.
The Industrial History of the Negro Race in the United States.
Richmond: n.p., 1908.

Johnson, James Weldon.
Black Manhattan.
New York: Alfred A. Knopf, 1930.

Larkin, Oliver.
Art and Life in America.
New York: Holt, Rinehart and Winston, 1960.

Lewis, Samella S., and Waddy, Ruth G.
Black Artists on Art.
2 vols. Los Angeles: Contemporary Crafts, Inc., 1971.

Lloyd, Tom.
Black Art Notes.
n.p.: n.d.

Locke, Alain.
"Negro Art." In *Encyclopaedia Britannica,* 14th and 15th eds.

Locke, Alain.
Negro Art: Past and Present.
Washington, D.C.: Associates in Negro Folk Education, 1936.

Locke, Alain.
The Negro in Art.
Washington, D.C.: Associates in Negro Folk Education, 1940.

Locke, Alain.
The New Negro.
New York: Albert & Charles Boni, Inc., 1925. Reprint. Boston: Atheneum Press, 1968.

Locke, Alain, ed.
The New Negro, an Interpretation.
New York: Arno Press and The New York Times, 1968.

Louisiana: A Guide to State W.P.A. in the State of Louisiana.
New York: Hastings House, 1941.

Mallett, Daniel Trowbridge.
Mallett's Index of Artists: International-Biographical: Including Painters, Sculptors, Illustrators, Engravers, and Etchers of the Past and Present. Orig. and Supplement.
New York: Peter Smith, 1948.

McPherson, John M.; Holland, Laurence B.; and Bell, Michael D.
Blacks in America, Bibliographical Essays.
Garden City, N.Y.: Doubleday, 1971.

Miller, Elizabeth W.
Negro in America: A Bibliography.
Cambridge: Harvard University Press for the American Academy of Arts and Sciences, 1966.

Morsbach, Mabel.
The Negro in American Life.
New York: Harcourt, Brace & World, in conjunction with the Cincinnati Public Schools, 1967.

Murray, Freeman Morris Henry.
Emancipation and the Freed in American Sculpture: A Study in Interpretation.
Washington, D.C.: Freeman Morris Henry Murray, 1916.

Myers, Carol L., ed.
Black Power in the Arts.
Flint, Mich.: Flint Board of Education, 1970.

National Conference of Artists.
A Print Portfolio by Negro Artists: A Souvenir in Observance of the Emancipation Proclamation Centennial, 1863-1963.
Chicago: n.p., 1963.

Patterson, Lindsay, comp. and ed.
The Negro in Music and Art.
International Library of Negro Life and History. Under the auspices of the Association for the Study of Negro Life and History. New York: Publishers Co., Inc., 1968.

Ploski, Harry A.; Kaiser, Ernest; and Lindenmeyer, Otto J., eds.
"The Black Artists." In *Reference Library of Black America.*
New York: Bellwether Publishing Co., 1971.

Porter, Dorothy B.
A Working Bibliography on the Negro in the United States.
Reproduced by University Microfilms for the National Endowment for the Humanities Summer Workshops in the Materials of Negro Culture, 1968.

Porter, James A.
"The Negro Artist." Master's thesis, New York University, 1937.

Porter, James A.
Modern Negro Art.
New York: Dryden Press, 1943. Reprint.
New York: Arno Press, 1969.

Porter, James A.
"The Transcultural Affinities of American Negro Art." In *Africa Seen by American Negros.*
Dijon: Presence Africaine, 1958.

Ritchings, G. F.
Evidences of Progress among Colored People.
Philadelphia: George S. Ferguson Co., 1899.

Robinson, Wilhelmena S.
Historical Negro Biographies.
International Library of Negro Life and History. Under the auspices of the Association for the Study of Negro Life and History. New York: Publishers Co., Inc., 1967.

Roelof-Lanner, T.V., ed.
Prints by American Negro Artists.
Los Angeles: Los Angeles Cultural Exchange Center, 1965.

Romero, Patricia W., comp. and ed.
I Too Am America: Documents from 1619 to the Present.
International Library of Negro Life and History. Under the auspices of the Association for the Study of Negro Life and History. New York: Publishers Co., Inc., 1968.

Rose, Barbara.
American Art since 1900: A Critical History.
New York: Frederick A. Praeger, 1967.

Roucek, Joseph S., and Kiernan, Thomas, eds.
The Negro Impact on Western Civilization.
New York: Philosophical Library, 1970.

St. Gaudens, Homer.
The American Artist and His Times.
New York: Dodd, Mead, 1941.

Schoener, Allon, comp.
Harlem on My Mind: Cultural Capital of Black America, 1900-1968.
New York: Random House, 1968.

Siegel, Jeanne.
"Four American Negro Painters, 1940-1965, Their Choice and Treatment of Themes."
Master's thesis, Columbia University, 1966.

Simmons, W. J.
Men of Mark, Eminent, Progressive and Rising.
Cleveland: Revel, 1887.

Stull, Edith.
Unsung Black Americans.
New York: Grosset & Dunlap, 1971.

Wesley, Charles H.
In Freedom's Footsteps: From the African Background to the Civil War.
International Library of Negro Life and History. Under the auspices of the Association for the Study of Negro Life and History. New York: Publishers Co., Inc., 1967.

Wesley, Charles H.
The Quest for Equality: From Civil War to Civil Rights.
International Library of Negro Life and History. Under the auspices of the Association for the Study of Negro Life and History. New York: Publishers Co., Inc., 1967.

Wesley, Charles H. and Romero, Patricia W.
Negro Americans in the Civil War: From Slavery to Citizenship.
International Library of Negro Life and History. Under the auspices of the Association for the Study of Negro Life and History. New York: Publishers Co., Inc., 1968.

West, Earle H., comp.
A Bibliography of Doctoral Research on the Negro: 1933-1966.
Ann Arbor, Mich.: University Microfilms, 1969.

Wheadon, Augusta Austin.
The Negro from 1863 to 1963.
New York: Vantage Press, 1964.

Wilson, James G., and Fiske, John, eds.
Appleton's Cyclopedia of American Biography.
New York: D. Appleton and Co., 1888.
Reprint. Detroit: Gale Research Co., 1968.

Wilson, Joseph.
Sketches of the Higher Classes of Colored Society in Philadelphia, by a Southerner.
Philadelphia: Merrihew and Thompson, 1841.

Catalogs

Woodruff, Hale A.
The American Negro Artist.
Ann Arbor, Mich.: University of Michigan
Press, 1956.

Work Projects Administration, Illinois.
Subject Index to Literature on Negro Art.
Chicago: Chicago Public Library, 1941.

Writers' Program of the WPA, Alabama.
Alabama: A Guide to the Deep South.
New York: Richard R. Smith, 1941.

Yenser, Thomas, ed.
*Who's Who in Colored America: A
Biographical Dictionary of Notable Living
Persons of African Descent in America.*
New York: Thomas Yenser, 1933.

Young, William, ed. and comp.
*A Dictionary of American Artists, Sculptors
and Engravers from the Beginnings through
the Turn of the Twentieth Century.*
Cambridge, Mass.: William Young and
Co., 1968.

Acts of Art Gallery, New York.
Black Women Artists 1971.
June 22-July 30, 1971.

Acts of Art Gallery, New York.
*Rebuttal Catalogue: Catalogue of the Rebuttal
Exhibition to the Whitney Museum.*
1971.

Aesthetic Dynamics, Wilmington, Del.
*Afro-American Images 1971. Memorial
Exhibition for James A. Porter.*
Held at the State Armory, Wilmington,
Del., February 5-26, 1971.

Albany Institute of History and Art
*The Negro Artist Comes of Age: A National
Survey of Contemporary American Artists.*
January 3-February 11, 1945.

American Negro Exposition, Chicago.
The Art of the American Negro, 1851-1940.
Exhibition organized by Alonzo Aden.
Introduction by Alain Locke. 1940.

Art Institute of Chicago.
Exhibitions by Artists of Chicago and Vicinity.
1923.

Art Institute of Chicago.
Negro in Art Week.
November 16-23, 1927. Chicago: Guston,
1927.

Art Institute of Chicago.
Exhibitions by Artists of Chicago and Vicinity.
1931.

Arthur Newton Galleries, New York.
An Art Commentary on Lynching.
Introduction by Sherwood Anderson and
Erskine Caldwell. February 1935.

Association for the Study of Negro Life
and History, Washington, D.C.
*Exhibition of Works by Negro Artists at the
National Gallery of Art.*
October 31-November 6, 1933.

Atlanta University.
Exhibition.
Organized by Hale Woodruff and the
Harmon Foundation. February 1934.

Augusta Savage Studios, Inc., New York.
*First Annual Exhibition Salon of
Contemporary Negro Art.*
June 8-22, 1939.

Baltimore Museum of Art.
Contemporary Negro Art.
February 3-19, 1939.

Barnett-Aden Gallery, Washington, D.C.
Eighteen Washington Artists.
Introduction by James A. Porter and
Agnes Delano. 1953.

Boston Public Library.
*The Black Artist in America: A Negro History
Month Exhibition.*
Boston: Boston Negro Artists Association,
1973.

Brockman Gallery, Los Angeles.
Contemporary Black Imagery: 7 Artists.
October 10-30, 1971.

Brooklyn College.
*Afro-American Artists since 1950: An
Exhibition of Paintings, Sculpture, and
Drawings.*
April 15-May 18, 1969.

Carnegie Institute.
Pittsburgh International Exhibition of Contemporary Painting.
1955.

Chicago World's Fair.
Century of Progress Exhibition.
1933-34.

City College of New York.
The Evolution of Afro-American Artists, 1800-1950.
Catalog by Carroll Greene, Jr. Organized in cooperation with the Harlem Cultural Council and the New York Urban League.
1967.

College of Marin Art Gallery, Kentfield.
California Black Artists.
March 13-April 10, 1970.

Commodore Hotel, New York.
Exhibition.
Organized by Rev. Maurice F. Noonan and the Harmon Foundation. New York: Propagation of Faith Mission, 1934.

Detroit Institute of Arts.
Other Ideas.
1969.

District of Columbia Art Association, Anacostia Neighborhood Museum.
D.C. Art Association 2nd Annual.
1970.

District of Columbia Art Association, Anacostia Neighborhood Museum.
Exhibition '71.
Washington, D.C.: Smithsonian Institution Press, 1971.

District of Columbia Art Association, Anacostia Neighborhood Museum.
The Barnett-Aden Collection.
Catalog by Edmund B. Gaither.
Washington, D.C.: Smithsonian Institution Press for the Anacostia Neighborhood Museum, 1974.

Downtown Gallery, New York.
American Negro Artists Exhibition.
1941.

Downtown Gallery, New York.
American Negro Art: Nineteenth and Twentieth Centuries.
December 9-January 3, 1942.

DuSable Museum of African American History, Chicago.
Contemporary Black Artists.
Illustrated calendar, 1970-71.

Edmonton Art Gallery, Edmonton, Can.
The Washington Artists: 1950-1970.
1970.

Fairleigh Dickinson University Art Gallery, Madison, N.J.
Some Negro Artists.
October 20-November 20, 1964.

Fisk University, Ballentine Hall, Nashville.
39th Arts Festival Exhibition. Sculpture by Richard Hunt, Paintings by Sam Middleton.
April 21-May 17, 1968.

Fisk University, Art Galleries, Nashville.
Three Afro-Americans: Paintings by Merton Simpson, Sculpture by Earl Hooks, Photography by Bobby Sengstacke.
Foreword by David C. Driskell. April 20-May 15, 1969.

Fisk University, Nashville.
Amistad II: Afro-American Art.
Essays by Grant Spradling, Clifton Johnson, David C. Driskell, and Allan Gordon. New York: American Missionary Association, 1975.

Flint Community Schools, Flint, Mich.
Black Reflections: Seven Black Artists.
1969.

Fort Huacuca, Ariz.
Exhibition of the Works of 37 Negro Artists.
1943.

The G Place Gallery, Washington, D.C.
New Names in American Art.
Foreword by Alain Locke. June 13-July 4, 1944.

Greene, Carroll, Jr.
Afro-American Artists: 1800-1968.
Slides and commentary. Baldwin, N.Y.: Prothmann Assoc., 1968.

Greenwich Village Galleries, New York.
Autumn Exhibition of the Primitive African Art Center and the Boykins School of Arts and Crafts, Inc.
November 16-31, 1932.

Harlem Community Art Center.
Harlem Art Teacher's Exhibit.
October 17, 1938.

Harlem Cultural Center.
Negro Artists of the Nineteenth Century.
1966.

Harlem Cultural Council.
The Art of the American Negro: Exhibition of Paintings.
June 27-July 25, 1966.

Harmon Foundation, New York.
Exhibition of Fine Art by American Negro Artists.
Organized in cooperation with the Commission on the Church and Race Relations, Federal Council of Churches.
New York: International House, 1928-1935.

Harmon Foundation, New York.
Exhibition of Productions by Negro Artists.
"The African Legacy and the Negro Artist," essay by Alain Locke. 1931.

Harmon Foundation, New York.
Exhibition of Productions by Negro Artists.
"The Negro Takes His Place in American Art," essay by Alain Locke. 1933.

Harmon Foundation, New York.
Non-Jury Exhibition of Works of Negro Artists.
1933.

Harmon Foundation, New York.
The Art of the Negro.
Traveling exhibition organized in cooperation with the College Art Association. 1934.

Harmon Foundation, New York.
Negro Artists: An Illustrated Review of Their Achievements.
In cooperation with Delphic Studios.
April 22-May 4, 1935.

Harmon Foundation, New York.
Select Picture List.
n.d.

Harmon Foundation, New York.
Cumulative Biographical Reference Index of Contemporary Negro Artists.
n.d.

Howard University Gallery of Art, Washington, D.C.
Art Exhibit: The Public Schools of the District of Columbia.
May 3-11, 1931.

Howard University Gallery of Art, Washington, D.C.
An Exhibition of Paintings by Three Artists of Philadelphia: Laura Wheeler Waring, Allan Freelon, and Samuel Brown.
Foreword by James A. Porter. February 1-29, 1940.

Howard University Gallery of Art, Washington, D.C.
American Paintings 1943-1948.
Foreword by Charles Seymour, Jr.
October 22-November 15, 1948.

Howard University Gallery of Art, Washington, D.C.
Ten Afro-American Artists of the Nineteenth Century.
Catalog by James A. Porter. February 3-March 30, 1967.

Institute of Contemporary Art, Boston.
Paintings, Sculpture by American Negro Artists.
Catalog by James A. Porter. January 5-20, 1943.

La Jolla Museum of Contemporary Art.
Dimensions of Black.
Edited by Jehanne Teihet. 1970.

Lincoln University, Jefferson City, Mo.
The Black Experience.
Statements by Romare Bearden and Jay Jacobs. 1970.

Los Angeles Country Museum of Art.
Three Graphic Artists: Charles White, David Hammons, Timothy Washington.
January 26-March 7, 1971; Santa Barbara Museum of Art, March 20-April 18, 1971.

The Metropolitan Museum of Art, New York.
American Paintings in the Twentieth Century.
Catalog by Henry Geldzahler. 1965.

Museum of Fine Arts, Boston.
Afro-American Artists: New York and Boston.
Organized in collaboration with the National Center of Afro-American Artists.
Special Consultant: Edmund B. Gaither.
May-June, 1970.

Museum of Modern Art, New York.
In Honor of Dr. Martin Luther King, Jr.
October 31-November 3, 1968.

Museum of Modern Art, New York.
Social Comment in America.
Catalog by Dore Ashton. 1968.

National Center of Afro-American Artists, New York.
Five Famous Black Artists Presented by the Museum of the National Center of Afro-American Artists: Romare Bearden: Jacob Lawrence: Horace Pippin: Charles White: Hale Woodruff.
February 9-March 10, 1970.

National Gallery of Art, Washington, D.C.
Exhibition of Works by Negro Artists at the National Gallery of Art.
Sponsored by the Association for the Study of Negro Life and History. October 31-November 6, 1933.

The Newark Museum.
Black Artists: Two Generations.
May 13-September 6, 1971.

New Jersey State Museum, Trenton.
Arts and Crafts Exhibition.
Sponsored by the Harmon Foundation and the New Jersey State Museum Advisory Board. March 31-April 30, 1935.

New York Public Library, 135th Street Branch.
Catalog of the Negro Arts Exhibition.
1921.

New York Public Library, 135th Street Branch.
Harlem Art Workshop Exhibition.
Organized in association with the Harmon Foundation and the Harlem Adult Committee. 1933.

Nicholas Roerich Museum, New York.
Paintings and Sculpture by Four Tennessee Primitives.
January 12-February 9, 1964.

The Oakland Museum.
New Perspectives in Black Art.
Organized in association with Art of Art-West Associated North. October 5-26, 1968.

The Oakland Museum.
Black Untitled.
October 1970.

Oak Park Library, Oak Park, Ill.
Exhibition of Black Artists.
Organized by Margaret Burroughs of the South Side Community Art Center, n.d.

Phillips Memorial Gallery, Washington, D.C.
Three Negro Artists: Horace Pippin, Richmond Barthé and Jacob Lawrence.
1946.

Smithsonian Institution, Washington, D.C.
Exhibition of Paintings and Sculpture by American Negro Artists at the National Gallery of Art.
In connection with William E. Harmon Awards for Distinguished Achievement among Negroes. May 16-29, 1929; May 30-June 8, 1930.

Smithsonian Institution, Washington, D.C.
American Art in the Barbizon Mood.
Catalog by Peter Birmingham. 1975.

South Side Community Art Center, Chicago.
Chicago Collectors Exhibit of Negro Art.
April 8-May 3, 1945.

Studio Museum in Harlem.
Black Artists of the 1930s.
1968.

Studio Museum in Harlem.
Africobra II.
1971.

Texas Centennial Exposition, Museum of Fine Arts, Dallas, Hall of Negro Life.
Exhibition of Fine Arts Productions by American Negroes.
1936.

Texas Centennial Exposition, Museum of Fine Arts, Dallas, Hall of Negro Life.
Thumbnail Sketches of Exhibiting Artists.
1936.

University of California, Los Angeles.
The Negro in American Art: One Hundred and Fifty Years of Afro-American Art.
Catalog by James A. Porter. Co-sponsored by the California Arts Commission. September 11-October 16, 1966.

University of Michigan, Ann Arbor.
Eight New York Painters.
Statement by Hale Woodruff. July 1-21, 1956.

University of South Alabama, Art Department, Mobile, Ala.
Afro-American Slide Depository Catalog.
1972.

Washington, Intercollegiate Club.
The Negro in Chicago, 1779-1929.
Chicago, 1929.

Whitney Museum of American Art, New York.
Contemporary Black Artists in America.
Catalog by Robert Doty. April 6-May 16, 1971.

Whitney Museum of American Art, New York.
The Painter's America, Rural and Urban Life, 1810-1910.
Catalog by Patricia Hills. September 20-November 10, 1974.

Young Woman's Christian Association, Montclair, N.J.
Exhibition of the Paintings and Drawings by James A. Porter and James Lesene Wells.
April 16-30, 1930.

Periodicals

ABA: A Journal of Affairs of Black Artists.
Dorchester, Mass.: National Center of Afro-American Artists.

Adams, Agatha Boyd.
"Contemporary Negro Arts."
University of North Carolina Extension Bulletin, June 1948.

"African Art—Harlem."
American Magazine of Art, October 1932.

"Afro-American Artists 1800-1950."
Ebony 23: 116-22.

"Afro-American Slide Program."
Art Journal, Fall 1970, p. 85.

"American Negro Art at Downtown Gallery."
Design, February 1942, pp. 27-28.

"American Negro Art."
New Masses, December 30, 1941, p. 27.

"American Negro Art Given Full-Length Review in New York Show."
Art Digest, December 15, 1941, p. 5.

"And the Migrants Kept Coming."
Fortune, November 1941, pp. 102-9.

Andrews, Benny.
"The Black Emergency Culture Coalition."
Art, Summer 1970, pp. 18-20.

"Art at the University."
Howard University Bulletin, March 1957.

Art Digest.
"The Negro Annual," May 15, 1934.

"An Art Exhibit against Lynching."
Crisis, April 1935, p. 107.

Art Gallery.
"Second Afro-American Issue," April 1970.

"Art of the Americas: From before Columbus to the Present Day."
Art News Annual, vol. 18 (1948). Reprint. New York: Simon and Schuster, 1948.

Arts in Society.
"The Arts and the Black Revolution Issue."
vol. 5, no. 3 (Summer-Fall 1968).

Art Time.
Special issue: "Black America 1970." April 6, 1970, pp. 80-87.

Ashton, Dore.
"African and Afro-American Art: The Transatlantic Tradition at the Museum of Primitive Art."
Studio, November 1968, p. 202.

"Atlanta's Annual Exhibition of Paintings and Sculpture by Negroes."
Time, April 9, 1951.

Baker, James H., Jr.
"Art Comes to the People of Harlem."
Crisis, March 1939, pp. 78-80.

"Baltimore: Art by Negroes."
Art News, February 11, 1939, p. 17.

Barnes, Albert C.
"Negro Art and America."
Survey, March 1, 1925, pp. 668-69.

Barnes, Albert C.
"Negro Art, Past and Present."
Opportunity, May 1926, p. 148.

Barnes, Albert C.
"Primitive Negro Sculpture and Its Influence on Modern Civilization."
Opportunity, May 1928, p. 139.

"The Barnes Foundation."
Opportunity, November 1927, p. 321.

Bearden, Romare.
"The Negro Artist and Modern Art."
Journal of Negro Life, December 1934.

Bearden, Romare.
"The Negro Artist's Dilemma."
Critique: A Review of Contemporary Art I, no. 2 (November 1946): 16-22.

Bement, Alon.
"Some Notes on a Harlem Art Exhibit."
Opportunity, November 1933.

Bennett, Gwendolyn B.
"The Future of the Negro in Art."
Howard University Record, December 1924, pp. 65-66.

Bennett, Gwendolyn B.
"The American Negro Paints."
Southern Workman, March 1928, pp. 111-12.

Bennett, Mary.
"The Harmon Awards."
Opportunity, February 1929, pp. 47-48.

"The Black Artist in America: A Symposium."
Metropolitan Museum of Art Bulletin, January 1969.

"Black Art Program in Boston."
Today's Art, December 1, 1970.

"Black Art; What Is It?"
Art Gallery, April 1970.

Black Shades: A Black Art Newsletter.
Washington, D.C., 1970.

Bloomer, Jerry M.
"The Hudson River School Exhibition."
American Art Review, May-June, 1974.

Bontemps, Arna.
"Special Collections of Negroana."
Library Quarterly, July 1944, pp. 187-206.

Bowling, Frank.
"The Rupture: Ancestor Worship, Revival, Confusion or Disguise: Black Artist."
Arts, Summer 1970, pp. 31-34.

Bowling, Frank.
"It's Not Enough to Say 'Black Is Beautiful'."
Art News, April 1971, pp. 53-55.

Brown, Evelyn S.
"The Harmon Awards."
Opportunity, March 1933.

Carline, R.
"Dating and the Provenance of Negro Art."
Burlington Magazine, October 1940, pp. 115-23.

Catlett, Elizabeth.
"A Tribute to the Negro People."
American Contemporary Art, Winter 1940, p. 17.

"College Art News."
Art Journal, April 1969, pp. 328-29; Spring 1972, p. 330.

Conroy, F.
"Salvation Art."
Metropolitan Museum of Art Bulletin, January 1969, pp. 243-88.

Conway, M. D.
"The Negro as an Artist."
Radical 2 (1967): 39.

Daval, Jean-Luc.
"Lettre de la Suisse Romande, et de Zurich: Genève. Huit Artistes Afro-Américain."
Art International, October 20, 1971.

Douglas, Carlyle C.
"Romare Bearden."
Ebony 31, no. 1 (November 1975): 116-22.

DuBois, W. E. B.
"Social Origins of American Negro Art."
Modern Quarterly, October/December 1925, pp. 53-56.

DuBois, W. E. B.
"Criteria of Negro Art."
Crisis, May 1926, pp. 290-97.

"Exhibition of Paintings and Sculpture by Negro Artists."
Montclair Art Museum Bulletin, February 1946, pp. 3-4.

"Experience of Three Artists Points Out Value of WPA Federal Art Project."
Norfolk Journal and Guide, July 4, 1936.

Fax, Elton C.
"Four Rebels in Art."
Freedomways, Spring 1961.

"Federal Murals to Honor the Negro."
Art Digest, January 1, 1943.

"Fifty-Seven Negro Artists Presented in
Fifth Harmon Foundation Exhibit."
Art Digest, March 1, 1933, p. 18.

Fine, Elsa Honig.
"Mainstream, Blackstream and the Black
Art Movement."
Art Journal, Spring 1971, pp. 374-75.

"Fisk Art Center: Stieglitz Collection
Makes It Finest in South."
Ebony, May 1950, pp. 73-75.

"Fisk Universities Dedicates Alfred
Stieglitz Collection."
Crisis, March 1950, pp. 157-59.

Gaither, Edmund B.
"The Evolution of the Afro-American
Artists."
Artist's Proof 2: 24-33.

Gaither, Edmund B.
"Visual Arts and Black Aesthetics."
ABA: A Journal of Affairs of Black Artists,
vol. 1, no. 1.

Garver, T. H.
"Dimensions of Black Exhibition at La
Jolla Museum."
Artforum, May 1970, pp. 83-84.

"Harlem Goes in for Art."
Opportunity, April 1939.

"Harlem Library Shows Negro Art."
Art News, May 20, 1933, p. 14.

"Harmon Awards Announced for
Distinguished Achievement among
Negroes in Fine Arts for 1929."
Art News, February 8, 1930, p. 17.

"Harmon Exhibit of Negro Art, Newark
Museum."
Newark Museum Bulletin, October 1931,
p. 178.

"Harmon Foundation Exhibition of
Painting and Sculpture, Art Center."
Art News, February 21, 1931, p. 12.

"Harmon Foundation Spreads Public
Appreciation of Negro Art."
Art Digest, June 1935, p. 23.

Herring, James V.
"The American Negro as Craftsman and
Artist."
Crisis, April 1942, pp. 116-18.

Herring, James V.
"The Negro Sculpture."
Crisis, August 1942, pp. 261-62.

Hughes, Langston.
"The Negro Artist and the Racial
Mountain."
The Nation, June 23, 1926,
pp. 692-94.

Johnson, James Weldon.
"Race Prejudice and the Negro Artist."
Harper's, November 1928, pp. 769-76.

Jones, Lois M.
"An Artist Grows Up in America."
Aframerican Woman's Journal, Summer/Fall
1942, p. 23.

Jones, Lois M. (Pierre-Noel).
"American Negro Art in Progress."
Negro History Bulletin, October 1967,
pp. 6-7.

Lewis, T.
"Frustration of Negro Art: Vitiating
Influence of Color Prejudice."
Catholic World, April 1942, pp. 51-57.

Locke, Alain.
"The American Negro as Artist."
American Magazine of Art, September 1931.

Locke, Alain
"Chicago's New Southside Art Center."
Magazine of Art, August 1941, p. 320.

Locke, Alain
"Negro Art in America."
Design, December 1942, pp. 12-13.

Motley, Willard F.
"Negro Art in Chicago."
Opportunity, January 1940.

"On Black Artists."
Art Journal, Spring 1969, p. 332.

Porter, James A.
"Art Reaches the People."
Opportunity, December 1939, pp. 375-76.

Porter, James A.
"The Negro Artist and Racial Bias."
Art Front, March 1936, p. 8.

"Princeton Group Arts."
Crisis, January 1951, pp. 19-22.

Reed, Ishmael.
"The Black Artist: Calling a Spade a Spade."
Arts, May 1967.

Rose, Barbara.
"Black Art in America."
Art in America, September/October 1970.

Schuyler, George.
"The Negro Art Hokum."
The Nation, June 16, 1926.

Stahl, Annie L. W.
"The Free Negro in Ante-Bellum Louisiana."
Louisiana Historical Quarterly 25, no. 2 (April 1942): 301-95.

"Studio Watts Learning Center for the Arts."
Art Journal, Fall 1969, p. 35.

Thurman, Wallace.
"Negro Artists and the Negro."
New Republic, August 31, 1927.

d'Usseau, Arnoud.
"The Negro as Artist."
American Contemporary Art, Winter 1946, p. 7.

"What Is Black Art?"
Newsweek, June 22, 1970.

Woodruff, Hale
"Negro Artists Hold Fourth Annual in Atlanta."
Art Digest, April 15, 1945, p. 10.

"WPA Art Center Opened in Chicago Negro Community."
Museum News, April 1, 1941.

Young, J. E.
"Two Generations of Black Artists, California State College, Los Angeles."
Art International, October 1970, p. 74.

"Young Negro Artists."
Design, November 1943, p. 7.

Young, Stark.
"Primitive Negro Sculpture."
New Republic, February 23, 1927.

Newspapers

"About Art and Artists."
New York Times, November 3, 1955, p. 28.

Albright, Thomas.
"New Black Art Shows and Old Techniques."
San Francisco Chronicle, October 14, 1968.

"Art: Afro-American Artists: New York and Boston."
Amesbury (Mass.) News, June 17, 1970.

"Artists Praise Lynching Exhibit."
Boston Chronicle, March 1, 1935.

"Art Should Inspire Us Says Woman Artist of Los Angeles."
California News, February 22, 1935.

"Black Artists Work on View at Museum."
Brookline (Mass.) Chronicle Citizen, May 14, 1970.

"Black Crafts."
Christian Science Monitor, May 11, 1972.

Bloomfield, Arthur.
"Top Black Artists."
San Francisco Examiner, November 4, 1970.

Canaday, John.
"Negroes in Art: An Exhibition Examines 250 Years of Pictorial Social History."
New York Times, May 24, 1969.

Chatfield-Taylor, Rose.
"Howard U Holds Negro Exhibit."
Washington Post, February 16, 1941.

"Chicago Active in Effort to Establish Community Art Center."
Chicago Defender, May 20, 1939.

"College Art Association Assembles Negro Art Exhibition."
New York Times, May 1, 1934.

"The Community Art Center."
Chicago Defender, March 1, 1941.

Driscoll, Edgar J., Jr.
"Art Show Reflects Black Rage, Pride."
Boston Globe, April 18, 1971.

"Exhibition Sponsored by the Harmon Foundation Assembled by the College Art Association."
New York Times, May 6, 1935.

Frankenstein, Alfred.
"Whatever Happened to...."
San Francisco Sunday Examiner and Chronicle, October 26, 1969.

Glueck, Grace.
"1930's Show at Whitney Picketed by Negro Artists Who Call It Incomplete."
New York Times, November 18, 1968.

Glueck, Grace.
"America Has Black Art on Her Mind."
New York Times, February 27, 1969.

Glueck, Grace.
"Black Show under Fire at the Whitney."
New York Times, January 31, 1971.

"Harlem Sees Some Negro Art."
New York Herald Tribune, September 17, 1933.

"Howard University Gallery: Paintings by Three Artists Are Displayed."
Washington Star, February 18, 1940.

"Independent Art Show Opens Tomorrow."
Washington Post, April 21, 1935.

Kienzle, Connie.
"Blacks Pour Out Soul, Pride, at Their Art Show."
Pittsburgh Press, February 23, 1967.

Kramer, Hilton.
"Trying to Define Black Art: Must We Go Back to Social Realism?"
New York Times, May 31, 1970.

"Mrs. Roosevelt Featured Guest at Art Center."
New York Amsterdam News, December 25, 1937.

"Murals Battle Continues at New York Hospital."
Afro-American, March 21, 1936.

"Negro Art in New York."
Washington Post, December 14, 1942.

"Negro Artists Paintings on Display at University (Howard)."
East Tennessee News (Knoxville), June 6, 1932.

"Negro Students Hold Their Own Art Exhibition."
New York Herald Tribune, February 15, 1935.

"Negro Temple of Art."
Dayton Newsweek, June 19, 1941.

"New Project to House Work of Negro Artist."
Los Angeles Sentinel, December 21, 1945.

Porter, James A.
"Negro Artists Gain Recognition after Long Battle."
Pittsburgh Courier, July 29, 1950.

Porter, James A.
"Progress of the Negro in Art during the Past 50 Years."
Reprint, *Pittsburgh Courier*, 1950.

"Prejudice Raises Its Ugly Head, Art Fraternity 'Backs Up'."
Philadelphia Independent, December 13, 1942.

"Protests Cannot Halt Lynchings Exhibition New York: Art Gallery Closed to NAACP, But Show Will Go on Says White."
Afro-American, February 16, 1935.

Roosevelt, Eleanor.
"Negro Paintings at Howard Were Inspiring." in "My Day" column for the *Washington Daily News*, March 3, 1941.

Tuttle, Worth.
"Negro Artists Developing True Social Art."
New York Times, May 14, 1933.

"When You Think of Culture Think of Roxbury—Not Boston."
Muhammad Speaks, September 17, 1971.

Index of Artists

Photography Credits

Unless otherwise listed all photographs are courtesy of the lender.

Figures

2. Museum of African Art, Eliot Elisofon Archives
3. David C. Driskell
4. Muriel and Malcolm Bell
5. Ausbra Ford, Musée Royale de l'Afrique Central, Tervuren, Belgium
6. Reproduced by permission of the Trustees of the British Museum
8. F. B. Gautier, Vicksburg, Mississippi
9. David C. Driskell
10. Tony Wrenn
11. David C. Driskell
12. North Carolina Museum of History
13. North Carolina Museum of History, Department of Cultural Resources
14. William Edmund Barrett
15. Tony Wrenn
16. Tony Wrenn
17. William Edmund Barrett
18. Courtesy of the Cleveland Museum of Art
19. Department of Art, Fisk University
20. David C. Driskell, Department of Art, Fisk University
21. Abitare Magazine
22. Abitare Magazine
23. Department of Art, Fisk University
24. Library of Congress
25. Colonial Williamsburg
26. Steven L. Jones, courtesy of the Library of Congress
27. David C. Driskell
28. Department of Art, Fisk University
29. Steven L. Jones
31. David C. Driskell
32. Clark Thomas
35. Department of Art, Fisk University
37. Department of Art, Fisk University
38. Department of Art, Fisk University

Catalog Numbers

2. William Edmund Barrett

3. Bill Van Calsern
4. Los Angeles County Museum of Art Photography Department
5. Los Angeles County Museum of Art Photography Department
6. Stuart Lynn
7. Geoffrey Clements
9. Bill Van Calsern
21. Los Angeles County Museum of Art Photography Department
24. Jim Wells
29. Jim Wells
30. Jim Wells
31. Jim Wells
34. Clark Thomas
36. Jim Wells
38. Jim Wells
39. Jim Wells
41. Jim Wells
63. Los Angeles County Museum of Art Photography Department
68. Clark Thomas
73. D. A. Rollins
87. eeva-inkeri
88. eeva-inkeri
89. Los Angeles County Museum of Art Photography Department
91. O. E. Nelson
94. Roy Trahan
99. Department of Art, Fisk University
105. Edward D. Disney
113. Bob Stevens
114. Bob Stevens
126. Jim Wells
134. Jim Wells
137. Geoffrey Clements
140. Barney Burstein
151. Los Angeles County Museum of Art Photography Department
153. C. Grimmette
157. Jonathan Eubanks
158. Los Angeles County Museum of Art Photography Department

Designed in Los Angeles by Bradford
Boston, Boston and Boston, A
Corporation. All text set in Palatino by
Hi-Speed Advertising Typography, Los
Angeles. Catalog printed on Warren's
Lustro Offset Enamel Gloss by Murray
Printing Company, Forge Village,
Massachusetts. Color separations by
Chanticleer Press, Inc., New York,
New York. Color printing by Rae
Publishing Company, Inc., Cedar Grove,
New Jersey.